Camera

Victorian Eyewitness

A History of Photography: 1826–1913
by Gus Macdonald

A STUDIO BOOK

THE VIKING PRESS · NEW YORK

Published in 1980 by The Viking Press
625 Madison Avenue, New York, N.Y. 10022

Published simultaneously in Canada by
Penguin Books Canada Limited

Library of Congress Catalog Card Number: 79–5296

ISBN 0–670–20056–5

Printed in Great Britain by
Butler & Tanner Ltd, Frome and London

Contents

Acknowledgements

This book sprang, somewhat to my surprise, from a Granada Television series called *Camera* – a thirteen part exploration of early photography. This was not, in fact, the series which, with my colleague Maxine Baker, I had set out to make some two years before. Our intention then was to pursue a shared enthusiasm for the history of documentary film back to its source in the 1890s. But as we passed the century mark travelling backwards, we were increasingly fascinated by the range of photographic images we unearthed, many of them striking and unfamiliar. And no one, we observed, had yet attempted to cover fully on film the remarkable sweep of Victorian photography. One reason was quickly apparent. The Victorians had made billions of photographs, of which millions still survive; the job of finding them, sifting the best, then clearing thousands of individual pictures for television transmission proved to be daunting. However, it was accomplished by Maxine Baker, assisted by Trish Mulholland and Olga Sheppard, working to our picture researchers Elly Beintema, Phil Flower and Taylor Downing. Our team also called on the expertise of Jenni Pozzi, Katherine Digiulio, and Pat Hodgson in London; Eliane Arari in Paris; and Gail Buckland and Shirley Greene in America, where Jeanne White of Granada International also laboured selflessly on our behalf.

Taking the tens of thousands of images thus assembled and shaping them into programmes which would entertain as well as inform was the task of our four directors. John Pett bore the brunt with 5 episodes, *First Impressions, World on a Plate, Mirror Image, Eyewitness of War* and *Truth and Beauty*. Noel Chanan joined him to make *Soldiers of the Queen, Caught in Time* and *News Flashes*. Martin Smith made *Outback and Beyond, Photographic Pleasures* and *The Other Half*. David Naden then completed the series with *Wheel of Life* and *The Ends of Art*. As the only living thing on screen during most of the series I am beholden to the directors for their patience on those occasions when I wasn't looking too good myself, and for their mastery of one of television's most treacherous assignments – that of making still pictures into moving films.

I am similarly grateful to those skilful and companionable cameramen Mike Thomson, Nick Hale and Arthur Smith, and to Phil Taylor on sound. Indeed this gratitude extends, to all crew members, both staff and freelance, on locations which ranged from the French Alps to the deserts of New Mexico; and to John Worsfold who helped get us there. The painstaking job of bringing thousands of photographs to life on the rostrum camera was achieved by Ken Morse and Phil Phillips. Finally, the thirteen episodes were edited by Shelagh Brady, Jack Dardis, Ray Frawley and Eddie Mansell who cut to the inventive and entertaining score composed by Stephen Oliver and conducted by Marcus Dods. John Whitworth then mixed and dubbed with his usual assurance. On behalf of this production team, let me say that we are particularly indebted to our executive producer, Denis Forman, for his constant encouragement of our sometimes reckless ambition, his good counsel, and his unfailing equanimity.

Our advisors on the series were Brian Coe, Curator of the Kodak Museum at Harrow; Aaron Scharf, Professor of the History of Art at the Open University; Colin Ford, Keeper of Film and Photography at the National Portrait Gallery; and the Curator of the National Film Archive, David Francis. However, the historical, social, and cultural emphases of both book and series are, of course, entirely my responsibility, as are any errors of fact.

David Jenkins, our general researcher on the *Camera* series, also helped comb and criticise the text of the book, as did my friend Jane Cousins. Phil Flower prepared photographs and captions for the book and assembled the index. The text was typed by Charlotte Bird and Amanda Shaw.

Another typist (and more besides) was Teen Macdonald who, with Jean and Tracy, by good humour and timely abuse kept my incipient authorial neuroses firmly under control. This book is for them.

Gus Macdonald

Introduction

Old photographs have a peculiar power. A single image can set up a strong resonance with the past, evoking a nostalgia sometimes tinged with melancholy, and a sense of wonder that a visual medium like photography, seemingly so modern, should in fact reach back so far. Indeed in 1826, when a crude image of nature was first caught and fixed, Charles Dickens was still a schoolboy and Victoria, who would give her name to the coming age, was only seven. When a perfected process eventually went on offer to the public in 1839, photography was instantly popular and the earliest portraits summon back an even more distant past: Englishmen wear battle medals won at Waterloo, daguerreotypes show the faces of citizens who lived through the French Revolution, and others portray Americans who were born when their country was still a British colony. The sadness comes with the sure knowledge that even the youngest children featured in these early photographs are long since aged and gone.

Photography was a medium which met its time. The camera's objectivity recommended it to an empirical age, and in the visual arts the photograph's inherent realism helped deflate the prevailing romantic rhetoric. In a period of great stress and upheaval, photography was proclaimed, by Macmillan's Magazine in 1871, somewhat fulsomely, to be one product of progress whose benefits had at least reached across the chasm of social class: 'Anyone who knows what the worth of family affection is among the lower classes, and who has seen the array of little portraits stuck over a labourer's fireplace, still gathering into one the "Home" that life is always parting – the boy that has "gone to Canada", the "girl out at service", the little one with the golden hair that sleeps under the daisies, the old grandfather in the country – will feel with me that in counteracting the tendencies, social and industrial, which every day are sapping the healthier family affections, the sixpenny photograph is doing more for the poor than all the philanthropists in the world.'

Today, interest in the humble photograph is quickening. Exhibitions attract good audiences, early photography is an accepted subject of study, biographies and monographs multiply, collectors and historians continue to unearth material, and in the auction room a scrap of paper with a faded image can now command a five figure sum. However, the Granada series *Camera – Early Photography*, on which this book is based, was television's first sustained attempt to present the broad sweep of the subject to a mass audience.

Making good television from still pictures is not easy. Put bluntly, television pictures move and old photographs do not, thus they disrupt the smooth flow expected of a popular medium. The grammar used by moving pictures is now, of course, well understood and their story unfolds naturally in the third dimension supplied by time. Old photographs, by contrast, are two-dimensional, mute, and frequently confusing. Searching them for clues to their origin or significance, or simply absorbing them for visual pleasure, is necessarily much more subjective. Presenting photographs on television therefore invites a set of special problems: How long might it take the viewer's eye, unprompted, to construe a complex image? Which details, if any, need be picked out in close-up? Should the full frame of the photograph be respected when it is at odds with the shape of the screen? Can the tone and detail of the original be faithfully reproduced? And which images can be juxtaposed legitimately in fluent sequence without intrusive commentary? Sustaining some sort of flow in these circumstances meant omitting an attractive scatter of individual images, each of which would have demanded a heavy overlay of words to explain provenance and relevance.

Television is, at best, a poor teacher: without reprise, most unfamiliar names, dates

and places are almost immediately forgotten. This ruled out an overly technical or strictly chronological plod through the history of nineteenth century photography. On top of that, my own experience across a range of documentary styles has left me diffident about dilating on the aesthetic attraction of one image over another. *Camera* developed instead as a series of themes, and these are pursued in the chapters of this book in greater detail than was possible on television. As you will see, the story of early photography is placed firmly in the context of its time. Since an objective and definitive history is, I suspect, an impossibility, *Camera* is set frankly in a social, political, and cultural matrix of my own making.

This was an almost inevitable recourse given the nature of photographs. Even in their surviving millions, these nineteenth century images can be no more than selective, fleeting impressions preserved from the continuum of time and numberless individual experiences. Again, the forces which shape history are complex and abstract, yet photographs do no more than record the external appearance of things. However, if photographs are unable to explain history, they can nevertheless offer intriguing detail and occasional clues, while also allowing us to *see* the people and events of an irretrievable time. And, for me, photography has above all a marvellous ability to conjure up historical associations.

Conversely, the significance of the many uses to which photography was put, and the development of particular practices, are best understood inside the context of their time. What television does do superbly is to stimulate interest in previously neglected areas and give an audience a perspective, a mental map into which they can place their own experience or future reading. And among the many excellent general histories, biographies, specialist studies and technical manuals in the thriving literature of early photography, a gap still exists which I hope this book may go some way to fill.

As an insurgent from a younger, brasher medium, much of my personal relish in researching *Camera* came from the discovery of photographic controversies which preview by a century some of the recurring concerns of television – a cultural industry whose present dynamic actively encourages the belief that it has no past. For instance, the dilemma of documentarians tempted to manipulate reality in order to better illustrate the 'truth', is posed starkly by some of the best known pictures of the American Civil War. Roger Fenton's famous photographs, which today shape our mental picture of the Crimean War, censor by omission and were in fact stealthily commissioned as political propaganda. Dr. Barnardo, in his well-intentioned attempts to dramatise through photographic reconstructions the plight of London's homeless urchins, found himself accused, like television's practitioners of drama documentary today, of perpetrating 'artistic fictions'. And some of the most striking landscapes of the American West were actually taken to provide visual evidence for a futile campaign against Charles Darwin.

For our television series we selected several thousands of the millions of surviving Victorian photographs, and from these we chose for this book nearly four hundred of the most outstanding images. The book follows the practice of the series in offering several examples from the work of major photographers at the expense of a token attempt to alight on every photographer of note. In anticipation of an audience for the most part unfamiliar with Victorian camerawork, this selection is consciously weighted to include the century's most famous photographs. But many other pictures should be fresh to all but the most encyclopaedic. Whether the pictures are much acclaimed or newly uncovered, I trust that those coming to early photography for the first time will find in these enduring images the same fascination I felt on my first sight of them – and on my last.

1 First Impressions

'The origin of a new art in the midst of an old civilization; an art which will constitute an era, and be preserved as a title of glory . . . the daguerreotype represents inanimate nature with a degree of perfection unattainable by the ordinary processes of drawing and painting – a perfection equal to that of nature itself.'

JOSEPH LOUIS GAY–LUSSAC

First Impressions

Camera obscura is simply Latin for 'dark room'. In sixteenth century Naples there was an Academy of Secrets where each initiate offered a scientific illumination to lighten the medieval gloom; one contribution of its founder, Giovanni Battista della Porta, was an account of the *camera obscura*. He was not, however, the first to observe the phenomenon. As far back as the fourth century B.C. Aristotle had watched a partial eclipse of the sun with the aid of a pinhole. When light funnels through such a small hole it emerges in a cone and can therefore project the image of a bright scene outside on a dark wall inside – albeit upside down. But it was della Porta, polymathic author in 1589 of a twenty-volume compendium called *Natural Magic*, who first used this optical principle to create some visual mischief. His unsuspecting audience, ushered into a darkened room at the Academy of Secrets, suddenly saw come alive on the wall the most amazing scenes – performed, it transpired, by a troupe paid to cavort on the other side of the pinhole. Not unreasonably, the viewing public strongly suspected della Porta of sorcery.

In another fantasy published by Tiphaigne de la Roche in Paris in 1760 a magical substance allows the image of nature to be caught and fixed on a mysterious island by a process uncannily akin to what came to be called photography. 'What a mirror cannot do, the canvas does by means of its viscous matter; it retains the images . . . This impression of the image is instantaneous, and the canvas is carried away at once into some dark place. An hour later the prepared surface has dried, and you have a picture all the more precious in that no work of art can imitate it, nor can it be destroyed by time . . . (nature) with a precise and never-erring hand, draws upon our canvasses images which deceive the eye.' It was a prophetic vision; the optical sorcery of the *camera obscura* would indeed require the intervention of alchemy before the image of nature was eventually entrapped.

The fact that the action of light darkened salts of silver had been known for a century, but in 1725 Johann Schulze chose to dramatize its visual potential in an ironically literal way: placing stencils over a jar of silver solution he used light to print words into the liquid. By this time a lens had been inserted in the aperture of a *camera obscura* to enhance the brilliance of the image which was also bounced off a mirror and turned right-ways-up. In other words, the basic optics of the photographic camera had now been mastered and contained in a box. Yet it was to be another hundred years before these advances in optics and chemistry led to the consummation which created photography.

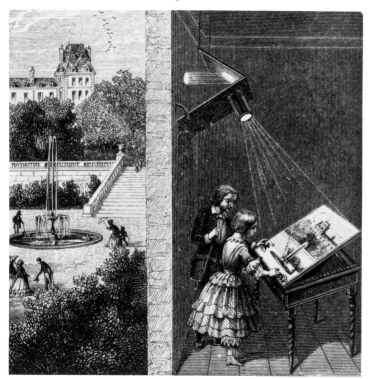

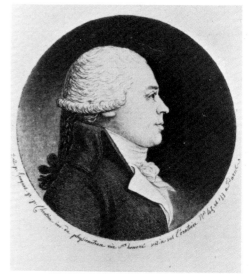

1 LEFT *A sophisticated example of the* camera obscura

2 ABOVE *A physionotrace of the inventor of the process, Gilles-Louis Chrétien, 1792*

Throughout this interminable courtship, Art danced attendance. Portable *camera obscura* were used by artists to draw scenes and heighten realism. Other contraptions appeared on the market promising to reproduce nature with mechanical accuracy. The physionotrace, for example, used a system of levers which retraced shadows into perfect small profiles for cameo silhouettes. But the old notion of somehow imprinting straight from nature continued to tantalize and in 1802 the prospects were assessed by Thomas Wedgewood, who had already made fleeting impressions with nitrate of silver, and the great British scientist Humphry Davy. They concluded that while in theory the fugitive image might soon be caught, it was still not at all clear how it could possibly be held.

In France, 1793 was a momentous year. Louis XVI and Marie Antoinette were guillotined, Marat was stabbed in his bath, Christianity was abolished and, while revolutionary France fought for her life and the British marauded through the Mediterranean, a young army officer on Sardinia, Nicéphore Niépce, was wondering how he might fix the image of nature. But it is the year after Water-

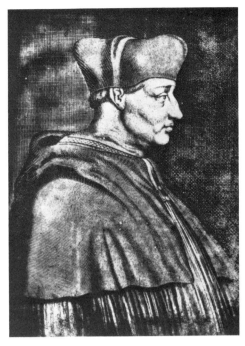

3 Nicéphore Niépce. *This engraving of Cardinal d'Amboise was pulled from a heliograph photocopied by the action of light from a portrait, 1826*

4 Nicéphore Niépce. *The first photograph. This crude impression of a view from an upper window of his house took eight hours to make, 1826*

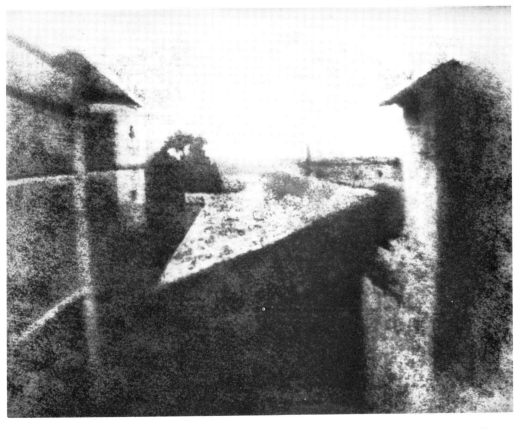

9

loo, 1816, before we hear more about the experiments which eventually led him to create the first ever photograph in 1826. This view taken from the upper window of the family mansion near Châlon in Burgundy was registered on a pewter plate coated with bitumen of Judea, a substance so insensitive that it took the sun eight hours to bake a crude image into it. Nevertheless, Niépce had at last achieved the first semblance of a permanent, positive image.

5 Louis Daguerre. *Oil painting of the ruins of Holyrood Chapel. One of the most famous scenes in his* Diorama, *1824*

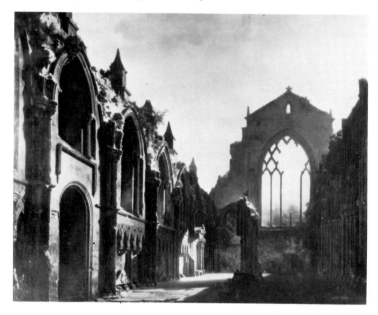

6 J.J. Mayall. *Daguerreotype portrait of Louis Daguerre, 1848*

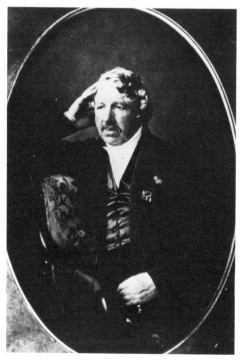

That year the secretive Niépce, innocently betrayed by his lensmaker in Paris, was approached by a showman called Louis Daguerre who was also engaged, with little success, in photochemical experiments. Niépce's initial suspicion was understandable: his discovery, if perfected and patented, might well restore the sagging fortunes of his once distinguished family. But the persistent and engaging Daguerre gradually broke down his reserve. Niépce was also much impressed by the *Diorama*, the showman's palace of illusion where spectacular effects were achieved with vast transparent paintings lit by an ingenious system of windows. Daguerre had one *Diorama* in Paris and another in London, where *The Mirror of Literature, Amusement and Instruction* acclaimed his backlit ruins of Holyrood chapel 'the greatest triumph ever achieved in pictorial art'. The inventor and the illusionist were finally joined in legal partnership in 1829, by which year Niépce was able to make detailed still lifes on glass plates. Sadly, the surviving example of this process was lent to a Professor Peignot who, in a fit of madness, smashed his laboratory and with it the historic glass plate. Niépce was still pursuing perfection when he died, unknown and impoverished, in 1833. The task of perfecting the process devolved onto Louis Daguerre who, although he did not know it, now had competition.

In England in 1833, the reforming Whigs had just put an end to the worst excesses of electoral corruption and successfully enfranchised the rising middle class. Surprisingly, the young member for Chippenham in that Reform Parliament, though grandson of an Earl and Lord of the Manor at Lacock, was himself a liberal Whig. But William Henry Fox Talbot was also a mathematician, botanist, linguist, inventor, and recently married man, who, in the autumn of the year, at last found time for a honeymoon. It was spent by the shores of Lake Como in Italy where, as he relaxed and sketched with an optical aid, an insight came which led him 'to reflect on the inimitable beauty of the pictures of nature's paintings which the glass lens of the camera throws upon the paper in its focus – fairy pictures, creations of a moment, and destined as rapidly to fade away. It was during these thoughts that the idea occured to me . . . how charming it would be if it were possible to cause these natural images to imprint themselves durably, and remain fixed on the paper!'

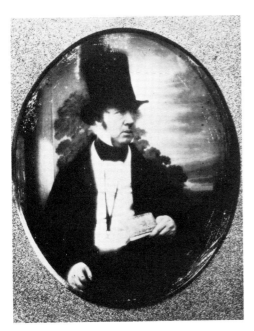

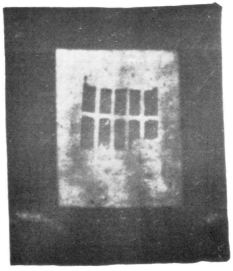

7 FAR LEFT Antoine Claudet. *Daguerreotype of William Henry Fox Talbot, 1844*

8 LEFT W.H.F. Talbot. *Latticed window at Lacock Abbey. Only 1½ inch square – this is the first negative photograph, 1835*

Returning to England, and oblivious of Daguerre's existence, Fox Talbot busied himself coating paper with salts of silver and soon succeeded in making prints of leaves pressed on the paper. By 1835 he had left Parliament and was experimenting with a small wooden camera in which he registered a tiny image less than 1½ inch square of the lattice window of his home at Lacock Abbey. This image, though faded, was evidently 'fixed' well enough to remain recognizable today – the oldest negative image in existence. Then for a couple of years Fox Talbot gave himself over to the problems of integral calculus and proceeded to solve them with an elegance which won him a medal – just a few weeks before the dismaying news arrived from France that Louis Daguerre had finally captured and fixed the image of nature.

After the setback of Niépce's death, serendipity had come to the aid of Daguerre. The most romantic account has him placing a briefly exposed plate, still blank, into a dark cupboard where it unaccountably develops an image. Daguerre then recalls a spill of mercury in the cupboard and goes on to deduce the principle of the latent image. Whatever the provenance of this discovery, in practice it meant that plates could be given brief exposures and subsequently fumed and developed with mercury vapour. The process now required a chemical which would fix the image and in 1837 he came up with a simple solution which worked quite well – hot salt water. The first successful photograph by this method was a still life of objects in Daguerre's studio.

With this much improved process, Daguerre advertised for 400 sponsors willing to put up a thousand francs each but a sceptical public ignored his cryptic offer of 'a chemical and physical process which gives Nature an ability to reproduce herself'. Daguerre now toured the boulevards ostentatiously making pictures but again public apathy was unshakeable. In despair he turned to a sympathetic politician François Arago who immediately saw the revolutionary implications of the process and set about persuading the French Government to buy it out. The cause of Arago's activity was made public by the *Gazette de France* which stated on 6 January 1839: 'We have much pleasure in announcing an important discovery made by M. Daguerre, the celebrated painter of the *Diorama*. This discovery seems like a prodigy. It disconcerts all the theories of science in light and optics, and, if borne out, promises to make a revolution in the arts of design . . . M. Daguerre shows you the plain plate of copper: he places it, in your presence, in his apparatus, and, in three minutes, if there is a bright summer sun, and a few more, if autumn or winter weakens the power of its beams, he takes out the metal and shows it to you, covered with the charming design representing the object towards which the apparatus was turned.'

When this report crossed the Channel, Fox Talbot wondered anxiously about the undisclosed details of Daguerre's process. 'I was placed,' he said, 'in a very unusual dilemma (scarcely paralleled in the annals of science),

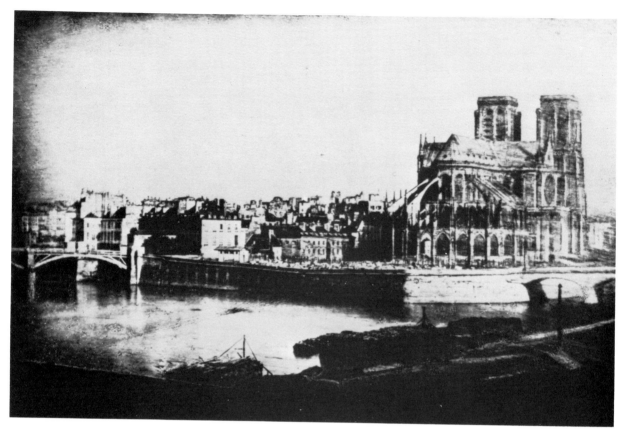

9 Louis Daguerre.
*View of the Ile de la
Cité and Notre Dame
taken before the
public announcement
of his discovery in
1839*

10 W.H.F. Talbot.
*An example of his
photogenic drawings
made by placing the
plant in contact with
sensitized paper and
letting light pass
through the leaves,
c.1839*

for I was threatened with the loss of all my labours, in case M. Daguerre's process proved identical with mine.' His first response was to lodge samples of his 'photogenic drawings' with the Royal Institute in London; he followed these up swiftly with a paper entitled 'Some Account of the Art of Photogenic Drawing', and fired off letters to Arago in France in a vain attempt to establish a prior claim.

In fact the two processes turned out to be very different – Fox Talbot took soft images on paper, Daguerre used a silvered copper plate. Both still shared the problem of not having an adequate fixative. This was soon solved by the dispassionate intervention of an English scientist Sir John Herschel who, intrigued by reports of the new marvel, worked out independently inside a week how it might be done. In addition, he suggested that hyposulphite of soda be used to fix the images firmly – and this 'hypo' was employed by generations of photographers. But Herschel's contribution did not end there. Assessing Talbot's photogenic drawings in which light areas showed up dark, he dubbed them 'negatives'; conversely, Daguerre's silver plate produced 'positives'. But comparing the English and French processes he had to concede to Arago that 'compared to the masterful daguerreotype, Talbot produces nothing but mistiness'.

The French government did buy out Daguerre's process and loftily agreed to donate it to the world. On 19 August 1839, at the Institute of France on the banks of the Seine opposite the Louvre, an excited crowd packed the meeting hall and overflowed into

the courtyards and the Quai de Conti outside. The sense of occasion may even have overcome the great showman himself, for Daguerre stood down pleading a sore throat and left Arago to make the historic announcement which revealed the secrets. 'A few days later,' an observer recalled, 'opticians' shops were crowded with amateurs panting for daguerreotype apparatus, and everywhere cameras were trained on buildings.'

Architecture was, of course, the subject best suited to the long exposures required. The camera could not normally show people although Daguerre himself, while preparing his first portfolio of pictures, had got on a plate, quite by accident, the minute image of a man in the Boulevard du Temple. This man, by standing on one spot just long enough to have his boots cleaned, unwittingly became the first person ever to be photographed. But despite the need for exposures which were many minutes long, Daguerre's process was an immediate sensation worldwide.

America got a head start through the enthusiasm of the painter and inventor Samuel Morse who, while in Paris demonstrating his Electro-Magnetic-Telegraph, swapped secrets with Daguerre and returned to proselytize in America. Morse exhibited his own daguerreotypes in October 1839 and experimented, along with his colleague John Draper, on portraits. By July 1840, Draper had made a successful portrait of his sister Dorothy in New York, one of the earliest examples in existence, with an exposure of 65 seconds. Morse and Draper are also credited with the logical deduction that since long exposures could not be affected by a few rapid blinks it was permissible to keep the eyes open. The first professional studio in the world was also opened in New York in 1840 by Alexander Wolcott. Exposures speeded up with the arrival of the much faster Petzval lens from Austria, and new chemical combinations helped sensitize the silver coating on the copper plate. Soon the average exposure was around half a minute, depending on light and conditions.

America produced some exceptional photographers in the first decade. The Boston pioneers, Southworth and Hawes (page 23) tried personally to make every portrait a work of art. Mathew Brady (page 83) hired operators to take his pictures, but he could still boast a gallery in New York hung with portraits of the most illustrious Americans. John Jabez Mayall introduced alle-

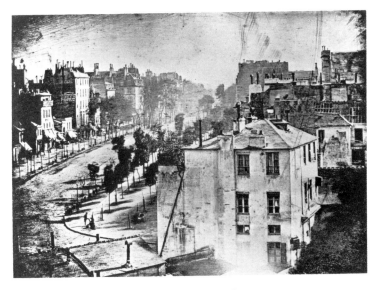

11 Louis Daguerre. *The first photograph of a human being. An anonymous Parisian in the Boulevard du Temple paused long enough to have his shoes cleaned, and make history, 1838–39*

gorical daguerreotypes (like the set of ten which illustrated each line of the Lord's Prayer) in his Philadelphia gallery, although he later moved to England where he set up a successful studio, photographed Queen Victoria, and was even elected Mayor of Brighton before he died.

Photography had an instant appeal for Americans. It was a natural leveller with none of the inherited mystique of older art forms. It also had a special appeal for emigrants to a

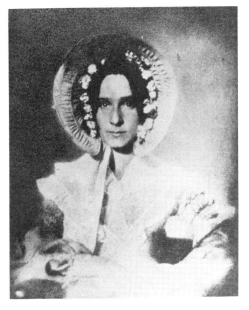

12 John Draper. *Daguerreotype of his sister Dorothy, taken in New York. Perhaps the earliest successful portrait to survive, June 1840*

13

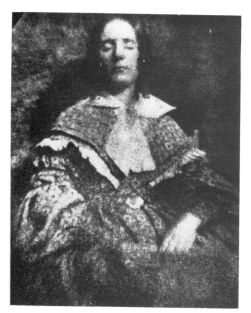

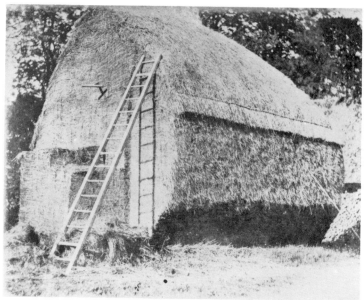

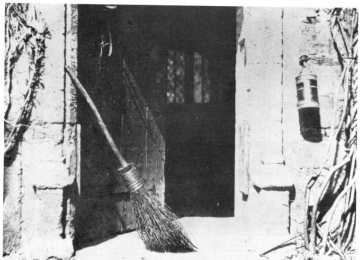

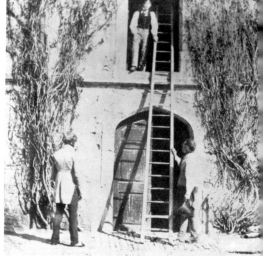

13 W.H.F. Talbot. *One of the earliest calotype portraits; his wife Constance at Lacock in October 1840*

15 W.H.F. Talbot. 'The Open Door', a study which helped illustrate The Pencil of Nature, *the first book with photographs, published 1844–46*

14 W.H.F. Talbot. 'The Haystack' – a study made at Lacock, c.1840

16 W.H.F. Talbot. 'The Ladder', taken in the courtyard at Lacock Abbey, c.1844

land still not fully explored, as the early advertisements were quick to emphasize:

'Nobody who travels knows when he shall return. Therefore he ought to leave something behind for his friends to remember him by. What can be more appropriate than a Daguerreotype.'

And as a trade, photography naturally appealed to a nation of entrepreneurs. Not only was there a daguerreotypist in every township worthy of the name, but many itinerants with cameras took to the trails in horse-drawn wagons.

By the end of the 1840s there were more professional photographers in New York City than in the whole of England where the census of 1851 counted only 51, just one of whom was a woman, Miss Wigley of 108

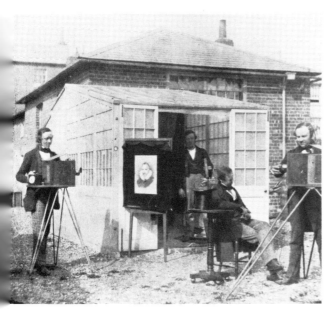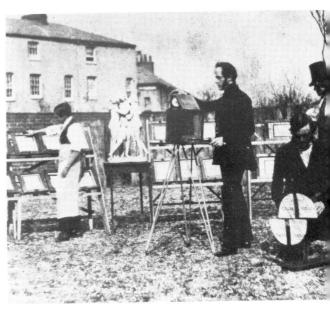

Fleet Street. That same year at the Great Exhibition in the Crystal Palace, the Americans, technically much more proficient, took three of the five prizes in the world's first international photographic competition.

Some blame for the stunting of British photography in that first decade may lie with Louis Daguerre himself who, in spite of the French government's magnanimous gesture, slyly patented his process in England. Also, Fox Talbot patrolled his patents with inhibiting zeal. In 1840 he too had discovered a way of bringing out latent images on his paper negatives. Talbot patented this process which he called 'calotype' and again used the negatives to print copies, the achievement which underpins his claim as founder of modern photography. The potential of the calotype was stressed by Sir David Brewster, the Scottish scientist who was later to perfect the stereoscope (page 50). He wrote in the *Edinburgh Review* in 1843: 'the great and unquestionable superiority of the calotype pictures is their power of multiplication. One Daguerreotype cannot be copied from another, and the person whose portrait is desired must sit for every copy that he wishes. When a pleasing picture is obtained, another of the same character cannot be reproduced.'

Fox Talbot got neither recognition nor reward; his process was never popular with professionals, and there was little interest in other countries. The glory had undoubtedly gone to Daguerre. But France also had its disgruntled man in Hippolyte Bayard who had followed Talbot in experimenting with

paper prints. Arago persuaded him to keep quiet during the delicate politicking of 1839 and rewarded him with a small gratuity. Bayard protested the injustice of it all by publishing a surreal self-portrait which depicted him half-naked as a drowned man.

Talbot's process was at least taken up by wealthy amateurs who valued the rich diffuse browns of the calotype above the vulgar mechanical precision of the daguerreotype. Fox Talbot himself took a large number of photographs of life at Lacock Abbey and made many views on his subsequent travels. His books *The Pencil of Nature* and *Sun Pictures in Scotland* published respectively in 1844 and 1845 were the first ever to be illustrated with photographs. Talbot's compositions have a direct, no-nonsense approach as

17 The first photographic factory in the world. Fox Talbot's printing establishment at Reading run by Nicholas Henneman from 1843 to 1847

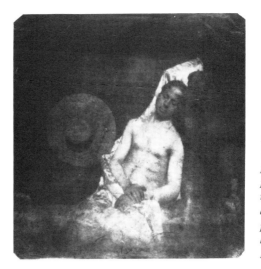

18 Hippolyte Bayard. The first protest picture. A self-portrait as a drowned man, done to dramatize the paper process with which he hoped to rival Daguerre, 1840

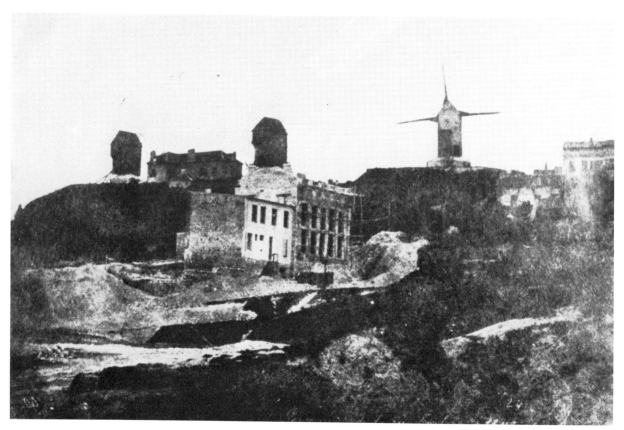

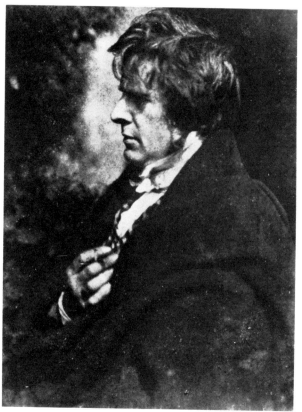

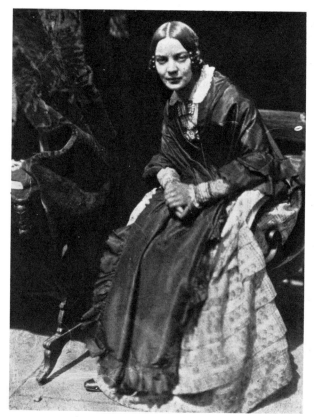

befits a scientist, but the finest work in calotype was undoubtedly done in Edinburgh by two friends of Sir David Brewster, David Octavius Hill and Robert Adamson. Hill was a painter and originally took up photography to make visual memoranda for a huge crowd canvas celebrating the schismatics who disrupted the Church of Scotland in 1843. Today this unsuccessful painting hangs in the headquarters of the Calvinist 'Wee Frees' Church in Edinburgh, but it is for the 1500 photographs produced by their partnership that Hill and Adamson are now remembered. In a few brief years before Adamson's death in 1848, they produced a remarkable range of portraits, landscapes and anecdotal studies as

19 LEFT Hippolyte Bayard. *Rue de Tholozé, one of his many studies of Paris, 1839*

LEFT, BELOW
20 Robert Adamson. *Calotype portrait of his partner David Octavius Hill,* c.*1843–47*
21 Hill and Adamson. *Mathilda Rigby,* c.*1843–47*

well as documenting soldiers in Edinburgh (page 80) and fisherfolk at nearby Newhaven. Hill the painter explained what was for him the particular appeal of the calotype. 'The rough surface, and unequal texture throughout of the paper is the main cause of the calotype failing in details, before the process of Daguerreotypy – and this is the very life of it. They look like the imperfect work of a man – and not the much diminished perfect work of God.'

But such achievements were few and it is significant that the calotype patent did not run in Scotland. Talbot's critics alleged that in his zeal he patented not just techniques but also abstract ideas and thus impeded progress. His patent also ran in France, and though it was not enforced Talbot did, with some justice, accuse Louis-Désiré Blanquart-

22 Hill And Adamson. *The Reverend James Fairbairn with the pious fisherfolk of Newhaven in Scotland. The hands support the heads through the long calotype exposure,* c.*1843–47*

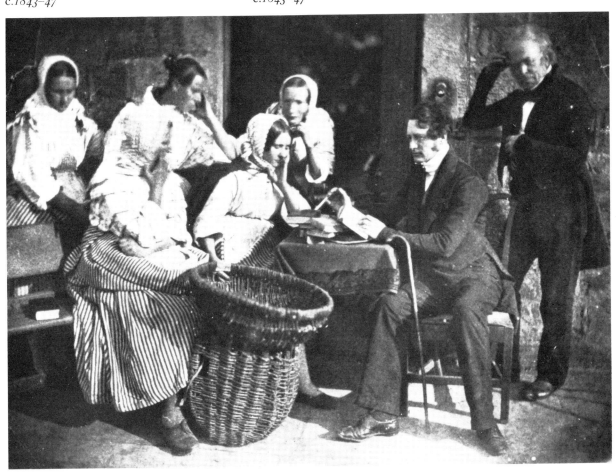

Evrard of a 'glaring act of scientific piracy'. However, the Frenchman went on to perfect the paper process and develop an albumen coating of egg-white which greatly improved the quality of paper prints. By 1851 Blanquart-Evrard had set up in Lille a photographic factory, mass producing prints on assembly-line principles.

The technical advance which ultimately made both the calotype and daguerreotype obsolete also came in 1851 with the invention of the collodion process by Frederick Scott Archer. The technical details were given away freely but again the litigious Talbot attempted to subsume Archer's process inside his ambitious patent. But this time he went too far. Public opinion was aroused and the Presidents of the Royal Academy and Royal Society made a joint appeal to Talbot to desist. In his defence it is argued that Talbot allowed free use of his process to scientists and amateurs and demanded fees only from

23 Hill and Adamson. *Man and boy in Newhaven, c.1843–47*

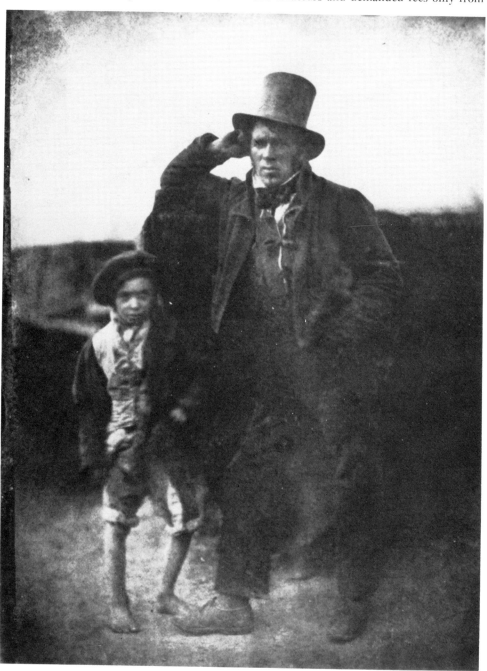

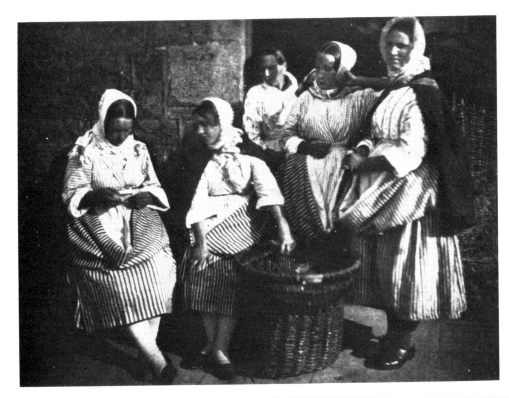

24 Hill and Adamson. *Newhaven fisherwomen,* c.*1843–47*

25 Hill and Adamson. *A Newhaven fisherman, James Linton, with his boat and bairns,* c.*1843–47*

professionals.

Unlike Fox Talbot, the other founding father Louis Daguerre had taken little active interest in photography once honour was secured. He was nevertheless held in general affection. When he died in 1851 American photographers wore black crêpe for thirty days of mourning. In that first decade Daguerre and Talbot had already seen much of photography's potential realized: first, the still lifes, architectural views, townscapes and landscapes; then, the modest documentary efforts, early news pictures and the tireless, exploring eye; art soon inspired the genre scenes and allegorical or anecdotal posturings, nudes were on offer discreetly as aids to artists or to repressed libidos; and, of course, overwhelming all else, there was the constant rage for photographic portraits.

The new process introduced in 1851 greatly extended the range of the camera in all these familiar directions, and a few more besides. Indeed collodion opened up a new and expansive phase in the 1850s and continued to dominate for the next thirty years. But it is a sad irony (which Fox Talbot might have appreciated most) that young Scott Archer, who had made it all possible by selflessly donating the collodion process to posterity, died in 1857 at the age of 44, in extreme poverty.

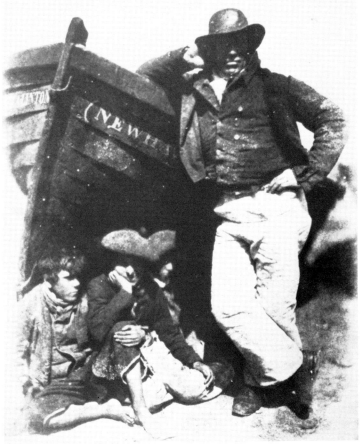

19

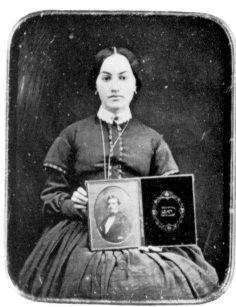

26 and 27 *The Americans took to the daguerreotype with particular enthusiasm. Galleries flourished in most towns by the early years of the 1840s. Both these portraits are anonymous*

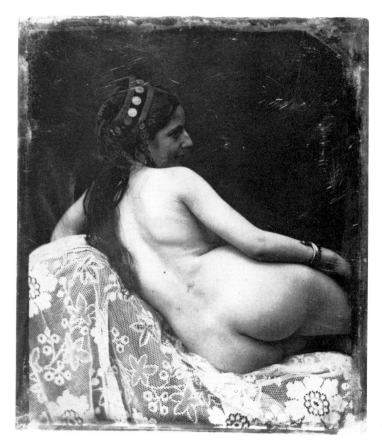

28 *This anonymous French daguerreotype is one of the earliest of the many nude studies made for painters or collectors of erotica, c.1845*

2 Mirror Image

'Human vanity is one of the most certain and profitable weaknesses of mankind . . . All those whose minds were empty and whose pockets were full, all the young people and beautiful coquettes, who, after their own appearance, love nothing better than the image of it, were pleased they could have their image multiplied.'

CHARLES D'AUDIGIER

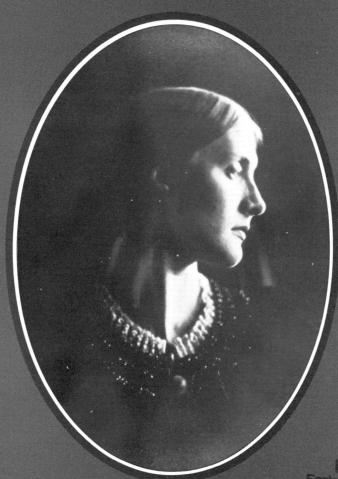

Mirror Image

Ninety-five per cent of all daguerreotypes made are said to have been portraits. The camera democratized the image and for the first time large numbers of people could afford pictures of themselves. These might show off through dress or stance the sitter's station in life, preserve a semblance of youth, or perhaps help memory to cope with distance or death – a function which the critic Walter Benjamin suggests, 'offers the last refuge for the cult value of the picture. For the last time the aura emanates from the early photograph in the fleeting expression of the human face. This is what constitutes their melancholy, incomparable beauty.'

Custom was drummed up with this rhyme from the time. 'Secure the shadow 'ere the substance fade, Let Nature imitate what Nature made.'

Before photography only the rich could afford a painted image of themselves. Sir Joshua Reynolds took up to fifty sittings for a portrait and twelve full sittings just to paint Sir George Beaumont's cravat. At the cheaper end of this market was the trade in miniatures. When Queen Victoria asked one miniaturist, Alfred Chalon, if photography would not ruin his business, his nonchalant reply was 'Ah non, Madame! photographie can't flattere.' But the *Athenaeum* asked more realistically 'What can the miniature painter do against the sun?' Very little as it turned out

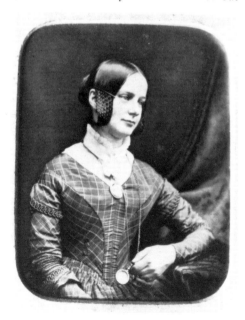

1 Antoine Claudet. *Unidentified portrait by the Frenchman who opened the second daguerreotype studio in England in 1841*

and within a couple of decades miniaturists were almost extinct.

In its earliest form the daguerreotype was too slow for good portraits since exposures could take up to 30 minutes. Faces were whitened and people made to sit in strong sunlight with eyes closed or tears running down their cheeks in the first attempts to fix a human face. But as better lenses and more responsive chemicals quickened the process, exposures were reduced to lengths of only a few minutes. Commercial portrait studios then set up shop with glass roofs to let in light and with mirrors which reflected the sun onto the sitter's face.

The first public studio in England was opened by Richard Beard in Regent Street, London, and celebrated by George Cruikshank in the following poem:

Your image reversed will minutely appear
So delicate, forcible, brilliant and clear
So small, full, and round, with a life so profound
As none ever wore
In a mirror before.

Heads were held steady with neck clamps, or chins were rested on fingers; an early injunction was 'sit there, still as death'. The expensive ordeal at the London studio of Antoine Claudet in 1841 was described by one disgruntled sitter, Thomas Sutton. 'I was seated . . . in the full blazing sunshine and after about an exposure of a minute the plate was developed . . . My eyes were made to stare until the tears streamed from them and the portrait was of course a caricature. I paid a guinea for it. It has since faded. . . .' Many people were also disappointed by the hard mirror-like honesty of the daguerreotype and the French studio photographer Lerebours, who was doing about 1,500 portraits a year by 1841, complained, 'The most terrible enemy which the daguerreotype has to combat is, without contradiction, human vanity.' But early sitters had some grounds for complaint: early lenses and sensitized materials distorted the translation of colour into tone; yellows and reds were rendered dark, blues turned pale. In 1857 Lady Eastlake, wife of the President of the Photographic Society of London, was still critical. 'If the cheek be very brilliant in colour it is as often as not represented by a dark stain. If the eye be blue it turns out as colourless as water.' To offset these inherent disadvantages, Dr. Andrew Winter in the *People's Journal* of 1846 had advised, 'If ladies must study for a bit of effect, we will

give them a recipe for a pretty expression of the mouth . . . let them place it as if they were going to say "prunes".'

America took enthusiastically to the daguerreotype. However one set which turned up recently in an attic at Harvard was distinctly sinister. These portraits of slaves were an attempt to prove photographically that blacks were physically inferior. Another early American curiosity is a photograph of a hand – a very early known example of a part being used to signify the whole – branded with the letters 'SS'. It was the hand of Captain Jonathan Walker who in 1844 made an unsuccessful attempt to free seven slaves; caught off the coast of Florida, 'SS', for Slave Stealer, had been burned on his right palm. There is no record of what Captain Walker looked like.

Southworth and Hawes, in partnership in Boston from 1843, were experimenting constantly and of their 1,500 portraits still in existence no two are posed alike. The partners claimed, with some justification, to take the best daguerreotypes in the world. Unlike other portrait factories, their studio never made a fortune but it did become a salon for the outstanding New Englanders of the day. With each portrait Southworth and Hawes tried simultaneously to fix a good likeness and to express the individuality of the sitter.

And this was the age of individualism. The fixed order of the feudal past was gone and a dynamic middle class now stared at the camera, and the world, with growing self-confidence. The new lords of humankind, defiant and unsmiling, display through the skill of the gifted photograph that strength of character which was soon to remake much of the world in their image.

Fortunes were made through portrait photography. Mathew Brady in New York had a gallery in which customers could promenade and view his ambitious attempt to make portraits of every American of distinction. In London Antoine Claudet had a 'temple of photography' built in Regent Street by Sir Charles Barry who had designed the Houses of Parliament. Leicester Square

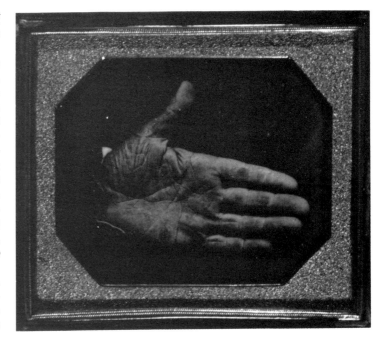

2 Southworth and Hawes. *The 'SS' branded on the hand of Captain Jonathan Walker stands for Slave Stealer. The daguerreotype image has laterally reversed the letters, 1845*
3 Southworth and Hawes. *Lemuel Shaw, Chief Justice of the Massachussets Supreme Court, placed to catch a shaft of sunlight in the studio, 1851*

boasted a 'Panopticon of Science and Art' with a room 54 foot long 'enabling family groups of eighteen persons to be taken at once'. Oliver Sarony at the small Yorkshire resort of Scarborough built a palatial 120 foot studio in Louis Quinze style and made £10,000 profit a year.

Yet the finest portraits in England were the work of extraordinary amateurs. The Reverend Charles Dodgson, now better known as Lewis Carroll, once said, 'I am fond of all children, except boys' and when Carroll took up photography as a hobby in 1856, his bachelor rooms at Christ Church, Oxford, were soon decked with toys and fancy dresses for the little girls he came to photograph so obsessively. Given exposure times of around 45 seconds, Carroll got remarkably good performances from his little girl friends in return for the attention he lavished on them. Carroll also picked off celebrities from his vantage point inside the intelligentsia but his portraits of girls are the most original and memorable. While children's scruples about immodesty were to be treated with 'utmost reverence', Carroll did admit his longings in a letter to a friend; 'I wished I dared dispense with all costume. Naked children are so perfectly pure and lovely; but Mrs Grundy would be furious – it would never do.' Carroll does seem to have pursued his interests in nude studies but it is not clear if Mrs. Grundy, in the shape of a young girl's mother, had anything to do with his sudden decision to give up photography in 1880. His most famous photograph in those twenty-five years was of course of Alice, the daughter of Dean Liddell of Christ Church, for whom in the hot summer of 1862 he spun one of the most fantastic stories in the language.

Alice Liddell also sat thirteen years later for another great Victorian amateur, Mrs. Julia Margaret Cameron. Wife of a member of the

7 and 8 Southworth and Hawes. *Some of the unidentified portraits among the partners' 1500 surviving daguerreotypes*

4 LEFT Southworth and Hawes. *Cassius Marcellus Clay, a southerner who advocated the abolition of slavery,* c.*1845*
5 Southworth and Hawes. *Lola Montez, Irish adventuress, Spanish dancer, and notoriously the mistress of many including mad King Ludwig of Bavaria, posing boldly with a cigarette, 1851*
6 Southworth and Hawes. *Rosary indicates that this 'sleeping' child is dead. High infant mortality and the Victorian cult of death sustained a demand for such funerary portraits,* c.*1855*

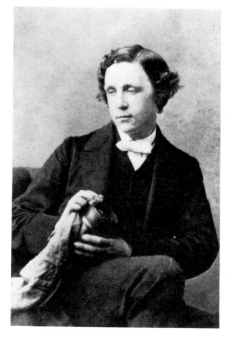

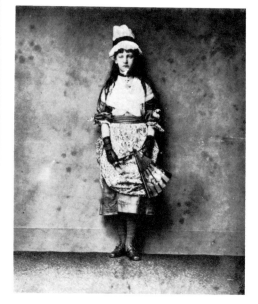

11 ABOVE O.G. Rejlander. *Portrait of the Reverend Charles Luttwidge Dodgson, better known as Lewis Carroll, author of* Alice in Wonderland, *and keen photographer of small girls*

12 BELOW Lewis Carroll. *A favourite model, Xie Kitchen, dressed up as Dolly Varden, a music hall star of the time, 1872*

9 and *10* ABOVE Lady Clementina Hawarden. *A Scottish heiress who married Viscount Hawarden, her interest in photography as a hobby predates that of Julia Margaret Cameron. Her work was greatly admired by* that other gifted amateur, Lewis Carroll, but plans for their collaboration were cut short by her untimely death in 1865. Her subjects were posed in the windows and balcony of her London home, c.1860–64*

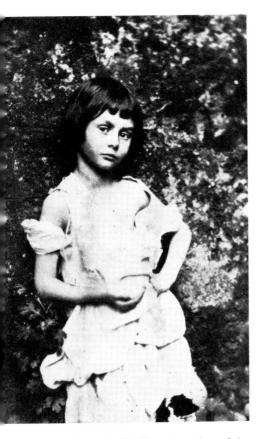

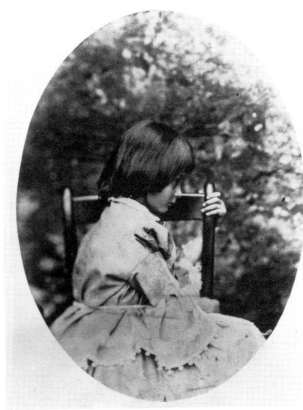

Supreme Council of India and mother of six, the ardent and eccentric Cameron was presented with a collodion photographic kit by a daughter in 1863 at the age of 48. She promptly converted the coal hole of her house in the Isle of Wight into a dark-room, glazed the chicken shed, and set to work making large close-up studies. Six months later Mrs. Cameron met Lewis Carroll who noted wryly, 'In the evening Mrs. Cameron and I had a mutual exhibition of photographs. Hers are all taken purposely out of focus – some are very picturesque – some merely hideous – however, she talks of them as if they were triumphs of art.' But Mrs. Cameron's use of close up, her distinctive and expressive soft focus, and dramatic side lighting, began to command attention within a matter of months.

Her reputation was no doubt enhanced by the distinguished range of subjects to whom her social position allowed access, including many of the greatest names in British intellectual life: Browning, Carlyle, Darwin, Herschel, Holman Hunt, Trollope, Watts, and the painter and photographer who most influenced her, David Wilkie Wynfield. Mrs. Cameron's unconventional technique deman-

ded exposures of five minutes and she spurned the head rest. Tennyson's warning when he brought Longfellow to sit for her was, 'You will do whatever she tells you. I shall return soon and see what is left of you.' Her romantic enthusiasms also led Mrs. Cameron into ill-judged artistic ventures like the attempt to illustrate with costume portraits Tennyson's *Idylls of the King*. But her bold and original use of close up, as she strove to show 'the greatness of the inner as well as the features of the outer man' was unmatched. Then in 1876, after twelve years of photography, Mrs. Cameron followed her husband to Ceylon where the muse deserted her, as she herself conceded; 'I longed to arrest all beauty that came before me, and at length the longing has been satisfied.'

Professional photographers had by now developed a repertoire of tricks and formulae with which to soften the hard eye of the camera and flatter their sitters: plump young ladies were bathed in soft diffuse light; wrinkles were brushed out of clothes and faces; dark features were strongly lit from all sides; gloves were used to shorten long fingers; and, for a few pence extra, retouching brought colour to the palest cheek.

13 and *14* Lewis Carroll. *Another favourite subject was Alice Liddell, the Alice for whom the book was written. Carroll kept a wardrobe of fancy dress and* LEFT *Alice is here posed as a beggar girl, 1859*

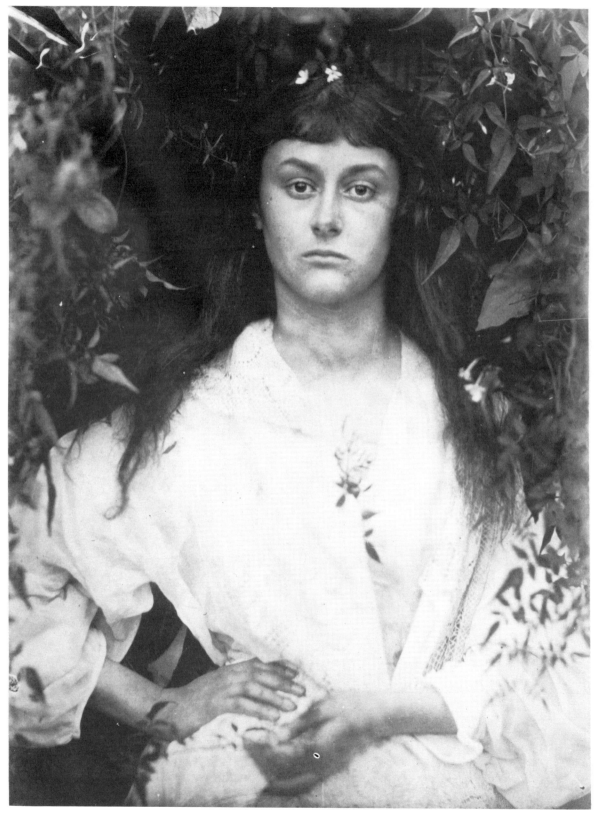

15 Julia Margaret Cameron. *Alice Liddell taken thirteen years later at the age of 20, 1872*

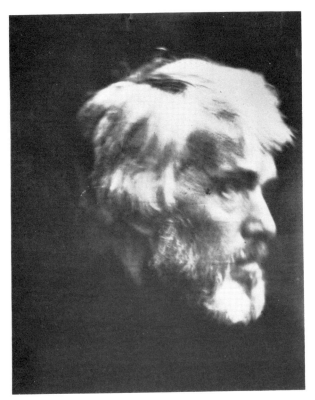

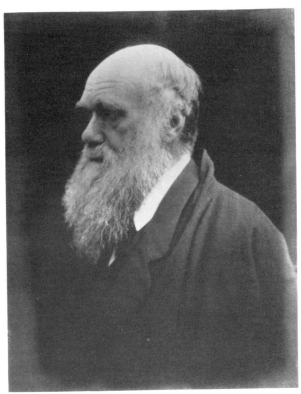

16 Julia Margaret Cameron. *Thomas Carlyle*

17 Julia Margaret Cameron. *Charles Darwin*

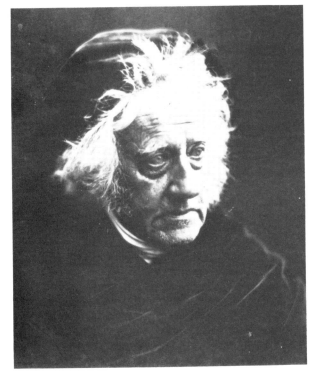

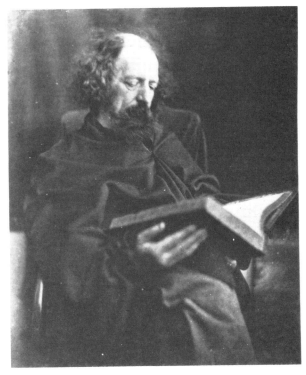

18 Julia Margaret Cameron. *Sir John Herschel*

19 Julia Margaret Cameron. *Alfred, Lord Tennyson*

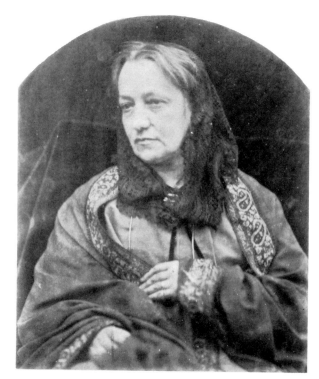

Many portrait studios had interchangeable backdrops, some on long rolls which could be wound through parklands, seascapes, conservatories and palm houses, until one was found to the sitter's taste. Studio furniture evolved down the decades from drapes and classical columns through rustic bridges and styles to swings and bicycles and motor cars. Frank Sutcliffe in the seaside resort of Whitby confessed to a box of sand and shells, an artificial rock, and two stuffed seagulls, one missing an eye; but he also claimed to have seen studios 'utterly unlike any place to be seen on earth, or dreamed of in dreams'.

But the flamboyance of one professional photographer outshone the rest – Félix Tournachon, better known to all Paris as 'The Great Nadar'. As a young satirist Nadar was one of the original bohemian set of painters, poets, writers and revolutionaries. In 1848 he had set out from Paris to liberate Poland but his column of 500 freedom fighters were arrested as soon as they crossed the German border marching east. By 1855 Nadar had set up a photographic business while sustaining his café style of life. He was, according to a friendly journalist, 'A man of wit without a shadow of rationality; enthusiastic about everything, wanting to do everything, taking on everything – and then always losing interest and giving up. His life had been, still is, and always will be incoherent.' Nadar was a radical who painted the outside of his studio bright red to match his politics; an inventor who designed helicopters; and a showman who built a giant balloon with a basket two storeys high capable of carrying 80 passengers. This balloon, 'Le Géant', was launched from the Champs de Mars at 5 pm on 4 October 1863 before 200,000 cheering Parisians but two weeks later a gale blew it into Germany where it crashed breaking Nadar's leg. Nadar also took the first ever

20 LEFT, ABOVE Henry Hay Cameron. *Portrait of his mother Julia Margaret, 1870*
21 LEFT Nadar. *Chorus girls at the Folies Bergère*
22 RIGHT ABOVE Nadar. *Portrait of his mother, Therese Tournachon, c.1855*
23 Nadar. *Mikhail Bakunin, the Russian anarchist and revolutionary, c.1863*
24 RIGHT BELOW Nadar. *Charles Baudelaire, fellow bohemian and sharp critic of photography, c.1863*
25 Nadar. *Jacques Offenbach, popular composer of light opera, c.1875*

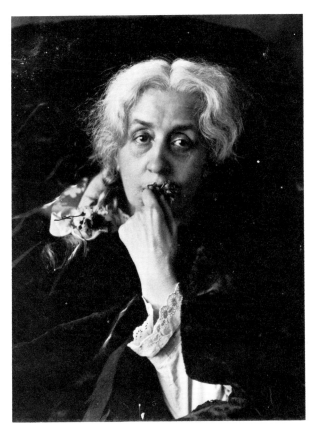

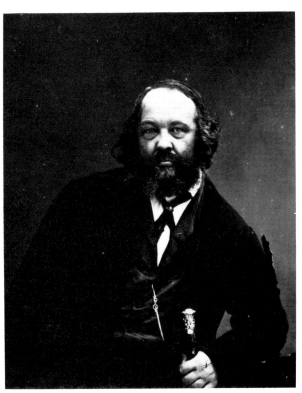

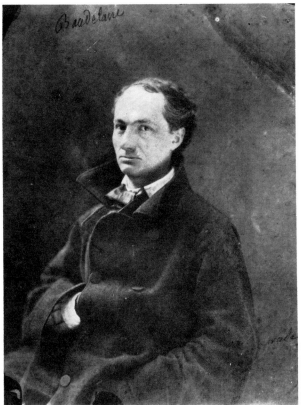

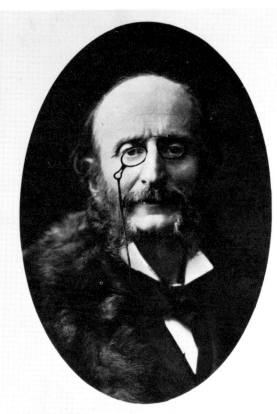

31

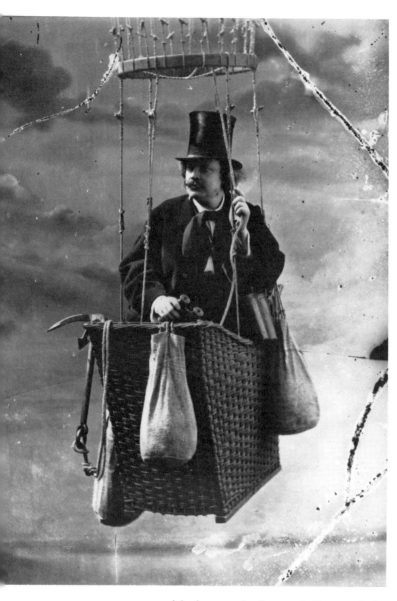

26 Nadar. *Self-portrait in a balloon basket set up in studio, 1860*

27 Nadar. *La Musette, the spirit of bohemia, 1855*

aerial photographs from a balloon and the first pictures by artificial light in the sewers and catacombs (page 143). When in 1874 the Impressionists held their first exhibition, the painter Monet said, 'Nadar, the great Nadar, who is as good as bread, gave us his place.'

This astonishing verve and sociability helps explain the range of Nadar's distinguished sitters: Hugo, Baudelaire, Balzac, Proudhon, Corot, Wagner, Verdi, Liszt, Bakunin, Offenbach *et al.* He claimed of his portraits, 'The person I do best is the person I know best' – and he knew just about everybody.

Even at 77 the irrepressible Nadar, having fallen out with his son Paul who took over the business, was opening another studio in Marseille. At the Universal Exhibition in Paris in 1900 he saw a special section set aside for his work; and at 84 was asking and exhorting, 'Who will provide instruction for tomorrow – for ever – through a Museum of Revolution ... Shall we ever acclaim loud enough the greatness and glory of Revolt? To Work!' Yet it is instructive that even the incandescent Nadar never found a way of using his camera to project his flaming political passion.

3 World on a Plate

'Photographers shall visit foreign parts, the courts
of Europe, the palaces of the pashas, the Red Sea
and the Holy Land, and the Pyramids of Giza,
and bring home exact representations of all the
sublime and ridiculous objects it now costs so
much to see.'

National Gazette of Philadelphia

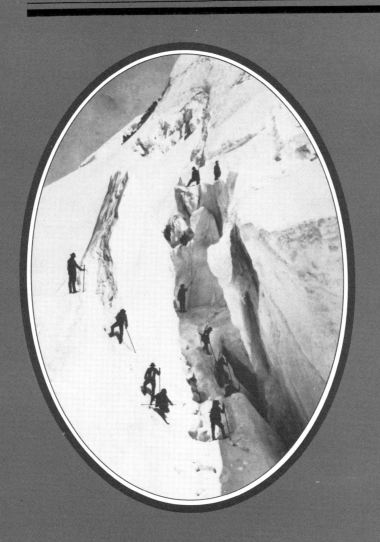

World on a Plate

Today leisure and travel are among the fastest growing industries. Each year some 200 million tourists are on the move, following the sun, seeing the sights and adding billions of snaps to the image-bank of good times and spectacle.

Before the coming of the railways only the idle rich could afford to travel for pleasure. Although travel books had excited curiosity since the eighteenth century, most people still had little idea of the world beyond their own horizon. In the nineteenth century, an age voracious for information, the camera immediately became its travelling eye.

By 1839 the camera was already commissioned to range freely for images which would help America and Western Europe complete the mental map of the world they were soon to dominate. In Paris, Noel-Marie Lerebours knocked together cameras and sent photographers in all directions. They brought back 1,200 daguerreotypes, over a hundred of which were copied as engravings and published in two eagerly awaited volumes, *Excursions Daguerriennes*.

But engravings and woodcuts lacked authenticity and the daguerreotype with its unique image which would not replicate could not satisfy public demand. The most intense interest was in lands romanticized in story; Greece and Italy, Palestine and Egypt. In the 1840s tourists began to turn up carrying cameras and in 1849 when the French novelist Gustave Flaubert toured the Middle East, his companion Maxime Du Camp made a record of the trip. Using an improved calotype process, Du Camp was able to produce prints which did not fade and 125 of his best views appeared in his book, *Egypte, Nubie, Palestine et Syrie*, published in 1851.

The monuments of Egypt now rank as the world's most instantly recognizable images. But a century ago, in an age still devoted to its Bible stories, the sight of the Great Pyramids and the Sphinx had an enormous impact. This fascination with the Middle East was first turned to commercial advantage by an Englishman, Francis Frith. In 1856, in the first of three photographic expeditions, Frith travelled up the Nile, past the Fifth Cataract, to the temples of Karnak, Luxor, and the ancient capital of Upper Egypt, Thebes. On later trips he went on to photograph the Holy Land, and *The Times* declared reverentially that these were the most important photographs ever published. They were also

1 Maxime Du Camp. *Sphinx and Pyramid, 1850*

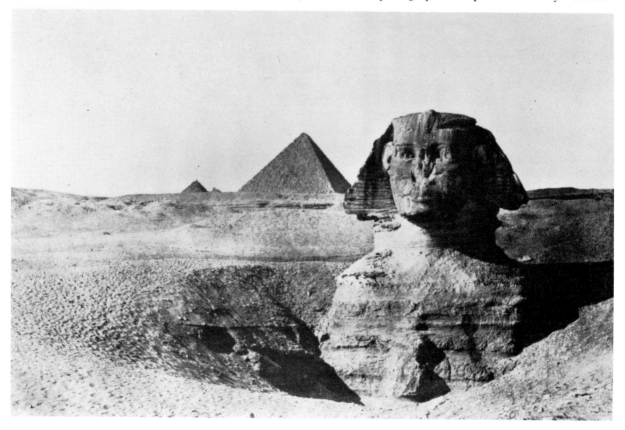

among the most profitable.

Using glass negatives coated with collodion solution Frith was able to strike off thousands of prints for stereocards, produce seven photographic books, and illustrate the first photo-Bible. Indeed his were the first photographs to have world-wide distribution. Although the new collodion technique made for better pictures and easier reproduction, it was a dauntingly cumbersome and messy process which Frith pioneered in the most trying conditions; desert sand and flies stuck to the wet glass plates, and the developing tent sometimes got so hot the collodion boiled.

A decade later the remote and mysterious tombs were being overrun by tourists. William Howard Russell of *The Times* complained in 1869, 'They crowd the sites which ought to be approached in reverential silence with a noisy crowd, and they do not inspire the natives with a sentiment of respect for our people.' He also found the temples of Luxor lit up by magnesium flares for the benefit of sightseers.

In Europe by this time, the Alps had also become the adventure playground of the well-to-do. The Italians presented the Savoy Alps to Napoleon III in return for his help in driving out the Austrians and, in 1860, the Emperor and his wife Eugénie went up to look over their new territory. Two brothers from Paris, Louis and Auguste Bisson, were summoned to record the event. In fact the Bissons' memorable series of 24 photographs lend the Alps a scale which quite dwarfs the climbing Emperor and his party. But mountain photography was an arduous affair. When Auguste Bisson came back in 1861 to climb Mont Blanc, the highest mountain in Europe, he had 25 porters just to carry his kit. At high altitude the oil lamps which melted snow for washing the plates would barely light in the thin air and it took three days to climb the 15,782 feet to the summit where Bisson got three photographs.

But in the hazardous business of mountain photography the honours go to an Englishman, Samuel Bourne. In 1861 Bourne had set up shop at Simla in India and at first, like the other photographers then active on the subcontinent, his eye was attracted by the alien culture and exotic palaces and temples. Then, in 1863, Bourne took to the hills and made himself an international reputation.

To tackle the Himalayas Bourne needed an entourage of up to sixty 'coolies', plus personal servants, to carry the incredible load of

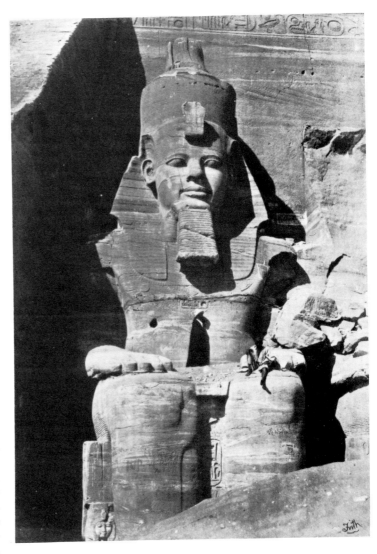

chemicals, bottles, trays, tents, tripods, lenses, heavy glass plates and large cameras. In addition, Bourne was determined to maintain his gentlemanly standards with stocks of brandy, bundles of books, 'sporting requisites', and even the odd piece of furniture. His first trip lasting ten weeks took him to a height of 15,000 feet, and produced 147 negatives, some taken in excruciating cold.

In 1864 Bourne set off with 21 bearers on a ten-month climb through the mountains of Kashmir. As the climbs got higher and more dangerous, some of the bearers dumped their equipment and ran off only to be pursued by the fanatical Bourne who beat them into line with his stick. On his third and final trip he climbed 18,600 feet to the Manirung Pass, higher than any photographer before. As Bourne himself concluded, 'Photographic

2 Francis Frith.
Colossus of Rameses II at Abu Simbel, 1857

35

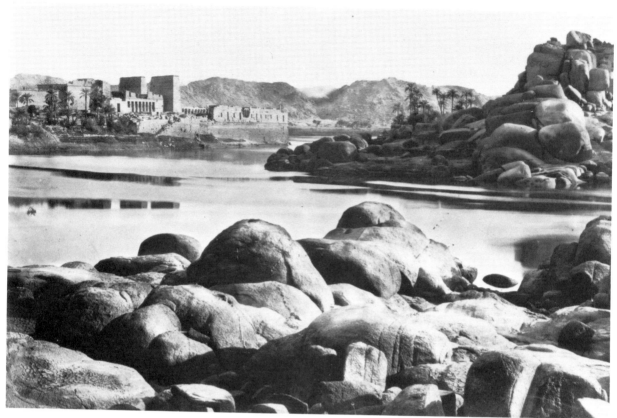

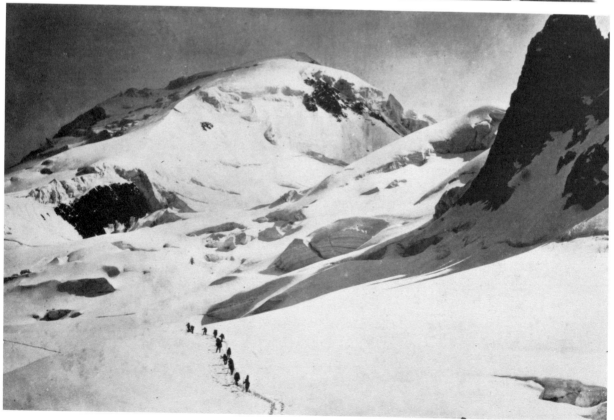

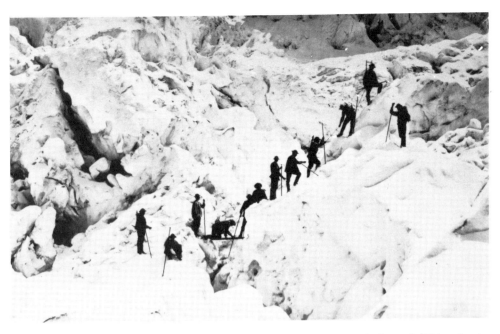

enthusiasm could not go much further than this.'

Beyond the Himalayas was China – a vast empire in disintegration, undermined by rebellion, opium, and the depredations of foreigners. A Scots photographer, John Thomson, journeyed through China in the 1870s at some personal risk, for the Chinese were understandably hostile to foreigners and Thomson slept with a knife under his pillow. 'The superstitious influences rendered me a frequent object of mistrust and led to my

7 Samuel Bourne.
*View from the
Manirung Pass at
18,600 feet, 1866*
8 Samuel Bourne.
*Villagers at Toda
Mund, 1866*

being stoned and roughly handled on more occasions than one.' Thomson based himself on the coast and over several years made long trips through the turmoil of the interior. He composed with a frankness in advance of his time and had an inquisitive eye for social detail. 'The camera . . . has supplied the only accurate means of portraying objects of interest along my route, and the races with which I have come in contact. Thus it came about that I have always been able to furnish readers of my books with incontestable pictorial evidence of my "bona fides", and to share with them the pleasure experienced in coming face to face for the first time with the scenes and the people of far off lands.'

The closed Kingdom of Japan was forced open in 1853 when Commander Perry sailed

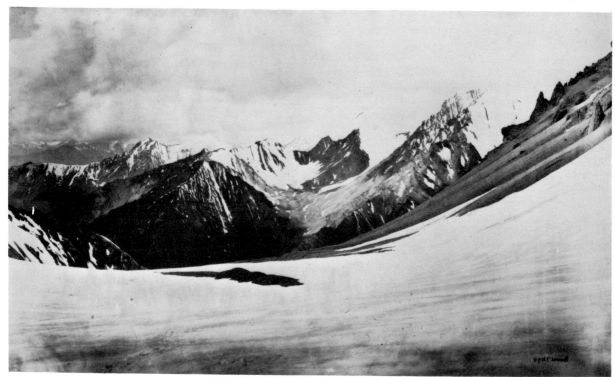

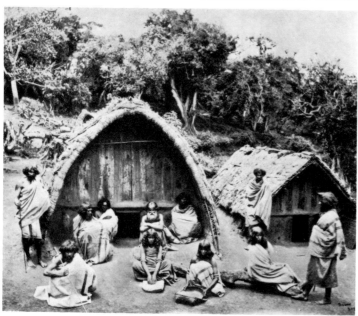

into Tokyo Bay with four American warships. A Japanese scroll dating from that time shows two long-nosed photographers pointing a box at a geisha girl. The official report of the expedition was later published in Washington with fourteen illustrations but the daguerreotypes on which they were based are lost.

When the warships from the West returned to Japan in the 1860s they brought with them one of the earliest war photographers, Felice Beato, whom *The Times* in London dubbed 'The Knight of The Camera'.

Beato arrived in 1862 and four years later a trade directory for Yokohama listed, 'Artists: Felix (sic) Beato and Charles Wirgham'. Beato's partner also published a magazine for Britons in the Orient called *Japan Punch*. Beato's studies of Japanese people and customs circulated widely. They succeed in capturing the dignity and highly stylized

traditions which exerted such an enormous fascination after the World Fairs of the 1860s introduced Japanese art to the West. Some of the most beautiful Beato photographs are tinted delicately by hand.

The Americans who first prodded Japan out of medieval torpor had not yet finished exploring their own vast territories. In 1849 the ports on the coast of California attracted thousands of fortune hunters who set off inland in search of gold. After the prospectors came the photographers, searching the wilderness for the most dramatic scenery. They found it in what is now Yosemite National Park. The Yosemite Valley was just a few days' journey from the coast and the art of American landscape photography flourished there in the 1860s. These photographers of

9 John Thomson.
Punishment in China,
c.*1870*

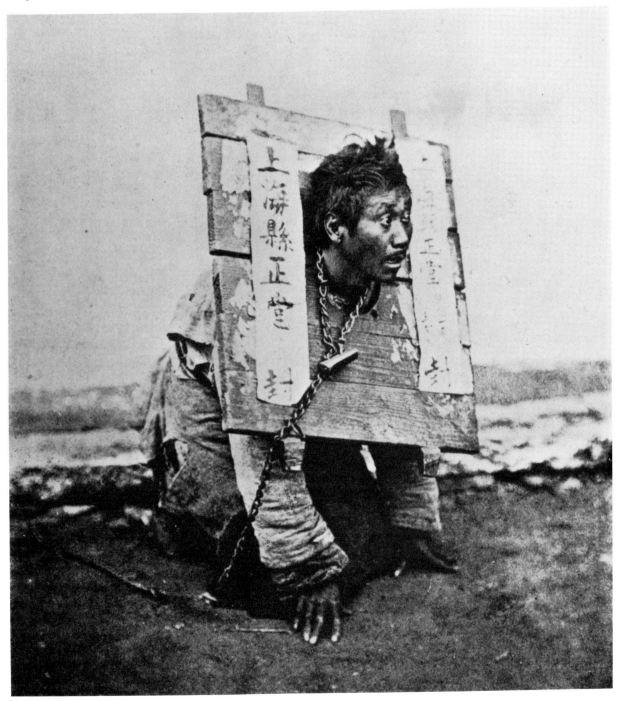

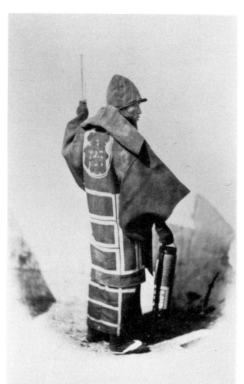

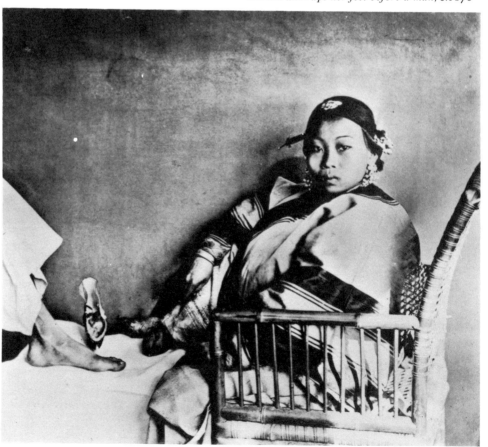

10 Felice Beato.
Japanese fireman with paper lamp, 1868

11 John Thomson. *Our interpreter Chang,* c.*1870*

12 John Thomson. *Indecent exposure: Chinese woman unwraps her feet before a man,* c.*1870*

13 John Thomson.
Chinese streetcrier,
c.*1870*

14 Felice Beato.
A woman carried in a
litter, 1868

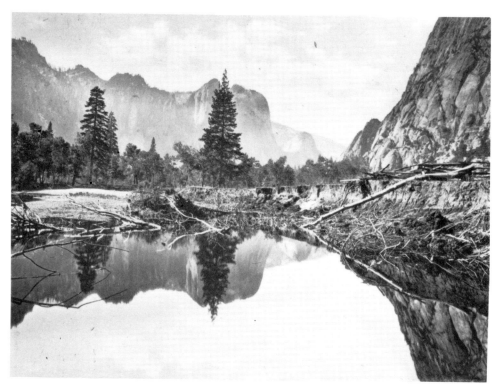

C.E. Watkins.
Yosemite, California,
1865

C.E. Watkins.
Agassiz Column,
c.1870

17 OPPOSITE T.H.
O'Sullivan. *Canyon*
de Chelle, Arizona,
1873

the wilderness were not frontiersmen with an off-beat hobby, but experienced professionals out from San Francisco and possibly influenced by the work of Frith in the Middle East and the Bissons in the Alps. Their landscapes were widely popular for a number of reasons: at that time the educated classes were going through a long romance with

nature; the spread of the stereoscope allowed the mountain scenes to be viewed in three-dimensional depth; and many East Coast Americans and Europeans were eager to see how wild the West really was.

The outstanding photographer in Yosemite was Carleton E. Watkins whose work made a strong impression at the Paris Exhibition of 1867. To show the full grandeur of Yosemite, Watkins used large glass negatives, some as big as 18 by 21 inches, the prints of which could be bought and hung straight on the wall. He would also wait for perfectly still days to render his trees unblurred in exposures which could last as long as an hour. Other professionals, like the Englishman Eadweard Muybridge, came to work in Yosemite, often competing with almost identical views in the hope that the buying public would favour their particular nuance of style. Muybridge, for instance, was partial to clouds which he superimposed from other negatives. Yosemite was declared a public pleasure area as far back as 1864 and today it is a national park: some credit for its conservation must go to the early photographers who advertised its wonders.

There is, however, much more going on in some of the old photographs of the American West than at first sight meets the eye. One mountain in Yosemite, Mt. Starr King, is

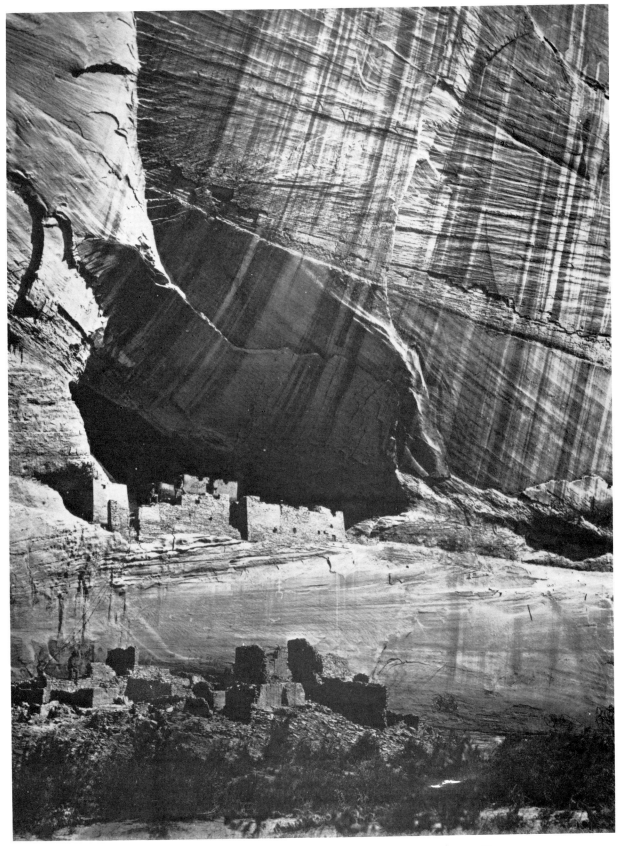

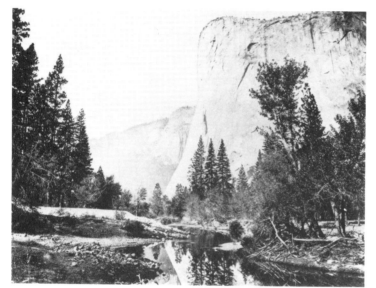

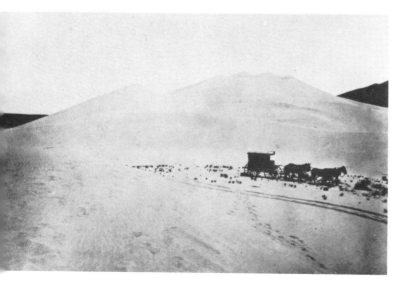

18 C.E. Watkins. *Lassen Park, California, 1870*

19 Eadweard Muybridge. *El Capitan outcrop, Yosemite, 1872*

20 T.H. O'Sullivan. *Photographer's wagon in desert, Nevada, 1868*

named after a churchman who vigorously opposed the theories of Darwin. A freakish rock formation photographed by Watkins is named after Louis Agassiz, at that time America's foremost natural scientist and an outspoken critic of Darwin's theory of evolution which struck at the roots of orthodox religion and science.

Agassiz and Starr King propounded a counter-theory called Catastrophism which argued, partly from visual evidence, that the landscape was obviously not moulded by long ages of evolution and must therefore have been thrown up dramatically by divine and recurring wrath. Carleton E. Watkins was also an advocate of Catastrophism and today some of his compositions can be read as visual propaganda for this futile attempt to disprove Darwin. When the first government-sponsored expedition set out to follow the 40th Parallel through the deserts of the South West, both the leader, Clarence King, and his photographer, Tim O'Sullivan, were Catastrophists. Fortunately, although O'Sullivan served the cause, he was also a very gifted photographer who continued mapping the American wilderness into the 1870s.

As the age of exploration advanced there still remained the ultimate journey, the most pitiless, in some ways the most beautiful, the journey across the ice caps to the Poles. In 1845, when Sir John Franklin and his British naval expedition set out for the North Pole, the camera took portraits of the officers before they sailed but did not travel with them, which was just as well: Franklin perished with his entire company of 128 men.

Thirty years later another British expedition sailed north in the ships *Alert* and *Discovery* under the command of Captain Nares. By now the development of dry plate photography allowed pictures to be taken in the intense cold. Again the sailors failed to reach the Pole but the assistant paymaster of *Discovery*, Thomas Mitchell (who went on to become Paymaster-in-Chief of the Royal Navy), later published 107 photographs taken in the High Arctic.

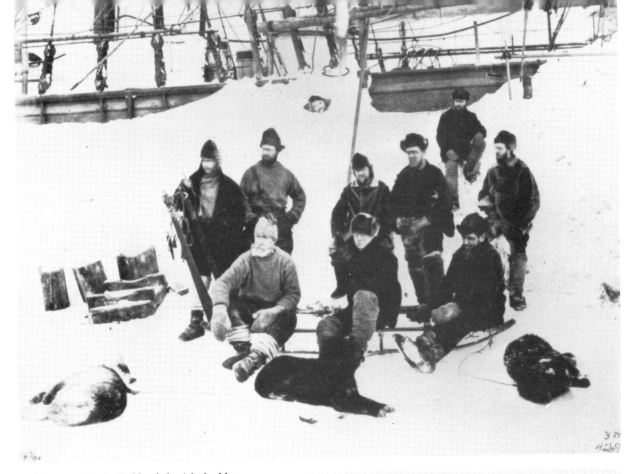

21 Thomas Mitchell. *Men left with the* Alert *during Nares Expedition, 1875–76, Discarded face protector is on the snow bank behind*

22 Richard Beard. *Daguerreotype of Sir John Franklin, 1845*

23 RIGHT Richard Beard. *Le Vicomte, officer on Franklin expedition, 1845*

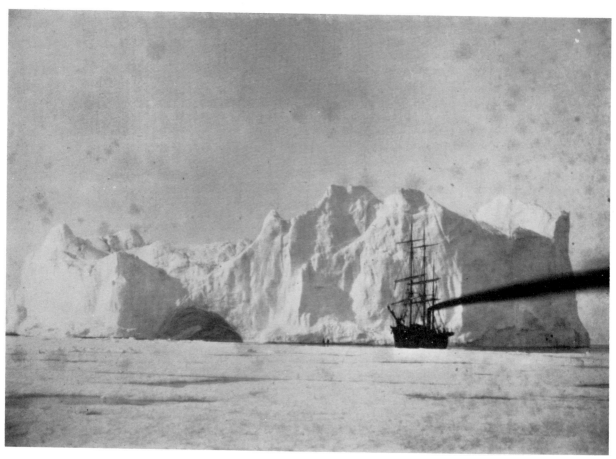

24 Dunmore and
Critcherson.
Bradford Expedition,
c.1860's

One artist who made many trips to the
north was the American William Bradford.
As a painter Bradford was enthralled by the
translucent light and strange shapes and
colour. He hired two photographers from
Boston, called Dunmore and Critcherson,
and sailed north again in 1869 'to study
Nature under the terrible aspects of the
Frigid Zone' and pursue 'the purposes of art'.
His account of the trip, *The Arctic Regions*,
carried 125 original photographs and the
voyage cost $150,000, on which Bradford's
patron defaulted. But the photographs
brought back from this alien region at the end
of the earth did inspire awe in a picture
buying public which had not yet lost its sense
of wonder.

The tragic climax of what came to be called
'the polar passion' of the Anglo-Saxons
occurred at the beginning of the century when
Captain Robert Falcon Scott set out for the
South Pole in 1910. Scott took with him in
the *Terra Nova* a well-travelled and ex-
perienced professional photographer, Herbert
Ponting. The excellence of Ponting's travel
pictures led Scott to hire him at a salary of £5

a week – £1 more than the scientists – as
official photographer and cinematographer.
The voyage south from Southampton was not
auspicious. Scott wrote, 'Ponting cannot face
meals but sticks to his work constantly being
sick . . . with a developing dish in one hand,
and an ordinary basin in the other.' But
Ponting's first sight of the Antarctic repaid
the discomfort, 'The grandest and most
beautiful monuments had not inspired me
with such a feeling of awe as I experienced
with meeting this first Antarctic iceberg.'

Conditions at the base camp were predict-
ably severe. Water froze in Ponting's tanks,
flesh stuck to frozen metal, and exterior
photography meant the risk of frostbite.
During the long winter darkness he enter-
tained the crew with slide shows and on one
still 'day', in a temperature of fifty below, he
contrived to take a picture of an iceberg using
three successive flashes of magnesium powder.

When Scott and his party finally set out for
the South Pole on 31 October 1911, Ponting
travelled the first few miles with them and
took his last pictures. On the 18 January
1912 Scott reached the Pole, only to find that

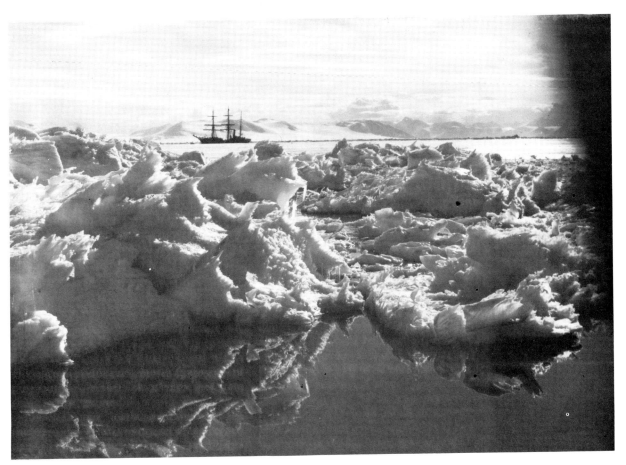

25 Herbert Ponting.
Broken ice and the
Terra Nova, *1911*

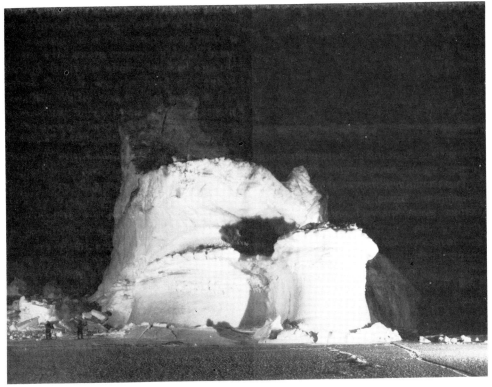

26 Herbert Ponting.
Castle berg by
flashlight, 1911

Amundsen the Norwegian had got there first. On the way back to base Captain Scott and his companions died of hunger and cold. Herbert Ponting afterwards devoted himself to preserving the record of the expedition and the memory of its leader who had meant so much to him. Many exhibitions were mounted, his book *The Great White South* was published in 1921, and the film he shot was recut and put on general release as *Ninety Degrees South* as late as 1933. But Ponting never again took photographs of such beauty as those in the Antarctic – by then, however, the great age of exploration was over.

27 Herbert Ponting. *C.S. Wright on return from Barrier, 1911*

4 Photographic Pleasures

'Photographic portraiture is the best feature of
the fine arts for the millions the ingenuity of man
has yet devised. It has in this sense swept away
many of the illiberal distinctions of rank and
wealth . . .'

Photographic News

Photographic Pleasures

In Paris in 1839, public enthusiasm for Louis Daguerre's new process was so unrestrained that it came to be called 'daguerreotypomania'. By 1847, half a million plates a year were being used by the city's 2,000 cameras. In America by the 1850s a town called Daguerreville had grown up on the banks of the Hudson around a factory which produced three million daguerreotype plates a year.

In Britain squabbles over patents curbed expansion and in the census of 1851 only 51 people registered as photographers. But the trade grew so rapidly that by 1857 the *Art Journal* could complain of importuning street photographers. 'It has really now become a matter for police interference both on grounds of propriety and public comfort.' By 1861 there were 2,879 professionals at work; other entrepreneurs sold 'an eel-pie and your likeness for sixpence' and barber-photographers offered 'a shave and your shape'.

The first mass photographic craze was touched off by Albert and Victoria. A stereoscope at the Crystal Palace took their fancy, and within three months of receiving the royal imprimatur a quarter of a million stereoviewers were bought in London and Paris. The novelty and appeal of the stereoscope lay in its ability to create the illusion of depth. It works because human eyes are set $2\frac{1}{2}$ inches apart which means that each eye sees the world a bit differently from the other. This difference is used by the brain to create a perception of distance. By placing two lenses $2\frac{1}{2}$ inches apart, it is therefore possible to make two views of the same scene exactly as the eyes would do. These views placed side by side in a stereoscope are sent back separately by the eyes to the brain which then fuses the scene into three-dimensional relief.

The stereoscopes themselves ranged from cheap and simple hand models to ornate pieces of free-standing furniture. By the mid-fifties one version had sold more than a million in England alone and by the end of the decade the ambition of the London Stereoscope Company, 'no home without a stereoscope', was almost fulfilled. George Nottage, one of the largest manufacturers in England, had 10,000 stereocards on offer through the London Stereoscopic Company in 1854 and a few years later the catalogue had grown to 100,000; Nottage made a fortune and went on to become Lord Mayor of London.

All manner of exotica was soon available – ghost pictures, moral tableaux, freaks and

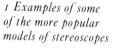

1 Examples of some of the more popular models of stereoscopes

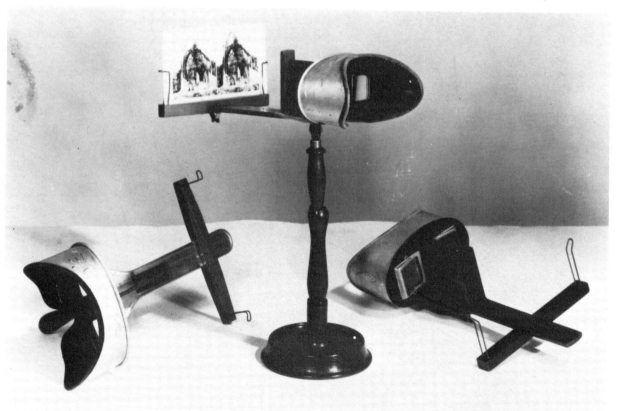

*2 Risque stereocard of
lady at her toilet,
c.1850s*

*3 Touching tableau:
The Orphan's Dream,
1857*

*4 French novelty
card. 'Le Sort
Satannique', c.1865*

oddities. Some stereoscopes even had a drawer in which gentlemen could lock away their risqué pictures. The stereoscope was to the Victorian parlour what television is today.

The royals who had encouraged the stereo-scope both promoted and starred in the next craze – cartomania. Cartes-de-visite were small portraits on cards, $2\frac{1}{4} \times 3\frac{1}{2}$ inches, developed by a French photographer, Andrè Disdéri, in 1854. Using a camera with four

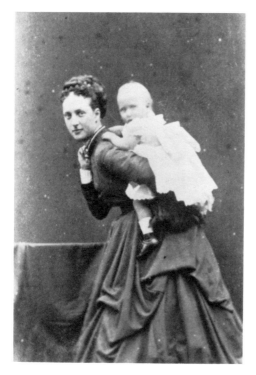

5 W.D. Downey. The most popular carte-de-visite ever. Princess Alexandra with her daughter Louise, 1867

6 Prime Minister Gladstone, himself a popular subject, planned to raise revenue by taxing cartes-de-visite

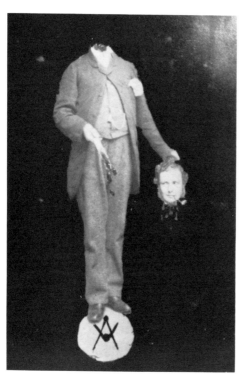

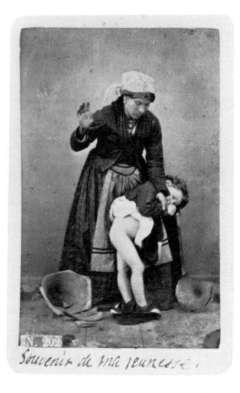

7 This macabre joke card is from the album of Bishop Wilberforce

8 A French card of the 1860s, 'Souvenir de ma jeunesse'.

52

lenses he got eight small portraits on one large plate. That made the pictures very cheap and by uncapping the lenses one at a time Disdéri also got different poses much in the manner of the modern photo booth.

The carte-de-visite caught the popular imagination in 1859 when the story spread that Emperor Napoleon III, on his way out of Paris to fight the Austrians, had stopped his army outside Disdéri's studio in the Boulevard des Italiens and popped in to have his picture taken. Soon Disdéri was taking 200 sitters a day and making £48,000 a year. Sales of his small card portraits of celebrities grew to 65,000 a year.

In London, Mayall and Co made sets of carte-de-visite portraits of Queen Victoria *en famille* which sold in their hundreds of thousands at a guinea a dozen. Another firm, Marion and Co, paid £35,000 for the rights to photograph the royal family; within a week of Prince Albert's sudden death in 1861 they sold 70,000 copies of his portrait. The record sale for one card is thought to be that of Princess Alexandra giving a piggyback to her daughter, taken just after her recovery from a dangerous attack of rheumatic fever. The combination of public relief on her safe recovery and delight at the informality of the portrait helped sell some 300,000 copies.

Cards sold for sixpence or a shilling and some public figures were paid royalties of £400 per 10,000 copies. Others proved reluctant to have thousands of copies of their portraits circulated; an understandable reticence – until the spread of the carte-de-visite a leading politician could walk the streets unrecognized. Gladstone however was not at all camera shy, and at the height of the boom, when sales grew to an astonishing 300 million or more cards a year, he toyed with the idea of taxing cartes-de-visite and thereby raising £5 million a year.

A hero-worshipping age was genuinely excited about the prospect of seeing what the great men – and the few great women – really looked like. The curiosity even embraced the celebrity's spouse as the wife of Thomas Carlyle noted when, to her surprise, her own portrait appeared for sale in a Chelsea photographer's shop. It was perhaps this that encouraged her to say of photography, 'It has given more pleasure to poor suffering humanity than anything else that has cast up in my time.'

The elaborate family album first became popular in the 1860s and Queen Victoria had 110 photographic albums, 36 of them filled with cartes-de-visite. Most albums had a section set aside for celebrities, who would often be the heroes of the household, and in 1862 the *New York Observer* commented on the new fashion, 'No drawing room table of the day can be considered furnished without its photographic album; and among the pretty toys of the season few can proffer so many substantial merits. There is one practical use of a selection of cartes-de-visite which ought to be attended to – it helps visitors wonderfully as a key to the tastes and prejudices of the house.'

In the 19th century the extended family of traditional country life was being broken up by industrialization and emigration. To com-

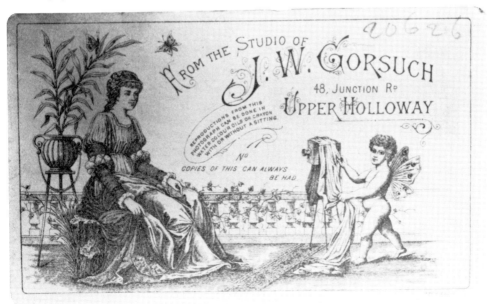

9 J.W. Gorsuch.
The reverse side of a carte-de-visite

bat the social turmoil the Victorian patriarchs turned the home into a fortress and the family into something akin to a sacred institution.

The family's album was often maintained by the daughters of the home, under-occupied, bored, and housebound by the proprieties of the age; submissive victims of what one carte-de-visite celebrity, Florence Nightingale, saw as 'the petty grinding tyranny of the good English family'.

The enthusiasm for portrait cards fell away suddenly in the 1860s and for the next couple of decades photography was rather sedate. But there was a steady demand for foreign views or scenery. Francis Frith's views of the Middle East (page 35) sold well but his firm also did a brisk trade in pictures of the high streets of English towns. In Scotland, Valentines of Dundee and George Washington Wilson of Aberdeen were among the world's biggest publishers of views (page 118). These photographic companies, with their extensive archives, were also ideally placed to take advantage of the great boom which came with the introduction of the picture postcard and the annual holiday in the last years of the century.

The Duke of Wellington had been against the building of railways because he feared they might encourage the lower classes to move about, and his fear was justified. Quick cheap travel opened up the countryside and seaside to the people of the towns and, as the century advanced, the leisure and prosperity created by the factory system and the imperial market began to be shared by the working people. Little England, now the strongest, most stable and prosperous country in the world, was at last learning to enjoy itself, splashing about in the waves it claimed to rule. As the seaside holiday or day excursion grew in popularity, the beach photographers appeared, a cheery bunch of professionals who promised for a few pence a happy memory to help lighten the drab months until the next holiday.

The attitude of the public to photography was changed fundamentally in 1888 by an American, George Eastman, who brought about a technical revolution. Under the slogan 'You press the button and we do the rest', Eastman took photography out of the province of the professionals and his cheap Kodak camera ushered in the era of the snapshot. The Kodak was portable, weighed two pounds three ounces and cost five guineas. The small box had two convergent lines on the top for sighting the subject and a fixed lens

55

which got everything in focus beyond a few feet; exposures were on a roll which took a hundred circular-shaped snaps. The camera was then posted to Eastman's factory where the roll was developed and the camera reloaded before being posted back. Eastman summed up the Kodak's instant success thus, 'Anyone who has sufficient intelligence to point a box straight and press a button could now take a picture.'

Control of the patents and improvements like celluloid film rolls allowed Eastman to develop and dominate a huge world market. His sales pitch went to the heart of photography's appeal, 'A collection of these pictures may be made to furnish a pictorial history of life as it is lived by the owner, that will grow more valuable every day that passes.'

In the 1890s large numbers of cheap portable cameras came on the market and life, as recalled by the snapshot, seemed to take on a much livelier aspect as children played, people smiled, crowds mingled, and bears danced. The stiff, tight-lipped poses of the studio were soon left far behind by the faster, friendlier snapshot.

In the old days, if a perfectionist disliked an image, the plate could always be wiped

12 ABOVE *George Eastman with his Kodak number two camera on board ship on his way to Europe, 1890*

clean and used again. Snapshooting was inevitably a much more haphazard affair. As that enthusiastic amateur, and professional cynic, George Bernard Shaw, observed, 'The photographer is like a cod which lays a million eggs in order that one may be hatched.' Photography and family life remained inseparable and most snaps were still portraits of family and friends. But fidgety children no longer had to endure the ordeal of the studio; the dominant backdrop was now a patch of sunshine against a garden fence.

The cheapness and ease of the portable camera also encouraged a more ambitious breed of amateurs who attempted to capture and retain for their own pleasure the details of everyday life.

The atmosphere of small town ennui in Australia was captured by an amateur photographer, Charles Louis Gabriel, described by the *Gundagai Independent* as 'chief medical officer, student, scholar and gentleman', And as though to fill some of the emptiness he saw through the camera, Dr. Gabriel left a peculiar imprint on many of the photographs, his own long shadow (page 61).

Brighton was a world away from Gundagai, a high-spirited seaside resort and the perfect venue for a photographer of independent means like George Ruff. The beaches and esplanades were a *flâneur's* delight and Ruff wandered across them with his camera snatching pictures of people and groups as they frolicked through the summers of England's most tranquil decades. His fellow photographer George Wood, along the coast at Hastings, also seemed to catch the vitality and gaiety of the time. But some saw the increasingly mobile eye as a threat to privacy and decency. The *Weekly Times and Echo* in 1893 wrote, 'Several decent young men are forming themselves a Vigilance Association with the purpose of thrashing cads with cameras who go about at seaside places taking snapshots of ladies emerging from the deep . . . I wish the new society stout cudgels and much success.'

But the snapshot camera proved unstoppable. Free of complex rituals and old inhibitions, it quickly endeared itself to the citizens of the emerging mass societies. Over the past century there have been no dramatic

13, 14, 15, 16 LEFT AND RIGHT *These snapshots of Hastings were taken at the turn of the century by a local photographer, George Wood*

17 and *18 George Ruff snapped at Brighton on the south coast of England at the turn of the century*

shifts in the preoccupations of the people's camera: family, friends, home and holidays. And of course the celebrations: weddings, birthdays, anniversaries and christenings – but rarely funerals. The snapshot camera, like private memory, works selectively to recall the good times; photography is now a principal keeper of the family's memory hoard, the store of images to be laid down against a time when children and relatives will inevitably grow and scatter and die. The early studio portraits for the few, then the snapshots for the mass, all in the end are infused by the warmth of the past and come eventually to reinvest life with some reminders of its continuity and purpose.

The cheap camera clearly met a felt need. By 1900 George Eastman was selling 100,000 Box Brownies a year. Of the 300,000 visitors to the Exposition Universelle in Paris in 1900, no fewer than 51,000 carried cameras. In 1902, the *Daily Mail* commented, 'The demand for snapshot cameras has this year beaten all records. It would appear the photographic "craze" is likely to continue.'

20 Snapshot of army comrades relaxing during the Boer War, c.1900

19 Amateur's circular snap taken with an early Kodak roll camera c.1890.

21, 22, 23 Anonymous snapshots taken around the turn of the century

24 LEFT *On the beach, an anonymous snapshot*
25 BELOW Dr. Charles Gabriel. *The amateur of the Australian outback who left his own peculiar signature, his shadow, on many of his prints* c.1900

26 'The Brownie Girl', c.1901

5 Caught in Time

'Posterity, by the Agency of Photography, will
view the faithful image of our times: the future
student, in turning the page of history may at the
same time look on the very skin, into the very
eyes, of those, long since mouldered to dust,
whose lives and deeds he traces in the text.'

WILLIAM LAKE PRICE

Caught in Time

Many hundreds of millions of photographs were taken in the nineteenth century and hundreds of thousands, perhaps millions, survive today as visual traces of a host of vanished lives, some famous, most long forgotten. Other old photographs are fragments often struck at random from events still deemed important. And while these cannot show the forces which were shaping history, they do act as a template at least for the exterior aspect of the people and events which helped shape our own age.

In the first decade of its active life the camera documented events in a very haphazard way. Fox Talbot, for instance, took a picture of Trafalgar Square when the builders' huts were still on site. The power of that photograph to evoke and detail such a moment from the past is what fascinates today, but back in 1844 Talbot was most probably attempting to pass on to posterity a small piece of history in the making.

Yet consider the calamity which Mr Nicholas Cummins, a magistrate from Cork, described in a letter to *The Times* in December 1846, 'In a few minutes I was surrounded by at least two hundred phantoms, such frightful spectres as no words can describe, either

from famine or from fever. Their demoniac yells are still ringing in my ears, and their horrible images are fixed upon my brain.' In the great famine of 1846 and '47 a million Irish died and another million emigrated, but of this calamity not a single photograph can be found.

Then in February 1848 the barricades went up in Paris, the first city of photography, and in the months that followed the old regimes of Europe were shaken by popular revolts. Again if pictures of these historic events were taken, few survive. In Paris Hippolyte Bayard did set up his tripod on the steps of the Madeleine church and left us a photograph of a forlorn barricade in a Rue Royale, quite bereft of action, taken months after the ferment had subsided.

This French revolution of 1848 forced King Louis Philippe to abdicate and seek refuge in England. A counter-coup followed in 1851. It put Napoleon III on the throne as Emperor but drove into exile the radical politician and writer Victor Hugo, author of *Les Miserables*, perhaps better known today as the creator of Quasimodo, the hunchback of Notre Dame. The Hugo entourage took itself off to a house in Marine Terrace, St.

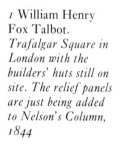

1 William Henry Fox Talbot. *Trafalgar Square in London with the builders' huts still on site. The relief panels are just being added to Nelson's Column, 1844*

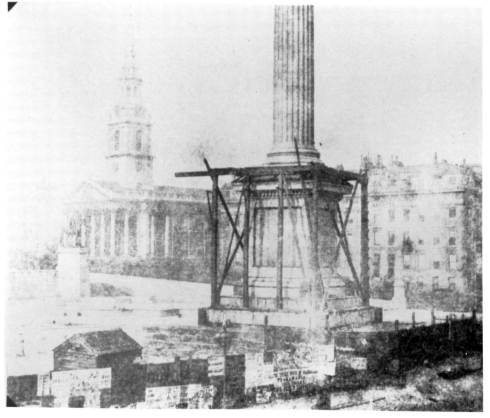

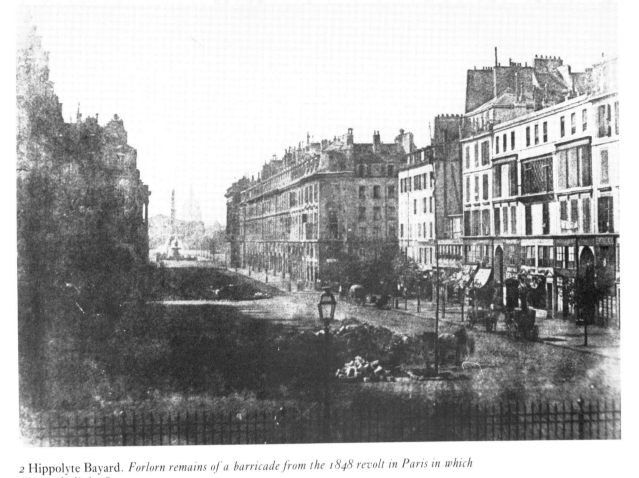

2 Hippolyte Bayard. *Forlorn remains of a barricade from the 1848 revolt in Paris in which thousands died, 1849*

3 Charles Hugo. *Portrait of his father Victor in exile in Jersey, 1852–3*

4 Charles Hugo. *Portrait of his mother from the family album, 1852–3*

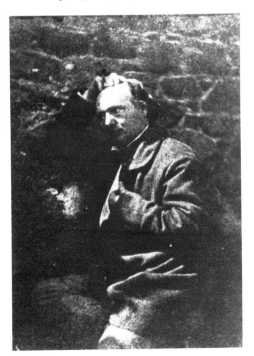

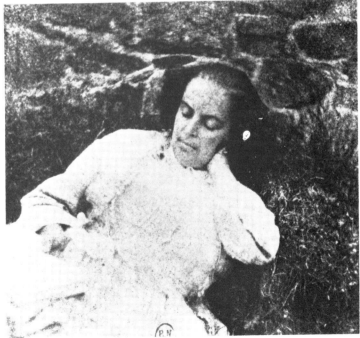

Helier, on the Channel Island of Jersey. They were accompanied by a writer Auguste Vacquerie, a keen photographer who helped Hugo's son Charles produce one of the first ever family photographic albums, the intimacy of which not only suggests the closeness of exile but also looks forward a generation to the style of the snapshot.

Although there had been a decade of violent agitation for an extension of suffrage and political reform, England escaped the upheavals of 1848. A Chartist call for a mass demonstration at Kennington in London did greatly alarm the authorities. However, it fizzled out without commotion, but not before the photographer Kilburn took what must be the earliest surviving crowd scene, and certainly the first of a protest demonstration. This picture was only recently unearthed after being buried for more than a century in the Queen's photographic collection at Windsor.

In 1851 it was Queen Victoria's consort Prince Albert who emerged as the force behind a public event which certainly did catch the imagination of England – the Great Exhibition in the Crystal Palace. Thirteen thousand exhibitors – half from overseas – were housed in a glorious cocoon of 300,000 sheets of glass set in a web of iron, and the sponsors confidently proclaimed, 'The history of the world records no event comparable in its promotion of human industry, with that of the Great Exhibition of the Works of Industry of All Nations.' Six million people paid to file through this temple of Progress and the exhibits were documented in four volumes illustrated by photographs prepared specially by Fox Talbot's assistant Nicholas Henneman.

The Great Exhibition detonated an explosion of optimism after two decades of social unrest. Its bewildering machines confirmed Britain's ingenuity and dominance, and pro-

5 W.E. Kilburn. *The last great Chartist demonstration and the first picture of mass protest. Taken on Kennington Common, London, on 10 April 1848, it was recently rediscovered in the Royal Collection at Windsor*

6 P.H. Delamotte. *Dinner break during the reconstruction of the Crystal Palace at Sydenham, London, 1852–4*
7 P.H. Delamotte. *The open colonnade at the new Crystal Palace, 1852–4*

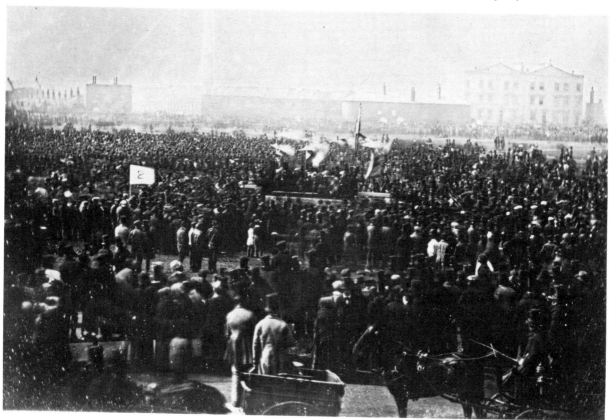

8 P.H. Delamotte.
*Full scale replicas of
the Colossi of Abu
Simbel at the Crystal
Palace, 1854*

mised quick release from the drudgery of the past:

'These England's arms of conquest are
the trophies of her bloodless war'

So when the time came to pull down the extraordinary glass house in Hyde Park there was a great outcry, and Lord Carlisle declared, 'To destroy Crystal Palace would be a perverse and senseless act of vandalism.' In the end it was dismantled then reassembled and enlarged on a new 200 acre site at Sydenham in south London. This two year project was documented from foundation work to ceremonial opening in two volumes of 160 photographs by P. H. Delamotte. The collodion process – which, by 1854, was rapidly displacing the daguerreotype and calotype – allowed Delamotte to make a photograph of the opening ceremony – one of the earliest of such an historic occasion – but prudently he also appears to have waited until the audience was immobilized by speeches or prayers.

In its move from Hyde Park to Sydenham, the glass hive of industry was transformed into a palace of uplift and entertainment. Amongst its exotica, both scavenged and replicated, were galleries devoted to the glories of Greece, Cathay, Rome, Byzantium and Ancient Egypt, so that the two million visitors each year 'might gain in practical fashion, an idea of the successive stages of

68

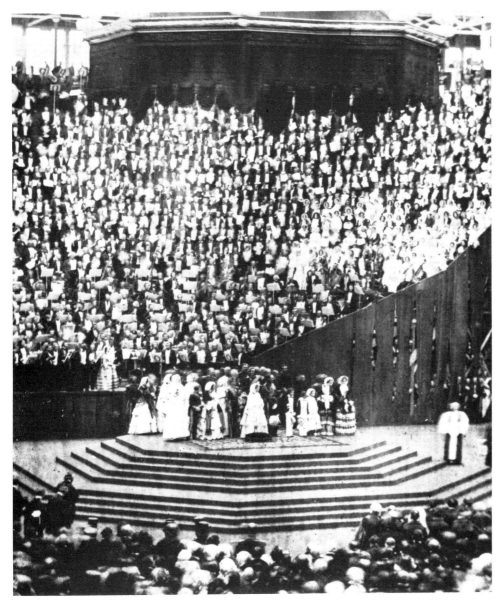

9 P.H.Delamotte.
Queen Victoria and mass choir at the opening of the Crystal Palace. The Archbishop of Canterbury is on the extreme right, 1854

civilization, which . . . have changed or sunk into decadence, have been violently overthrown, or have passed away, by the aggression of barbarians or the no less degrading agency of sensual or enervating luxury.' But some of this instructive statuary was itself too sensual for Victorian sensibility. *The Times* reported that in the days before the Queen arrived the organisers had problems finding 'a supply of fig leaves for the nude statues'. The full-size replicas of the Colossi of Abu Simbel were eventually destroyed by fire in 1866 just two days before an advertised lecture by the Reverend M. M. Hart on 'Fire, what causes it, how it can be extinguished'. Many had predicted back in 1851 that the

Crystal Palace would be destroyed by the first heavy hail storm, but it lasted 85 years before it finally burned down one autumn night in 1936.

Back in the white hot 1850's, Albert the industrious was still able to exult, 'Nobody will doubt for a moment that we are living at a moment of most wonderful transition. The distances which separated the different nations and parts of the globe are gradually vanishing before the achievements of modern invention and we can traverse them with incredible speed.' And in London by 1862 there was even a railway that ran underground. Cockney passengers called it 'the sewer'. Mr. Gladstone graced an early inspection trip

sitting in an open wagon, pulled through noisy tunnels by a belching engine from Paddington to Finsbury. This signalled another historic moment: the first underground railway in a world which, to Tennyson at least, now seemed destined to 'spin forever down the ringing grooves (sic) of change'.

On Queen Victoria's first train journey, the driver of the locomotive had been that prodigy Isambard Kingdom Brunel, the engineer they called 'The Little Giant'. Brunel dug his first tunnel at twenty, then went on to build five suspension bridges, twenty-five railways, and a hundred and twenty-five railway bridges – projects whose progress Brunel could sometimes only follow through photographs. His last great feat was the construction of the biggest ship ever built, an iron leviathan which could carry 4,000 passengers or a whole year's exports to India in one trip, *The Great Eastern*.

Inventors and engineers were among the folk heroes of Victorian times and 3,000 people paid to watch Brunel launch the great ship. But during the launch a winch snapped, killing a labourer; during the sea trials a heater exploded, killing six engineers. These set-backs hastened Brunel's end and he died,

burned out, at 53. *The Great Eastern* however went on to lay the first transatlantic cable in 1866 for the electric telegraph of Samuel Morse. The camera later witnessed many of the breakthroughs in engineering and science, including one branch which did not prosper, 'electro-physiognomy', devised by a Monsieur Duchenne of Bologne now best remembered for his attempts to turn his victim-patients into living art. 'I have performed some new electro-physiognomical experiments which I hope . . . put together the principal conditions required by aesthetics, that is to say, beauty of form combined with truthful physiognomical expression.'

On the morning of the very day Queen Victoria proposed (as protocol dictated) to Prince Albert in 1839, Victoria had been shown the first examples seen in England of the French invention, the daguerreotype. In consequence, perhaps, the royal couple took a keen and lasting interest in photography and their large family became the most photographed of the nineteenth century. The early portraits are surprisingly informal and show Victoria as she chose to be seen, not as sovereign, but as wife and mother. The Queen remained an avid collector, constantly re-

10 An inspection trip of the world's first underground railway. Mr Gladstone is on the right of the man in the white top hat, 1863

arranging and updating her scores of albums. In 1860 one of her ladies-in-waiting wrote, 'I have been writing to all the fine ladies in London for their and their husbands' photographs for the Queen. I believe the Queen could be bought and sold for a photograph.' Victoria also solicited photographs from other dynasties; an undertaking eased no doubt by

11 The Great Eastern *on the stocks by the Thames. Built of iron and driven by steam it was the biggest ship ever made, 1857*

12 Robert Howlett. Isambard Kingdom Brunel, 'the little Giant', against the anchor chains of the Great Eastern, *1857*

13 G.B. Duchenne. Aesthetic agony of victim-patient, 1862

14 The first photograph of Queen Victoria. A calotype taken in 1844 or '45 and attributed to Henry Collen. *The child is the Prince of Wales who in 1902 was to be crowned Edward VII*

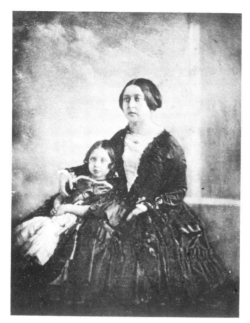

15 ABOVE Roger Fenton. *Victoria and Albert at Buckingham Palace on 30 June 1854*

16 LEFT Prince Alfred. *Study of his mother Victoria and sister Alice mourning the death of his father Albert, 1862*

17 Family reunion for the marriage of two of Queen Victoria's grandchildren – Princess Victoria Melita (daughter of Prince Alfred, Duke of Saxe-Coburg-Gotha) and the Grand Duke of Hesse – on 19 April 1894. Seated: Kaiser Wilhelm II, Queen Victoria, the Empress Frederick of Germany. 2nd row: Prince Alfred of Saxe-Coburg-Gotha, the Czarevitch, his fiancée Princess Alix of Hesse, her sisters Princess Louis of Battenberg and Princess Henry of Prussia, the Grand Duchess Vladimir of Russia, the Duchess of Saxe-Coburg-Gotha. 3rd row: the Prince of Wales, Princess Henry of Battenberg, Princess Philip of Saxe-Coburg-Gotha, and at the right end of this row the Duchess of Connaught, and behind her the Duke of Connaught. Back two rows: Prince Louis of Battenberg, the Grand Duke Paul of Russia, Prince Henry of Battenberg (in uniform), Prince (later King) Ferdinand of Roumania, Count Mensdorff, the Grand Duke Serge of Russia, almost hidden behind him Princess Ferdinand of Roumania, Prince Henry of Prussia, the Grand Duchess Serge of Russia, Grand Duke Vladimir of Russia, Duke of Saxe-Coburg-Gotha

72

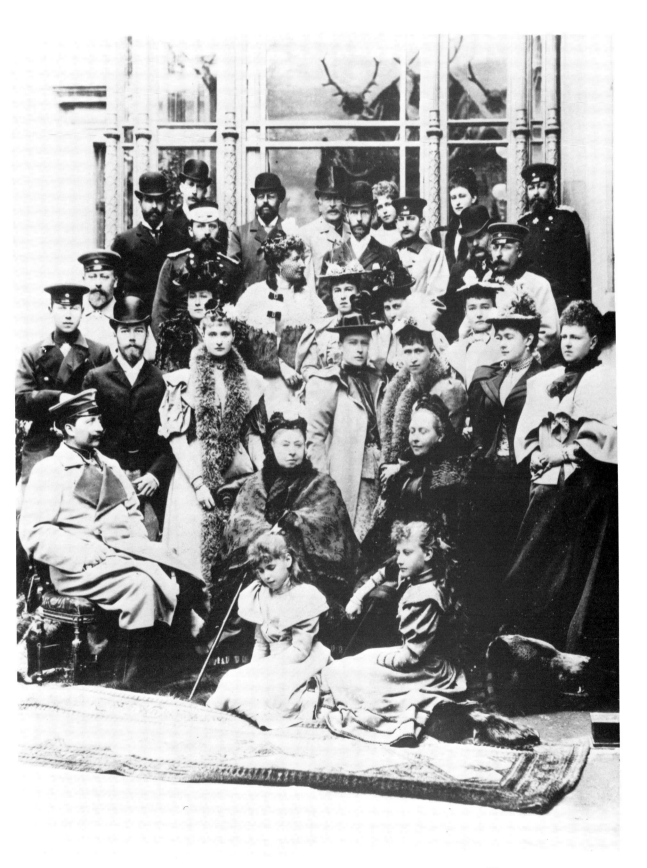

the fact that many of her own large family married into them, which eventually made her grandmother to much of royal Europe.

These dynasties ruled Europe against a background growl of resistance which could suddenly explode from below in rebellion. Among the bloodiest was that in Paris in 1871. The defeat of the French army, the capture of the Emperor, and a humiliating four-month siege of the city by Prussians, finally provoked Paris to revolt. After confronting the troops of their own French government, the citizens elected a council composed mainly of 'reds' who immediately proclaimed a people's 'Commune' and pulled France over the brink into civil war. Though many of the surviving photographs have a strong documentary impact, most are anonymous and some faked. Strangely, in a city full of well-known photographers, no one produced a documented account of the events which followed. The bold Nadar, who had ballooned over the Prussian blockade 'in the name of the revolution', was apparently too ill to work during the seventy-two days of the Commune.

Only twenty-one of those elected to the council of the Commune were workers and they were outnumbered by the intellectuals –

writers, journalists, and painters. One of the most ardent revolutionaries was also the finest realist painter in France, Gustave Courbet. As Government soldiers moved to crush the Communards it was Courbet who inspired an act of defiant and symbolic destruction which also became the best-documented 'news' event of the entire rebellion. A statue of Napoleon Bonaparte, dressed as a Roman emperor, had been placed on the top of a column 150 feet high in the middle of Paris, a standing offence to all French Republicans. Courbet's plan was to knock Napoleon off his perch, and cheering crowds turned up to see it done. But the Vendôme Column was yards thick and wrapped in a spiral of solid bronze made from twelve hundred captured cannon. Eventually it had to be chopped like a tree and toppled by winches with fifty men hauling on the ropes. To a great roar of 'Vive la Commune', Napoleon hit the straw covering the cobblestones, while English tourists scrambled for souvenirs. As a painter Courbet may have been a great realist, but as a revolutionary he was a bit naïve. He posed with other Communards for a souvenir photograph beside the fallen Emperor and this photograph is said to have been used later by an

18 Communard cannon in Rue de la Paix in Paris. The bearded man with his hand on the barricade is the artist Gustave Courbet, 1871

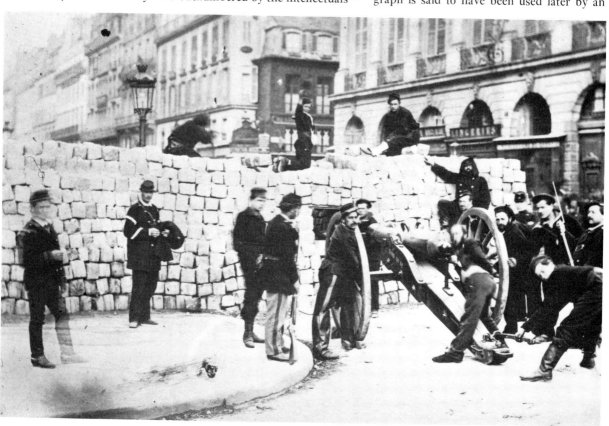

outraged French government to hunt down and kill the political vandals. Courbet himself was too illustrious to kill, so a punishment was devised to fit the crime: he was ordered to pay to put the column back up again. Instead, he fled to exile in Switzerland where, bohemian to the last, he died of dropsy and drink.

In the attack which finally suppressed the Commune, the Government troops were pitiless. Some 20,000 Communards were massacred. The revolutionaries made their last stand in the Père Lachaise Cemetery where 147 fighters were put up against a wall and shot. Although Karl Marx and his French followers had little influence on the Commune, the cemetery wall in Paris is today a Communist shrine, and the first Soviet Voskhod rocket into space carried with it a symbolic tatter from a Communard banner. The artist Auguste Renoir, who narrowly escaped death at their hands, supplied the most resonant epitaph for the Communards, 'They were mad men, but they had in them that little flame which never dies.'

The torch of the Statue of Liberty came to symbolize escape from the oppressions of old Europe, but it was in fact a gift from Republican France. Built in copper by the sculptor Bartholdi in Paris, the 151 foot high statue, properly called 'Liberty Enlightening the World', was shipped in sections across the Atlantic and unveiled in 1886. The mass exodus of the nineteenth century was the

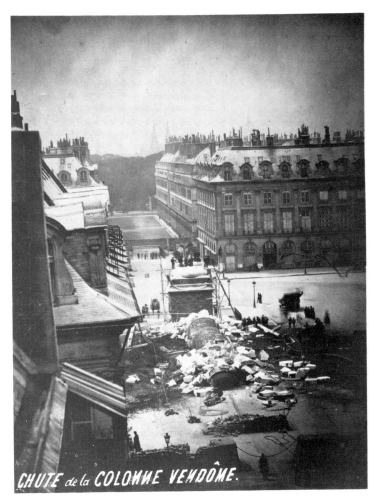

CHUTE de la COLONNE VENDÔME.

19 Top shot of the demolished column in the Place Vendôme, 1871

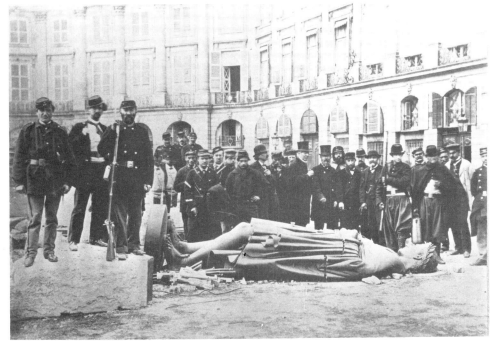

20 The architect of Napoleon's downfall was the bearded Courbet, standing at the back in cap. This photograph was later used to identify and kill those rash enough to pose in the Place Vendôme

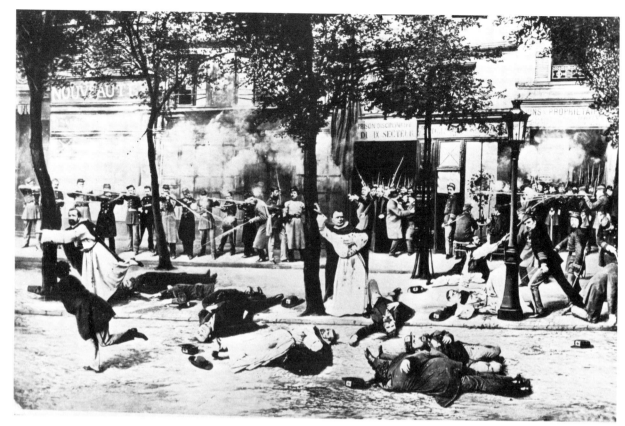

21 TOP *Blameless priests slaughtered by merciless Communards in shameless montage, 1871*

22 ABOVE *A propaganda picture of 'dead' children designed to discredit the Communards*

biggest in history with thirty-five million emigrants leaving Europe in search of freedom and opportunity in America. The five famous lines on the base of the statue proclaim the sympathy of white America towards its kith and kin left behind:

Give me your tired, your poor
Your huddled masses yearning to breathe free,
The wretched refuse of your teeming shore.
Send these, the homeless, tempest-tossed to me.
I lift my lamp beside the golden door!

But behind the promise of the Statue of Liberty lay the reality of Ellis Island. From its opening in 1892 some twelve million emigrants coming to New York had first to pass through this immigration station. It was an ordeal they dreaded, as one later recalled: 'When I first arrived in this country I was filled with so many hopes, dreams and fears. One of the greatest fears was of a place known as Ellis Island, but called by us the "Island of Tears". . . . When I landed the noise and commotion were unbelievable.' The migrants were first medically examined, then interrogated. Those who had an incriminating letter chalked on their coats were put back on the boat to Europe.

At the beginning of this century a sociologist, Lewis Wickes Hine, took up photography to help reveal the injustices suffered by poor immigrants first at Ellis, and then in the factories of the towns. The description 'photo story' was first used about Hine's pictures which were widely published as 'human documents'. The common people had been, throughout the nineteenth century in Europe, simply the spectators or victims of most events the camera judged to be historic. But in America by the turn of the century there began to emerge through the work of men like Jacob Riis (page 120) and Lewis Hine, a belief that the camera could be made the ally of those common people who were ceasing to be the victims of history and were quickly becoming citizens of a democracy with the power to reshape it.

23 André Disdéri. *Victims of the slaughter which followed the suppression of the Commune in the bloody week of May, 1871*

24 RIGHT *France's centenary present to America*
25 *Liberty's face is lifted ashore in New York*

26 Lewis Hine. *A group of Slavs prepare for the ordeal of Ellis Island, New York, 1905*

27 Lewis Hine. *Immigrant family searching for lost baggage at Ellis Island, New York, 1905*

6 Eyewitness of War

'Let him who wishes to know what war is look at
this series of illustrations. The wrecks of
manhood thrown together in careless heaps or
ranged in ghostly rows for burial were alive but
yesterday.'

OLIVER WENDELL HOLMES

Eyewitness of War

Within the technical limitations of the time, the 19th century offered war photographers great freedom. There was little military censorship, armies moved slowly, clashed predictably, and still observed in some measure the old etiquette of war. This last point was important. Only at the end of the century was the camera fast enough to catch the action; before that it showed the buildup to battle, or the aftermath. Custom would often dictate a truce while burial parties disposed of the dead and it was then the photographers were most active.

In 1846 the British army had not had a serious fight since Waterloo a generation before, the war in the Crimea was still eight years off, and the Gordon Highlanders were safe at home in Edinburgh Castle. In the spring of 1846, when the craft of photo-

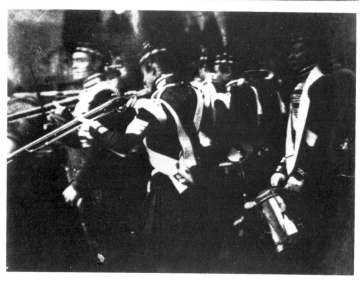

graphy was barely seven years old, photographs were taken on the ramparts of the castle which stand as the earliest series in existence of soldiers.

The photographers, David Hill and Robert Adamson, made 'sun pictures' by the calotype process which gave a soft, expressive effect. Some of the poses look remarkably relaxed considering the length of exposure. Even when Hill and Adamson did get a blur of movement, as on the raised rifles, it is somehow turned to advantage, giving a painterly, impressionistic effect.

Battle paintings traditionally celebrated martial glory and rendered gallant death with a decorous dab of gore. The inherent naturalism of photography was bound to contradict the romantic excesses which so appealed to the armchair patriot.

In 1854, Britain and France went jointly to war to shore up the empire of the Turks against the ambitions of the Czar and confronted the Russians on a barren peninsula in the Black Sea called the Crimea. The Crimean War, said Queen Victoria, was popular beyond belief and, one of her Ministers noted, 'The painful excitement for information beggars all description.' But the information when it came was shocking. News of the war was brought daily to the breakfast tables of the rising middle class by *The Times* of London. Their correspondent in the Crimea was an Irishman, William Howard Russell, one of the first modern war correspondents and, in his own words, 'the miserable parent of a luckless tribe'. Russell exposed the disarray of the British army in the first deadly winter of the war when only one death in six came in battle: 'This army has melted away almost to a drop of miserable, washed out, worn out spiritless wretches, who muster out of 55,000 just 11,000 now fit to shoulder a musket.' Russell's dispatches aroused great hostility among the army officers. Facilities were denied him and he was warned with understated menace, 'If I were you I should go away. I would indeed.' But Russell persisted and his reports helped bring down the government of Lord Aberdeen in January 1855. However the Secretary for War, Lord

1 D.O. Hill and Robert Adamson. *An informal and ambitious calotype which would require an exposure of several minutes, 1846*
2 D.O. Hill and Robert Adamson. *Swaying rifles on this exposure produce an impressionistic effect, Edinburgh Castle, 1846*

Newcastle, survived the fall and at last began to promote reforms.

In March 1855 a photographer, Roger Fenton, sailed on commission to the Crimea. Fenton had trained in France as a painter before turning with distinction to photography. Among his subjects were the royal family, and Prince Albert (who had called W.H. Russell 'that miserable scribbler') sponsored him for the mission. Although the commission came formally from a Manchester publisher, Thomas Agnew, an interested backer was the threatened Lord Newcastle. Fenton travelled to the Crimea on the *Hecla* with two assistants, five cameras, 700 glass plates, a photographic wagon and four horses he bought at Gibraltar. Working conditions were arduous, the heat was fierce, and water scarce. Near the front line the wagon was dangerously visible to Russian gunners.

The nonchalance of the British officer class in the squalor of the Crimean campaign left one reporter wailing, 'Oh this slutten aristocracy.' The commander of the British forces, Lord Raglan, was gallant, courtly and incompetent: five nephews held positions on his staff. Another aristocrat, Lord Cardigan, had paid a reputed £40,000 for the colonelship of the 11th Hussars, then dressed them in an outfit which astonished *The Times*. 'The brevity of their jackets, the irrationality of their headgear, the incredible tightness of their cherry-coloured pants altogether defy description.'

The vanity of the officers irked and hindered Fenton who was constantly pestered for portraits. 'If I refuse to take them I get no facilities for conveyancing my van from one locality to another.' However, Fenton's trained eye triumphed over the problems and primitive conditions, and today his photographs fix our images of that confused and dreary campaign.

But Fenton's was a cosmetic camera. Many months after the Charge of the Light Brigade he described a journey to the Valley of Death. 'We came upon many skeletons unburied. One was lying as if he had raised himself upon his elbows, the bare skull sticking up with still enough flesh left in the muscles to prevent it from falling from the shoulders.' There are no such scenes in Fenton's portfolio of 300 glass plate negatives: his dead are buried in neat Christian graves.

In fact Fenton's atmospheric and beautiful photographs conceal a political intent. If they now belong to history, they were at the time

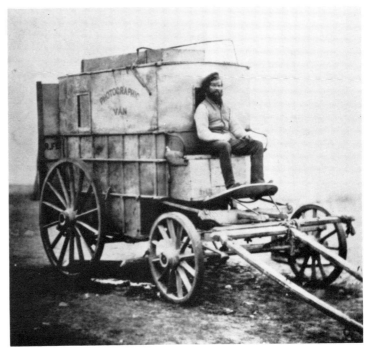

3 Roger Fenton. *Specially designed photographic van brought from England to the Crimea. Assistant Marcus Sparling is in the driving seat, 1855*
4 Roger Fenton. *Orderly serves Lt. Col. Halliwell, Crimea, 1855*

most useful to Newcastle, the Secretary for War who backed Fenton's trip. Troops who had the previous year lacked food and fuel could now be seen to have a cookhouse in the field; supplies piled up on the quayside and the army had its new tents; soldiers who had almost frozen to death were now photographed in woolly clothes. Servants poured

5 Roger Fenton. *The cookhouse of the 8th Hussars with a female camp follower in the background, Crimea, 1855*
6 Roger Fenton. *Supplies from England pile up on Ordnance Wharf at Balaclava Harbour, 1855*

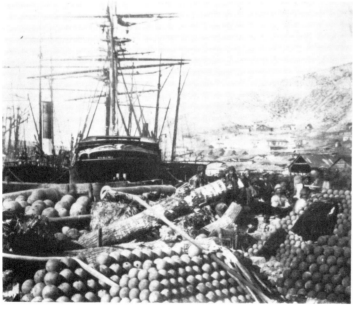

wine for reclining officers and British and French troops toasted the *entente cordiale* – the photographs were, after all, to be sent to Napoleon III in Paris after Victoria and Albert had exhibited them in London. But the viewing public was disappointed to discover that Fenton's photographs lacked both visual rhetoric and gruesome scenes. Indeed Queen Victoria probably saw more of the reality of war when she visited the military hospital at Chatham in 1856.

Five years later, on the battlefields of the American Civil War, the camera did look frankly into the face of battle. First in the field was Mathew Brady, already internationally famous for his studio portraits. Abraham Lincoln credited a Brady portrait with helping him to the Presidency but it was the election of Lincoln which in 1861 precipitated the bloody civil war in which 600,000 Americans died. The war was a conflict between the strong, industrialized states of the North and the largely agricultural states of the South. The prosperity of the South was founded on cotton and the slave labour of millions of blacks on the plantations. Northern hostility to slavery, and Southern fears that Lincoln might free the slaves, helped split the union. The war began with set-backs for the North but her industrial strength was soon turned into military muscle. Huge armies were recruited, drilled, then deployed in a war effort backed by the full might of the economy. It was the first modern example of total war.

The first battle of the war was at Bull Run near Washington and Brady used his political influence and a card which read 'Pass Brady – A. Lincoln' to get his photographic wagon to the front. This vehicle puzzled the Northern soldiers who dubbed it the 'Whatsit Wagon'. Bull Run was a dangerously confused affair: the 30,000 strong Northern army panicked and fled; Brady and his wagon were lost in the woods for three days.

The public followed the war avidly and newspapers and magazines clamoured for photographs which were copied and published as woodcuts. Views of the war also sold widely as prints and stereocards. The Northern Army of the Potomac alone issued passes to no fewer than 300 photographers. Most were professionals working in a competitive market and always on the look out for memorable shots. At the start of the 1860s, the American public had never seen dead men on a battlefield and the more grisly pictures

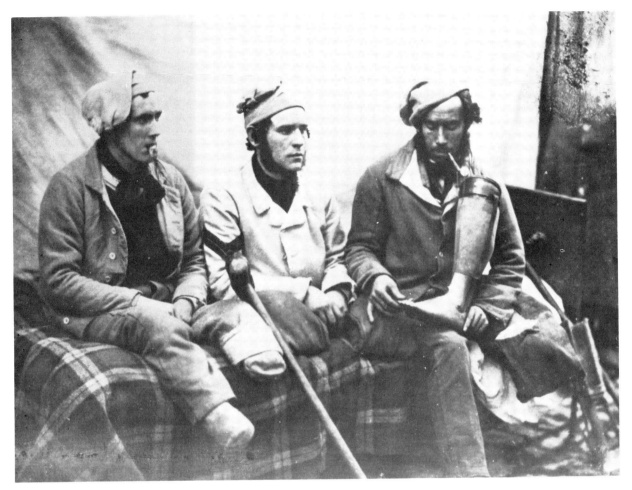

7 Crimean amputees. William Young, Henry Burland and John Connery photographed during Queen Victoria's visit to Chatham Hospital in Kent, 1856

8 LEFT Matthew Brady. *First photographer of the American Civil War after surviving the fiasco of the battle of Bull Run, 1861*

were in great demand.

Some of the most tragic pictures of the war were taken by Alexander Gardner on the field at Antietam on 17 September 1861, the single bloodiest day of the war when, said General Palfrey, 'the two lines almost tore themselves to pieces' and 23,000 men were killed or wounded. Gardner had worked initially for Brady but broke away because of his boss's habit of crediting all pictures to himself, a conceit which alienated his most talented men. Another defector, Tim O'Sullivan, took some of the most famous scenes of the war while working at Gettysburg with Gardner.

Gettysburg was the decisive battle of the war. The Southern army of Robert E. Lee had invaded the North in 1863 and threatened Washington but they were met at Gettysburg in Pennsylvania by a superior Northern force. The fighting lasted three days, then, in a last heroic but suicidal charge, some 7,000 Southerners were cut down. Lee's beaten army retreated and for two days the rain came down washing the blood from the grass. The burial parties on both sides toiled in the rain but 43,000 men had been wounded or killed; when the photographers arrived two days later, some of the dead were still unburied.

First on the scene were O'Sullivan and Gardner. Like the unlettered Brady, these immigrant Americans had a direct approach to the realities of war which was not subverted by style. But there were other pressures to distort. Alexander Gardner was a craftsman and radical journalist from Scotland who came to America to start a socialist colony. He hated war and his photographs, concentrating as they do on the dead, appear to proclaim the

9 Northern cannonballs piled up by a magazine during the American Civil War, 1861–65

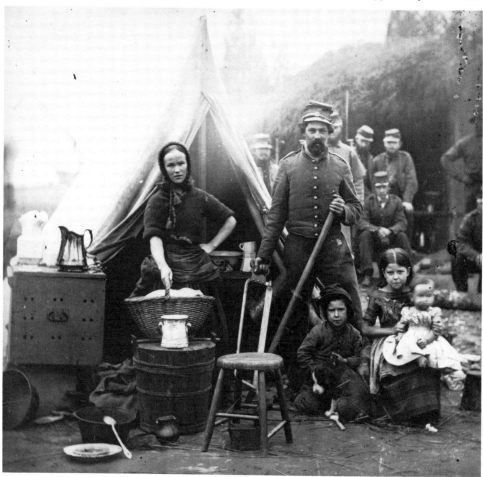

10 Matthew Brady. Soldier of the 31st Pennsylvania Regiment with family at camp in 1862

horror of war. Yet in doing so, they also raise some disturbing questions. Gardner's most poignant picture of Gettysburg is entitled 'Home of a Rebel Sharpshooter' and it shows a Southern soldier dead behind a rampart of boulders in a rocky outcrop called Devil's Den. It is one of the most famous war photographs ever taken – and it's a fake. There is no proof the soldier was a sharpshooter, more likely he was a plain infantryman. Moreover he had been killed forty yards away from the rampart and Gardner and O'Sullivan had already taken three rather undistinguished photographs of the young soldier in the spot where he had fallen days before. Gardner and O'Sullivan must have spotted the visual potential of combining the body and the rampart, picked up the dead soldier, and carried him for forty yards before arranging him in the required pose with his rifle propped behind him. Robbed of its integrity, this picture, which appeared to suggest so much about the futility of war, becomes just another piece of visual rhetoric, exploiting the innocence of

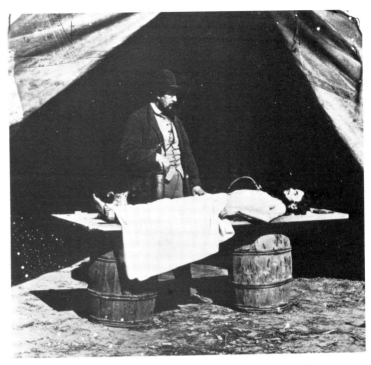

11 Embalmers followed the fighting. Dr. Burr would send home as many as a hundred bodies a day guaranteed 'free from odor and infection'

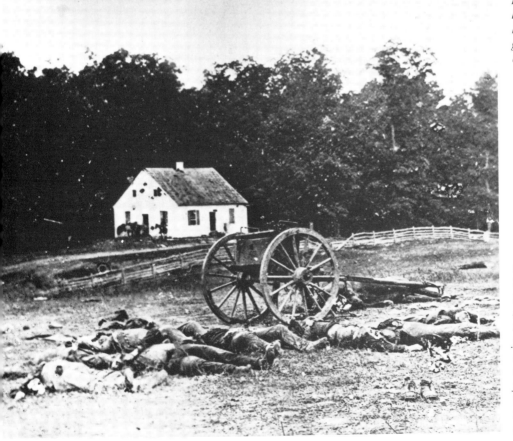

12 Alexander Gardner. Dunker Church and the dead at Antietam. 'The slaughter here was fearful. Each of the contending lines charged across the field in front of the building, and strewed the ground with their dead', 1861

85

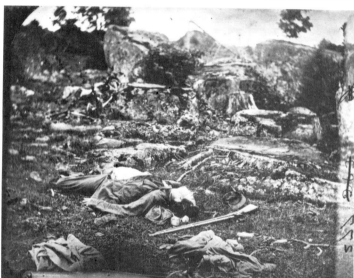

an age which had not yet learned to question the authenticity of the photographic image.

While the camera was learning to lie, it also proved its powers of evidence. In Georgia, there was a camp for prisoners of war at the village of Andersonville. In the summer of 1864, Andersonville housed 32,000 prisoners in its 26 acres; eleven thousand died of starvation and disease. The photographs of the living skeletons, a terrible augury of our own time, caused murderous anger in the North. The camp commander, a Swiss immigrant called Henry Wirz, was found guilty of conspiracy to destroy the life of prisoners and sentenced to death. Soldiers stood under the gallows chanting 'Wirz – remember Andersonville' as Alexander Gardner photographed the execution.

In Europe in 1870, the French went to war against Prussia, provoked by a diplomatic slight dealt by Bismarck. The French paid dearly for Napoleon III's *amour propre* when they were taught the realities of modern war by the Prussian military machine which mobilized a million men in 18 days and sped them to the front on a strategic network of railways. The supposedly impregnable French fortress at Sedan was captured and the Emperor taken prisoner. Indeed this first stage of the war was over so quickly that even contemporaries complained of the paucity of photographic coverage. The Prussians then surged on to Paris, overran the forts in the suburbs, and bombarded the city when it refused to surrender. At Versailles the Prussian general staff settled comfortably into the former palace of the French kings for what proved to be a four months' siege. The starving Parisians were reduced to eating rats and even two baby elephants in the zoo, but a pigeon post kept them in contact with the outside world. Messages printed on the front page of the London *Times* were microphoto-

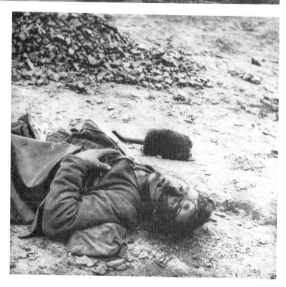

13 Alexander Gardner. '*Home of a Rebel Sharpshooter*'. *The dead rebel was carried by the photographer to these rocks in Devil's Den at Gettysburg and laid out with his rifle propped behind him. 1863*

14 Alexander Gardner. *The dead rebel taken where he was killed 40 yards away from Devil's Den. 1863*

15 Alexander Gardner. *A dead rebel at Petersburg with hand placed suspiciously over his heart, 1865*

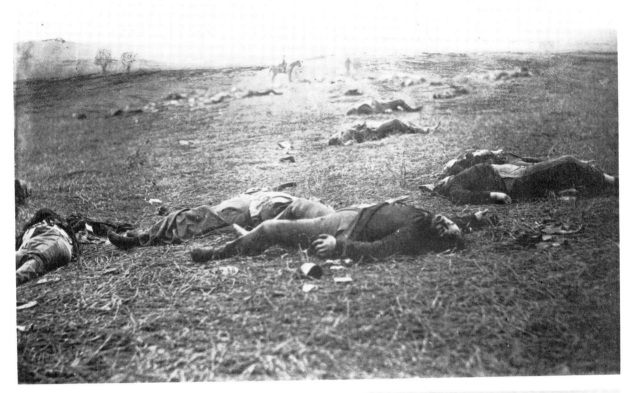

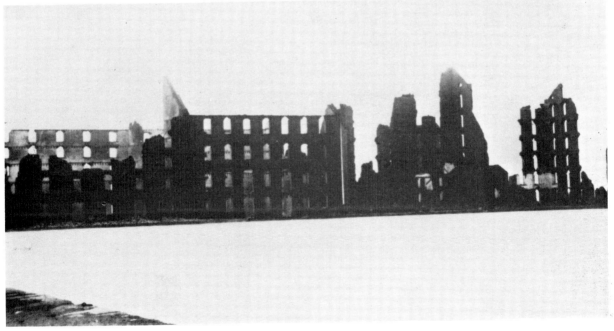

16 TOP T.H. O'Sullivan. '*A Harvest of
Death*' *originally identified the dead at
Gettysburg as rebel soldiers – but modern
research proves they are Northerners. Their
boots have been removed, 1863*

17 ABOVE Matthew Brady. *Ruins of the rebel
capital after the burning of Richmond, 1865*

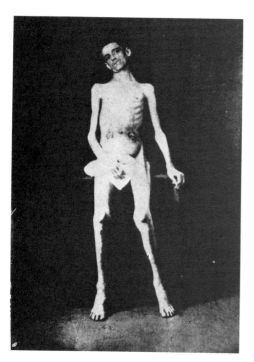

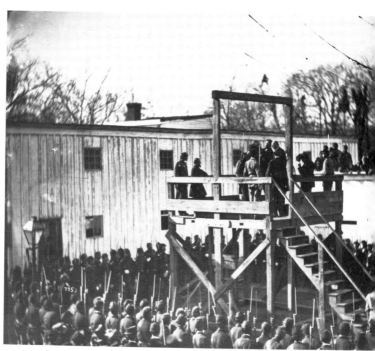

18 A survivor of the Southern death camp at Andersonville where a prisoner died every eleven minutes, 1865

19 The execution of the Commander of Andersonville, Henry Wirz, 1865

20 BELOW Conquering Prussians. Fort Issy on the outskirts of Paris, 1870

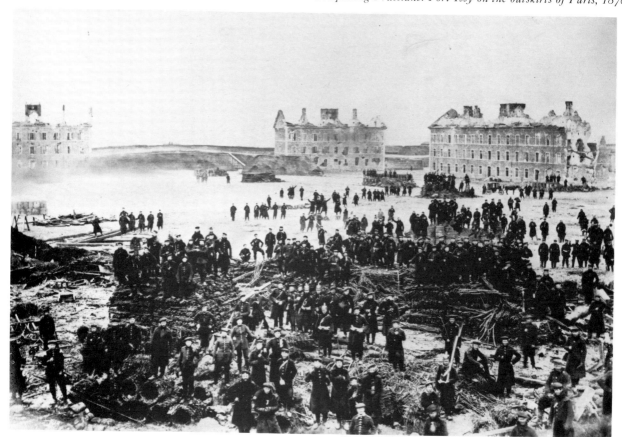

graphed and sent by pigeon to Paris where the microphoto was enlarged on a screen. Relays of clerks copied down the messages which were then delivered to the addresses in Paris.

The Japanese, in their convulsive leap out of feudalism in the 1860s, had called in the French to help them build a modern army. After the defeat of 1870 the French instructors were kicked out and replaced by Germans. Within a generation the Japanese were able to take on and humble a formidable European power – Imperial Russia.

In January 1904, when the *Daily Mirror* became the first daily newspaper to carry photographs, it printed a portrait of the Japanese Admiral Tora Ijiuin and a picture of three Japanese sailors sighting a gun on board a man-of-war above the caption 'Ready, Aye, Ready'. The news sense was uncanny. A month later, in a preview of Pearl Harbour, the Japanese attacked and sank the Russian Pacific Fleet. And when the Russians sent their Baltic fleet all the way round the world the Japanese sank that as well. It was the time of great advances in popular journalism and as the profession of news photography developed, picture agencies sprang up employing freelances strung across the world.

One of the biggest was the American agency of Underwood and Underwood. Its photographers had access to both sides of the line in the Russo-Japanese war and filed grim pictures. But by now the sights of battle no longer carried the shock of the American Civil War pictures of forty years before. Increasingly war photographs were to become part of a brisk market in images, fragments of horror which at best might provoke sombre reflection and occasionally outrage, but too often served only to titillate a mass audience through their residual authenticity.

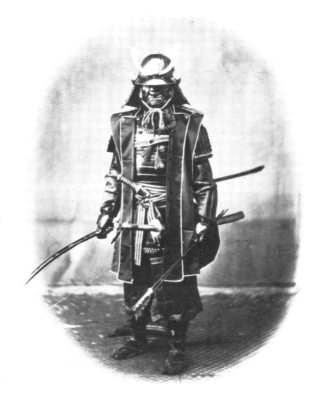

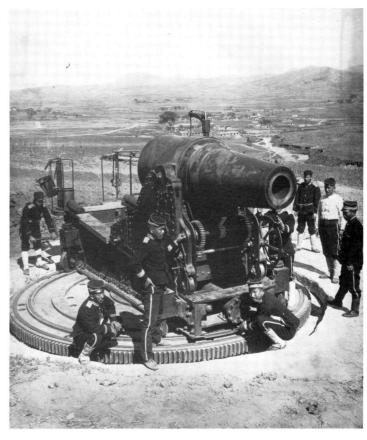

21 RIGHT, ABOVE Felice Beato. *A Japanese officer in full armour, 1868*

22 Japanese siege gun outside Port Arthur, 1904

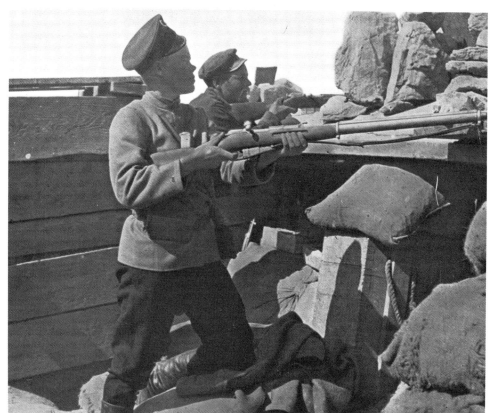

23 Russian soldiers in the trenches at Port Arthur in Russo-Japanese war, 1904

24 Japanese officers inspecting sunken fleet at Port Arthur, 1904

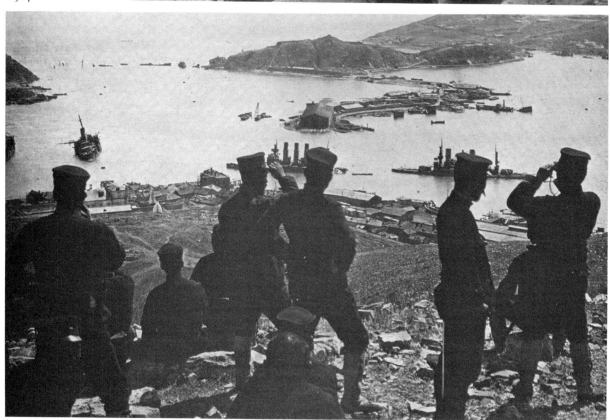

7 Soldiers of the Queen

'Take up the White Man's burden
Send forth the best ye breed
Go bind your sons to exile
To serve your captives' need.'

RUDYARD KIPLING

Soldiers of the Queen

In the years between 1839 and the Great War, the British army fought some fifty wars and campaigns which brought a quarter of the human race under the dominion of the great empire on which the sun dared not set.

Through photographs we can piece together a picture of this British army as it went about its business overseas. As early as the 1850s, officer cadets bound for service in India were being instructed at college in photography. In those days it was an expensive and time consuming craft, but officers were still men of private means with the leisure to indulge in the new hobby as they stood guard across the Empire.

Not that soldiering was yet associated in the public mind with imperial grandeur. Indeed the army was deliberately kept small and watched suspiciously lest it nurture another usurping radical like Cromwell, or an adventurer like Napoleon. The formation of a military caste was discouraged by the system which allowed commissions to be bought only by gentlemen 'with a stake in the country', or put another way, the conservative landed gentry. Their ignorance, snobbery, and plain incompetence led to the lethal shambles of the Crimea (page 81), but they did have that peculiarly English quality called 'character' which blended personal bravery, social conformity, stoicism in the most trying outposts of empire, an incorruptibility rare among colonialists, and a quite effortless sense of superiority.

The common soldier was distinctly inferior and the red coat an emblem of contempt. An Under-Secretary for War confessed, 'Our system of recruitment has, I believe, swept to a great extent the refuse of large towns.' These sweepings were augmented by levies of fierce Celts forced by famine and landlords from their homes in Ireland and the Scottish Highlands. Barracks were more crowded than jails and in 1858 the death rate from tuberculosis among soldiers was five times higher than that among civilians, floggings were still permitted, men signed up for a minimum of 21 years, and recruiting sergeants worked hard to fill ranks using bounty and lies. When asked what he would do if this army landed in Prussia, Bismarck replied, 'I would send a policeman and have it arrested.'

The British held their navy in higher

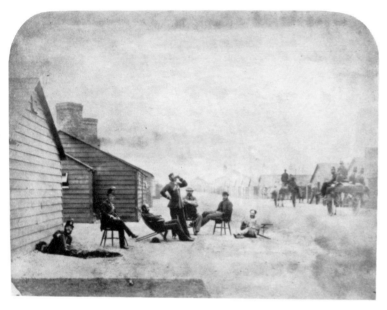

1 Officers of the 86th Regiment in the Curragh Camp, Ireland, c1860

2 British Army recruits with sergeants from St George's Barracks, Trafalgar Square

esteem. At one point last century every third ship afloat was British and the sea routes of the Empire were patrolled by the Royal Navy which had kept Britain free of sea-borne invasion for 800 years; a harshly disciplined force bound together, in the phrase attributed to Winston Churchill, by the old traditions of 'rum, sodomy, and the lash'. The British fleet even dominated the Mediterranean from the Rock of Gibraltar to the Golden Horn, and in 1875 the purchase of the Suez Canal brought swift and secure passage to the richest prize, the great empire in the East.

John MacCosh, a surgeon in the army of the East India Company, was the earliest 'war' photographer and the first of the many officer-

3 Sir Benjamin Stone. Officers with sextants, c1900

4 Roger Fenton. The British Fleet at anchor, 1854

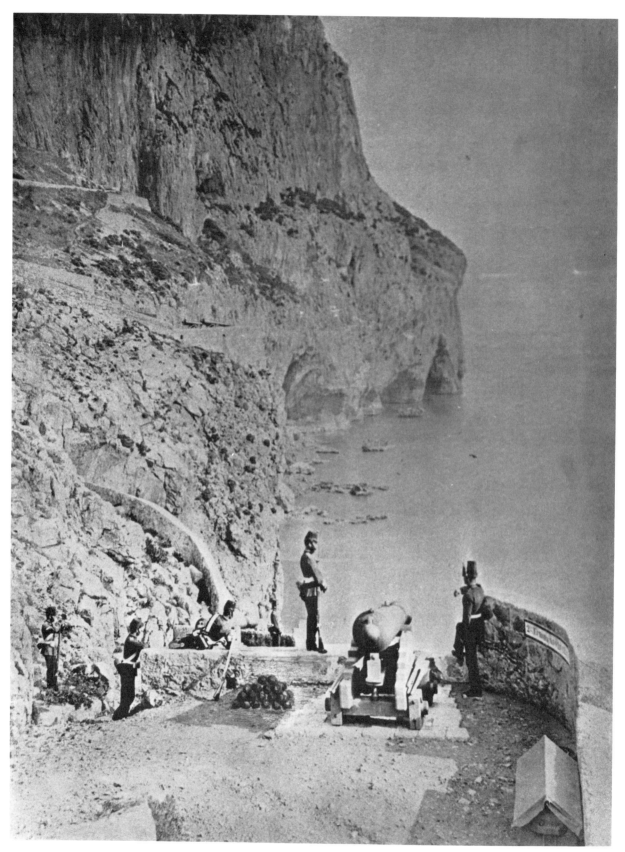

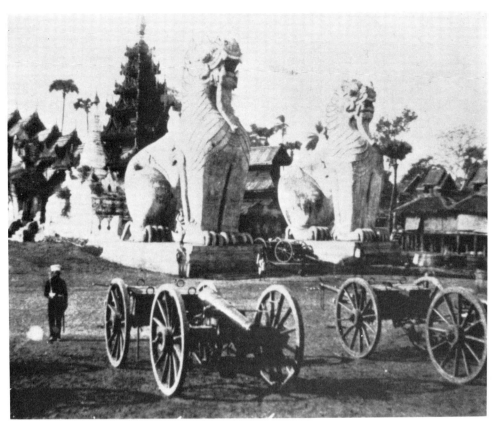

photographers. MacCosh made calotype portraits of fellow officers during the Second Sikh War in India in 1848–9, and in the Second Burma War of 1852 he extended his range to include views of cities and exotic temples occupied by troops and field guns.

In a book published in 1856, MacCosh advised that the British officer 'make himself master of photography in all its branches, on paper, on plate glass, and on metallic plates. I have practised it for many years, and know of no extra professional pursuit that will more than repay him for all the expense and trouble (and both are very considerable) than this fascinating study . . .'.

Another encouragement to photography was the global pre-eminence which led to the British to conclude that it was their heaven-touched destiny to subdue and civilize the planet through 'savage wars of peace'. This bred in the officers a well developed sense of history for they, after all, were the chaps chosen to make it. But the events of 1857 shocked the British out of the belief that all subject peoples actually welcomed the imperial presence; the sepoys of the Indian army mutinied, seized Delhi and massacred the entire British garrison at Cawnpore.

The suppression of the mutiny was not well documented, the camera mainly showing the ruined aftermath of actions. The veteran of war photography in the Crimea, Felice Beato,

95

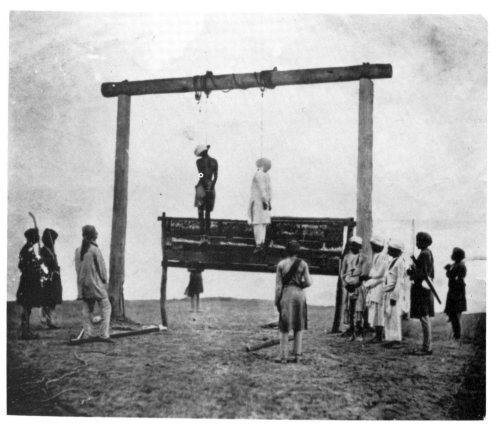

8 Felice Beato.
*Public hanging of
mutineers in India,
1858*

9 Felice Beato.
*Bones of rebel sepoys
litter the courtyard
of Secundra Bagh,
Lucknow, 1858*

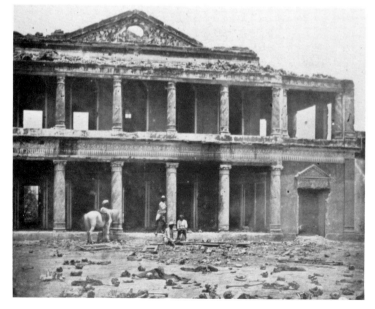

arrived and photographed many of the strong-holds and damaged buildings. There were acts of savagery on both sides and at the Secundra Bagh enclosure, on the outskirts of Lucknow, in November 1857, Sir Colin Campbell's Highlanders slaughtered nearly 2,000 sepoys in a few hours. Beato photo-graphed the human debris still littering the courtyard months later, and was present when leaders of the mutiny were publicly hanged. In the suppression of the rising, sepoy gun-ners were strapped to the muzzles of their own cannon and blown apart.

Another Crimean veteran, the redoubtable William Howard Russell of *The Times*, warned with prescience, 'The Anglo-Saxons must either abate their strong natural feelings against the coloured race . . . or look forward to the day . . . when the indulgence of their passions will render the Government of India too costly a luxury for the English people.'

But India, the jewel in the imperial crown, held a special fascination for its British rulers and an early Governor-General, Lord Can-ning, an amateur photographer himself, en-couraged a remarkable application of the camera. His officials were asked to take photographs as they travelled the country, and between 1863 and 1865 100,000 prints were amassed to show 'the various divisions in the great Asiatic family'. A selection was published in eight volumes entitled *The People of India* – the first ethnographic study to make such extensive use of photography.

Felice Beato followed the British army out

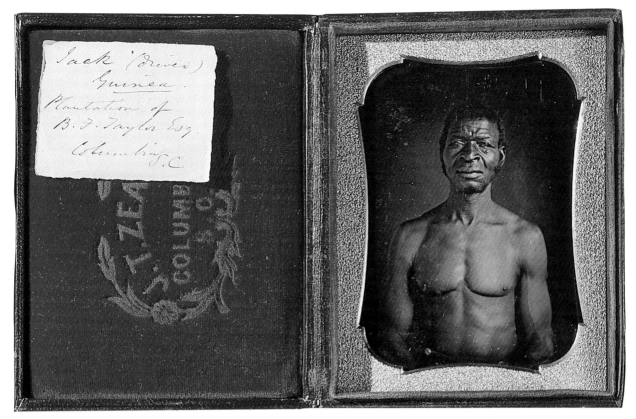

1 J. T. Zealy. *This daguerreotype protects its silvery image in a plush case. It is, however, no conventional portrait, being commissioned by the scientist Louis Agassiz as visual proof of his belief that blacks were an inferior species. Taken in 1850, this portrait of an African slave from Guinea was discovered along with 14 others in a Harvard attic only a few years ago*

2 Carpenter and Westley. *Daguerreotypes with their delicate silvered surfaces had to be hand tinted with great care. This stereo-daguerreotype was made in the 1850s*

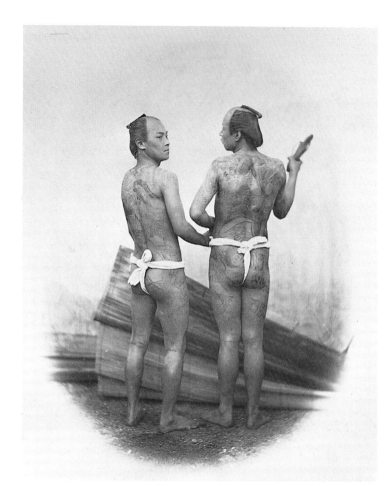

3 Felice Beato. *This albumen print of tattooed Japanese has been tinted by hand, c 1868*

4 Carlo Ponti. *A paper print of Venice, garishly coloured by hand then pin-pricked for back-lighting in a viewer*

5 *James Clark Maxwell first demonstrated the additive colour process. By superimposing these three photographs of a tartan ribbon taken through red, green and blue filters, Maxwell succeeded in projecting a full colour reproduction of the original, 1861*

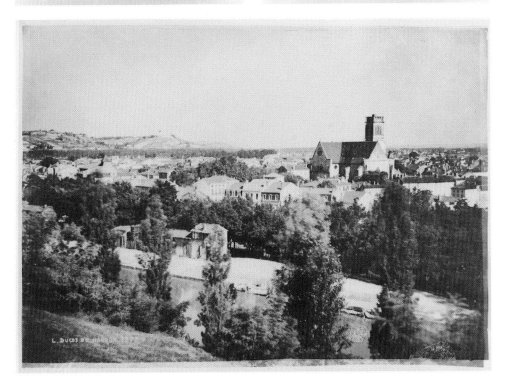

6 Ducos du Hauron. *View of Angoulême, 1877. As early as 1869, du Hauron had predicted virtually all practicable colour processes in his book* Les Couleurs en Photographie Solution du Problème

7 LEFT *Professor John Joly of Dublin marketed the first additive screen plate colour process in 1895*

8 and 9 BELOW *Auguste and Louis Lumière patented the autochrome process in 1904 and it dominated the field of colour photography for the next thirty years. These two early examples were made by the Lumière brothers themselves*

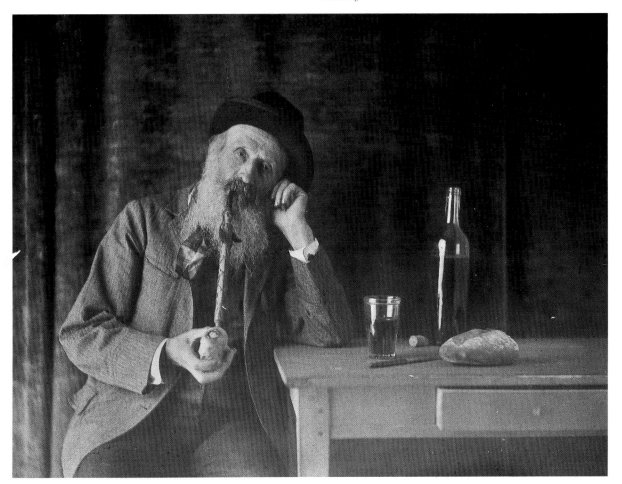

10 and 11 Alvin Langdon Coburn, prominent in the Photo-Secession Movement, was an early experimenter in autochrome colour

12 and 13 Two
autochromes. The still
life is attributed to
Baron de Meyer, the
photographer of the girl
in the hammock is
unknown

14 This autochrome was made by M. Tournassoud, a friend of the Lumières and an early experimenter in colour photography

15 Margate Beach is an autochrome by J. C. Warburg

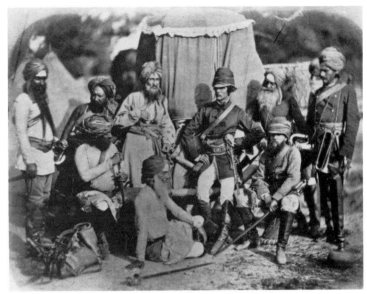

10 ABOVE *One of the 100,000 photographs taken by officers for Governor-General Canning in India, 1863–65*

of India on another imperial venture – the punitive expedition against China in 1860. British merchants grew opium in India and had by the middle of the last century addicted millions of Chinese, further undermining a decaying culture. The Celestial Emperor was advised, 'The English barbarians are an insignificant and detestable race' and through isolation and arrogance fatally underestimated the naval and military fire power which crushed Chinese resistance in the Opium War of 1840. From 1856 to 1860 the British and Chinese were engaged in another series of ragged conflicts.

Felice Beato most probably sailed for China along with the regiments of Indian troops like Probyn's Horse, the Sikh irregular cavalry who had remained loyal during the mutiny. The photographs of the 1860 expedition chart its progress from the arrival of the fleet off the mud-flats at Pehtang to the reduction of the forts guarding Peking. Beato shows the interior of the forts after their capture and at Taku Fort his powerful sequence shows not only the bristling defences but also the corpses strewn inside. It is the earliest and best attempt to deal with the realities of war; although carefully composed and frank, Beato does not gloat or linger over the Chinese dead. The photographer was still on hand when the British gunboats sailed up river and Peking was surrendered.

That famous advocate of gun-boat diplomacy, Lord Palmerston, had warned the world, 'As the Roman, in days of old, held himself free from indignity ... so also a British subject, in whatever land he may be, shall feel confident that the watchful eye and the strong arm of England will protect him from injustice and wrong.'

The most unlikely expedition was mounted in Abyssinia in 1867 when a force under the command of General Napier was sent to free a group of 60 Europeans held prisoner by the highly volatile King Theodore. Theodore

11 ABOVE Felice Beato. *Sikh irregular cavalry with British officers, 1858*

12 Felice Beato. *Chinese dead after the storming of Taku Fort guarding Peking, 1860*

was piqued that Queen Victoria had not replied to a letter. It later turned out that the letter had been mislaid by the Foreign Office, but by then 60,000 men had been dispatched with 8,000 camels and 44 elephants at a cost of £8½ million.

The Royal Engineers had begun to train in the military uses of photography soon after the Crimean War. For the Abyssinian Campaign they were allowed a budget of £447 to cover equipment and supplies for a squad of six sappers led by a Sergeant Harrold. The engineers used photography principally to copy maps and plans and during the campaign they produced 15,200 documents, but fortunately they also shot some other scenes along the line of march.

As Napier's column closed in on Theodore's stronghold at Magdala, the King retaliated by throwing 600 natives off a cliff. Undeterred, Napier pressed home the assault; Theodore than suddenly released his hostages unharmed and offered Napier a gift of cattle, hoping no doubt that the British would now do the decent thing and withdraw. When Napier refused the deranged Theodore committed suicide with an ornamental pistol, a gift from Queen Victoria in happier times. Ironically, the lowest priority in army photo-

13 Officers of the 93rd Highlanders with trophies of the hunt, India c1864

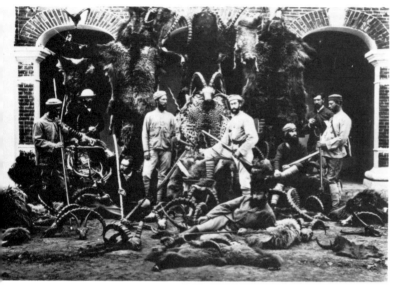

14 BELOW, LEFT Sergeant Harrold, R.E. Captain Speedy in native costume, Abyssinia, 1868

15 BELOW Sergeant Harrold, R.E. Queen of Gallas and son, Abyssinia, 1868

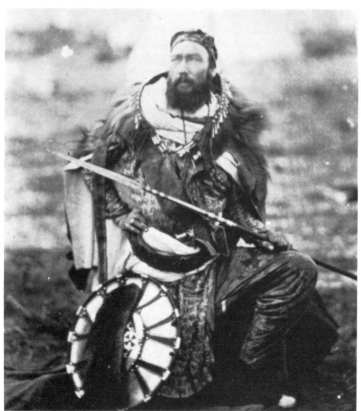

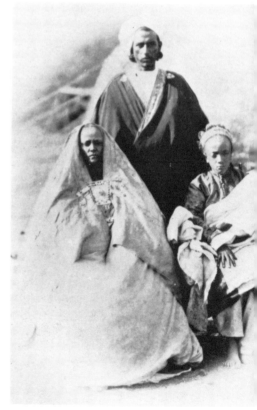

graphy was the action. And on this occasion when the sappers were asked to go and take a photograph of the dead king, they reached his fortress at Magdala only to find that Theodore had already been buried.

Britain's central imperial concern was, however, the consolidation in India of the Raj. Ten years after the Mutiny, the politician Sir Charles Dilke felt confident enough to hymn the mission of Greater Britain in 'a world that is growing more English every day'. And while the army officers' interest in photography led to the historic events being surprisingly well documented, some used their ample leisure to assemble collections which illustrate the domestic life of the Raj. Henry Wood, an officer in the Rifle Brigade, had served in the Crimea before coming to India where his interest in photography developed in the 1860s. Wood's informal pictures are rich in the detail of everyday life, seemingly mundane at the time, but absorbing today. His scenes from life among the officer class show that in that long golden afternoon of British rule, there was one corner of a foreign field that was, briefly, England.

But this privileged life was at times quite surreally distinct from that of the other India. Willoughby Wallace Hooper had done his officer training at Addiscombe in Surrey where two instructors in residence taught photography to cadets. He went on to serve

16 Colonel Henry Wood. *Interior of his bungalow at Rawalpindi, India, 1866*

17 W. W. Hooper. *Victims of Madras famine posed in studio style, 1877*

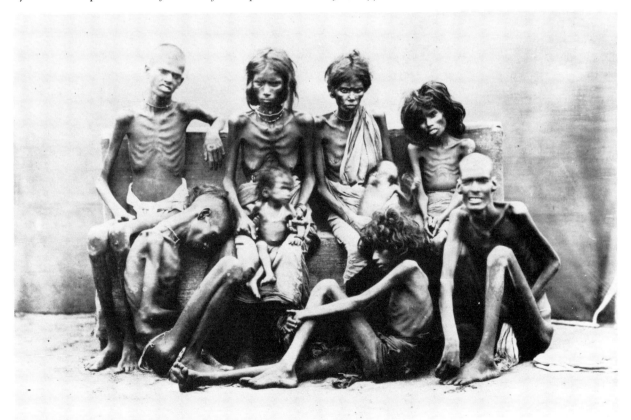

in the Madras Light Cavalry and was occasionally commissioned to take photographs. His most notable and macabre sequence is of the famine in Madras in 1877 when six million Indians died.

To the north of India was one country which the British found virtually untameable, Afghanistan. In the first Afghan War of 1839–42, the British were all but annihilated by the belligerent mountain tribes. In 1878 they returned in strength to neutralize Russian influence and forced the Afghan leader Yakub Khan to negotiate.

This Second Afghan War was covered by a commercial photographer from the Punjab, James Burke, who frequently worked with the army. During campaigns he was usually given rations, free transport, an honorary rank and, of course, a fee. In exchange Burke made six prints of each picture for the military records and when Yakub Khan rode into the British camp at Gundamuk in May 1879,

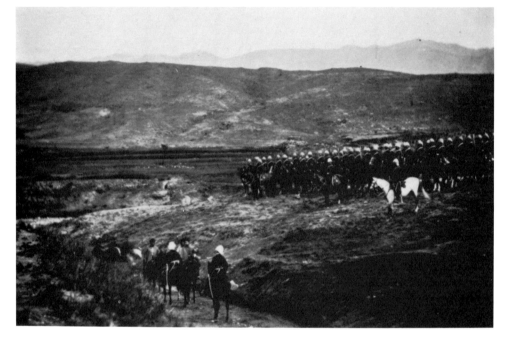

18 James Burke.
Afghan leader Yakub Khan rides into the British camp, 1879

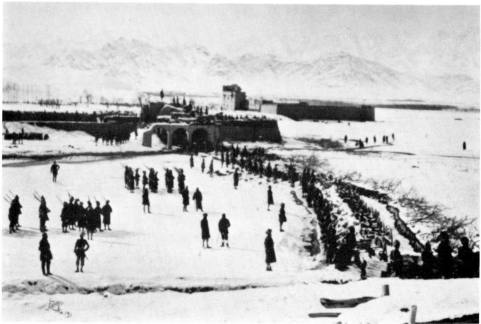

19 James Burke.
The winter siege of the Sherpur Cantonment, Kabul, 1879

Burke was on hand to record the signing of the treaty which conceded a British political presence in Kabul.

Four months later the 76 members of the Kabul mission were massacred. The British returned for revenge, and again Burke went with them. He photographed the preliminaries of the winter siege of 5,000 British troops at Sherpur by 100,000 tribesmen on whom the British inflicted 30,000 casualties for a cost of only twelve dead. The ragged war went on for six months before another settlement was patched together and the British eventually withdrew from Afghanistan with little gained.

In Africa the most punishing blow to British pride came from the Zulus. Bold, strong, and graceful, the Zulus had always been judged a particularly noble savage, an exemplary stereotype which photographers manipulated to fit the British preconceptions. But the Zulus were also fierce and fanatically regimented warriors, and at Isandhlwana in 1879 their Impis fell upon and slaughtered a column of 1,400 soldiers, killing more British officers in one day than Napoleon did at Waterloo. There are a few photographs of the ruins of Rorke's Drift where another Zulu attack was beaten off, and some of the battle

of Ulundi where the power of the Zulu nation was finally broken, but if this war was attended by an outstanding photographer the pictures have not come down to us.

In one of the last great colonial campaigns, an army of 15,000 men led by Kitchener advanced slowly into the Sudan. In 1898 they finally confronted and defeated the Dervishes at Atbara for the loss of only 21 British dead. At Omdurman the Dervishes returned fearlessly to the slaughter losing 11,000 dead and claiming only 48 British. A young cavalryman who charged at Omdurman, Winston S. Churchill, wrote to his mother Jennie two days later, 'I am sorry to say I shot five men for certain and two doubtful. . . . Nothing touched me. I destroyed those who molested me and so passed out without any disturbance of body or mind.'

But Churchill was to make his reputation in the next war, the last of the nineteenth century, and the first for a generation in which the British faced what was tactfully called a 'civilized' enemy. The Boers were the descendants of the Dutch farmers who first settled South Africa and for three years their guerilla army of 60,000 farmers pinned down a quarter of a million British soldiers.

20 Zulu women posed to the taste of unknown photographer, c1870s

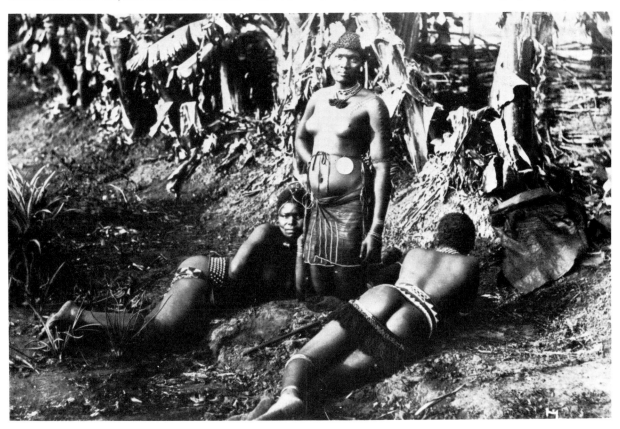

21 Chief Cetshawayo was captured after the Zulu War of 1879. He came to London to plead his case before Queen Victoria, then returned to Zululand where he was reinstated as King

22 When this portrait of Cetshawayo was taken in 1882 at Bassano's London studio, Bond Street was blocked by excited crowds

The Boer War in 1899 coincided with the rise of the mass circulation press with its huge appetite for news and events. Wars sold newspapers and Churchill went to South Africa, not as a soldier, but as correspondent for the *Morning Post* at £250 a month – the highest fee then ever paid to a press reporter.

It was also a period which saw a boom in picture magazines. Consequently vast num- bers of photographs were taken by both sides, and in them some of the styles of 20th century photo-journalism can be seen taking shape.

Horace Nicholls' photographs were pub- lished in magazines like the *Illustrated London News.* Nicholls covered the war as a freelance from Johannesburg and his sequence on the retreat of the Mounted Leicesters from Lady-

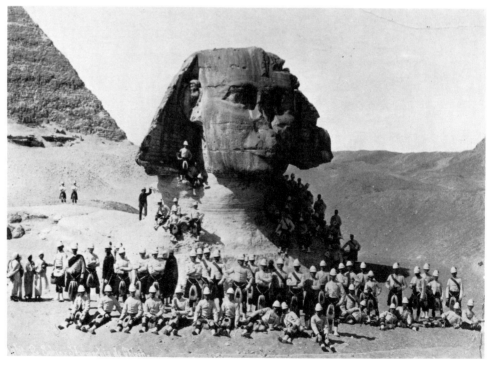

23 Scottish Highlanders surround the Sphinx at the beginning of the wars in Egypt and Sudan, 1881–98

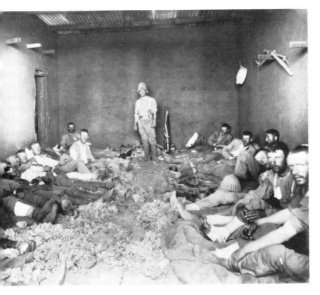

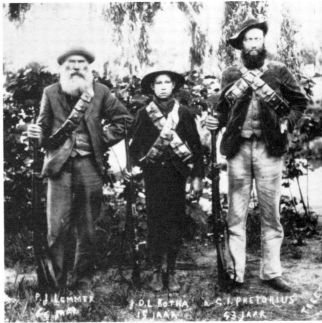

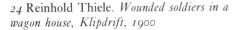
24 Reinhold Thiele. *Wounded soldiers in a wagon house, Klipdrift, 1900*

smith is among the most realistic and sombre of the war. Many of the war pictures were clearly posed, and others attempt to point a moral or relate an anecdote. Some are heavily retouched to cope with the crudities of the printing process. But press photographers like the German Reinhold Thiele, who worked for the *Graphic* in London, could also apply a hard eye which drained the glamour

from the conflict.

Another factor emerged. For the first time Britain faced an enemy which could use the camera as a weapon, and the Boers did circulate propaganda pictures to their many sympathizers abroad. The most powerful, if not the most persuasive scenes, showed the British dead heaped up after the defeat of which Churchill wrote, 'The scenes on Spion

25 *Three generations of guerrillas in the Boer War, 1900*

26 Horace Nicholls. *Retreat of the Mounted Leicesters from Ladysmith, 1899*

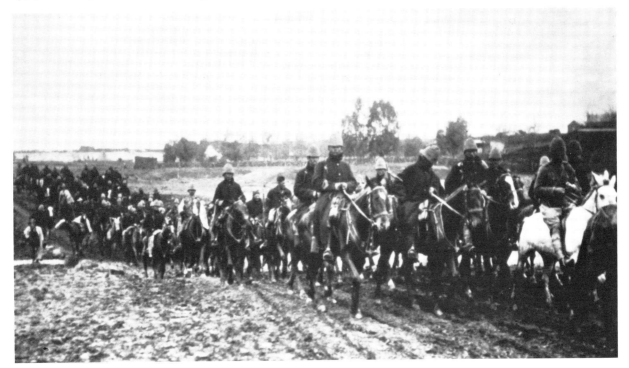

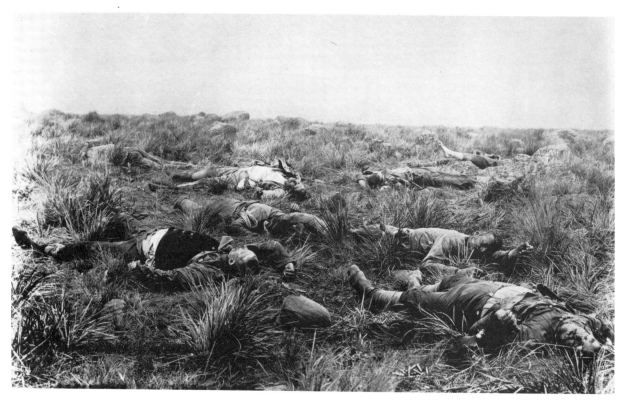

Kop are among the most terrible I have ever witnessed.'

The setbacks in South Africa were the military symptoms of the approaching decline. Other great states were now rising to challenge the global dominance of the small nation which, in the 19th century, produced the emigrants, entrepreneurs, statesmen and soldiers who conquered, then policed, the largest empire in history. As time passes it comes to seem an increasingly unlikely chapter in human affairs; fortunately, the camera stood witness to it.

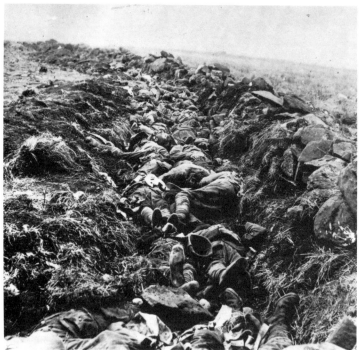

27 TOP Boer propaganda picture of British dead at Spion Kop, 1900

28 LEFT The British suffered 1200 casualties in two days at Spion Kop. Their dead lay three deep in the shallow trenches.

8 The Other Half

We are now making history and the sun picture
supplies the means of passing down a record of
what we are, and what we have achieved in this
nineteenth century of our Progress.

JOHN THOMSON

The Other Half

In that forced march of progress known as the nineteenth century, photography proved much less mutinous than other realist forms. While rebellious painters and writers confronted the ruthlessness of the age, the camera seldom went looking for trouble.

William Henry Fox Talbot experimented with the photographic process on his Lacock Abbey estate in the 1830s. In that decade there was more violence in the surrounding county of Wiltshire than anywhere else in England. For burning hayricks like the one in Talbot's famous calotype (page 14), 52 farm labourers were sentenced to death; one was eventually hanged and another 152 transported. Talbot's liberal sympathies may have saved Lacock Abbey itself from attack, but his photographs from the Hungry Forties give no clue to the plight of the rural poor.

Every photograph is in some sense a document. It can indicate the cultural influences or technical factors in the making of the image. A subject's dress or stance, location or expression, can imply social conditions or individual attitudes. Occasionally a photograph appears to offer irrefutable visual evidence, an authenticated trace of a past event which invites social investigators to practise their forensic skills.

Today the 'documentary' approach is strongest in didactic films. John Grierson, the philosopher-impresario who coined the word, defined documentary in this modern sense as 'the creative treatment of actuality'. His generation of documentarians applied their creativity to informing and educating the emerging masses in the rights and obligations of democratic citizenship. This aspiration survives, indeed now thrives, in the broad acres set aside in television schedules for public service broadcasting. Cross-bred with the more robust strains of popular journalism, the documentary camera can be campaigning, sometimes investigative, almost always socially concerned.

In 1839, when photography was at last coaxed out of its chrysalis, the world was already shaking under pressures which would, a decade later, explode in revolution. Given the concern of the nineteenth century reformers with the condition of the poor, the growing socialist belief in the evidence of history, and the belief of both in the potency of the proven fact, it is remarkable how infrequently the camera's accepted power of authenticity was used to expose the wretchedness which led to revolt against the existing order.

In mitigation it can be argued that in those early years the camera was still too slow and cumbersome to lunge into the brawl of human affairs. In fact, it settled quickly and comfortably into the studios which flourished in most towns, celebrating through formal portraits the individualism and/or domesticity of an increasingly self-confident bourgeoisie.

One of the first problems to be tackled in a systematic fashion with a camera was madness. The madhouses of old London had a fearful reputation, and deservedly so. Bethlem Hospital, in more brutal times, had been the inhuman zoo, 'Bedlam', depicted by Hogarth. But the Victorians were great reformers. In their attempts to introduce a humane regime and more scientific treatment they embraced the camera as an instrument of analysis.

The principal enthusiast for photographic diagnosis was Dr. Hugh Diamond, a founder of the Royal Photographic Society who set up a darkroom at the Surrey County Asylum and claimed in 1856, 'The photographer secures with unerring accuracy the external phenomena of each passion, as the really certain indication of internal derangement, and exhibits to the eye the well-known sympathy which exists between the diseased brain and the organs and features of the body.' But Diamond claimed too much. The use of photography in treating mental illness was very limited. Such portraits speak very imprecisely both of the people and their problems. Only the captions save the images from dissolving in an infinity of random associations. It is exactly this information on the record cards of the Chartham Down asylum in Kent which frames the subjects socially and reminds us of the obsessions of an age in which manias could be variously ascribed to 'revivalism', 'masturbation', and even 'love'.

In France in the 1850s, photography was used to promote a more positive approach to ill health. Having trampled over the Paris

1 and 2 ABOVE Dr. Hugh Diamond. *Mental patients,* c.*1852–56*

BELOW
3 Henry Hering. *Bethlem Hospital patient 'A.B. – Acute Mania'* c. *1854–56*

4 Henry Hering. *Bethlem Hospital patient 'S.B. – Acute Dementia'* c.*1854–56*

proletariat to seize power, the Emperor Napoleon III courted popularity by building a grand hospital at Vincennes where sick workers could recuperate in comfort at no cost. *Le Monde Illustré* of 27 August 1857, reported, 'The asylum at Vincennes with its restorative regime, its gardens and its immense galleries where fresh revivifying air may be breathed, will swiftly put on the road to recovery those whose powers have been diminished by ill-health.'

To further promote the Emperor's good works a photographer was commissioned to detail the virtues of Vincennes – libraries, laundries, central heating, steam-pumped water, kitchens, and 'an elegant refectory supported by slender iron columns'. The photographer was Charles Nègre; an ac-

5 and 6 ABOVE Henry Hering. *Bedlam patient 'E.J.' pictured suffering from 'Acute Melancholia', then convalescing, c.1854–56*

7 and 8 LEFT *Record cards from Chartham Asylum in Kent; photographer unknown*

108

complished painter and former pupil of
Ingres and Delaroche, he also used his
considerable talent to compose genre scenes
of common life, but mainly to serve as
studies for his salon paintings.

Most amateur photographers in Victorian
times belonged to the privileged middle class,
and most professionals were bound to their
studios. Only the very committed, or un-
usually inquisitive, attempted to report the
life of the poor. In 1851 Henry Mayhew
exposed the prevalent misery in his pioneering
investigation, *London Labour and the London
Poor*. The book was illustrated by Richard
Beard, the first professional photographer in
England, but his daguerreotypes – now lost –
had to be copied as woodcuts, which robbed
them of authenticity and the power to move.

But reformers, unable to make propaganda
through photographs, still used drawings.
In Cruikshank's moralising series 'The Bottle',
drink sends a respectable family staggering

9 Charles Nègre. *Linen Room, Vincennes
Imperial Asylum, 1859*

10 Charles Nègre. *Recreation Room,
Vincennes Imperial Asylum, 1859*

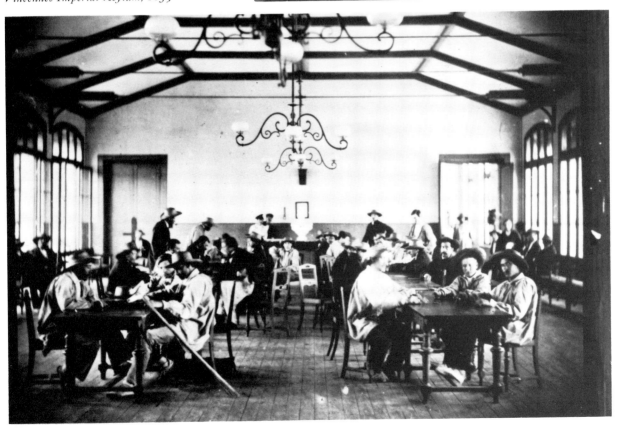

into bankruptcy, violence and madness. And moral squalor was as pervasive as drunkenness if the *Saturday Review*, reporting a murder trial in Aylesbury in 1857, is to be believed, 'Fornication and adultery, incest and murder, abortion and poisoning – all the tangled annals of the poor – this is Christian and happy England.'

John Thomson had previously photographed, at some personal risk, the alien lands of the Far East (page 39). Back in Britain in 1876 he set out on the trail, laid by Mayhew a quarter of a century before, into darkest London. The plan was to illustrate and sell a series of articles on slum life to be written by a journalist, Adolphe Smith. The text is concerned, and it quotes sympathetically the hardship of those who posed for Thomson's camera. The thirty-six photographs in *Street Life in London* are beautifully composed, relaxed, sometimes crowded and cheery, and rich in social detail. But one picture rips through the conventions and shows the latent power of the realist camera. It is called simply The 'Crawlers': the old woman minding a baby is one of a class of derelicts, the 'crawlers', of whom Smith writes, 'As a rule they are old women reduced by vice and poverty to that degree of wretchedness which destroys even the energy to beg.'

In those days an estimated 30,000 children also slept rough in the streets of London. Thomas John Barnardo was the first to enlist photography in a social crusade, but his zeal caused problems. Barnardo had dramatized the problem of the 'street arabs' by leading the great reformer Lord Shaftesbury and his guests from the dinner table to an alley in Billingsgate where a tarpaulin was pulled back to reveal 73 homeless boys. With his showman's flair for fund raising, Barnardo set up a photographic unit in 1874 and sold 'before' and 'after' pictures of urchins reclaimed in his Homes. This aroused the indignation of a rival evangelist who alleged, 'Barnardo's method is to take the

11 Illustration from Henry Mayhew's London Labour and the London Poor, *1851*

12 John Thomson. The 'Crawlers', 1877

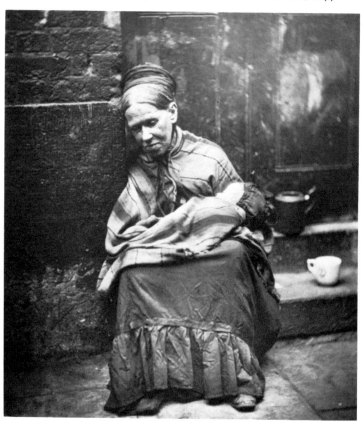

13 RIGHT *John Thomson. 'Hookey Alf' photographed outside a tavern in what the authors of* Street Life in London *called 'the wilds of Whitechapel'. The man on the right got his nickname when he lost an arm working as a coal heaver. A previous industrial injury had left him epileptic. He now sought work as a watchman or sold matches outside the railway station while his family lived in poverty, 1877*

110

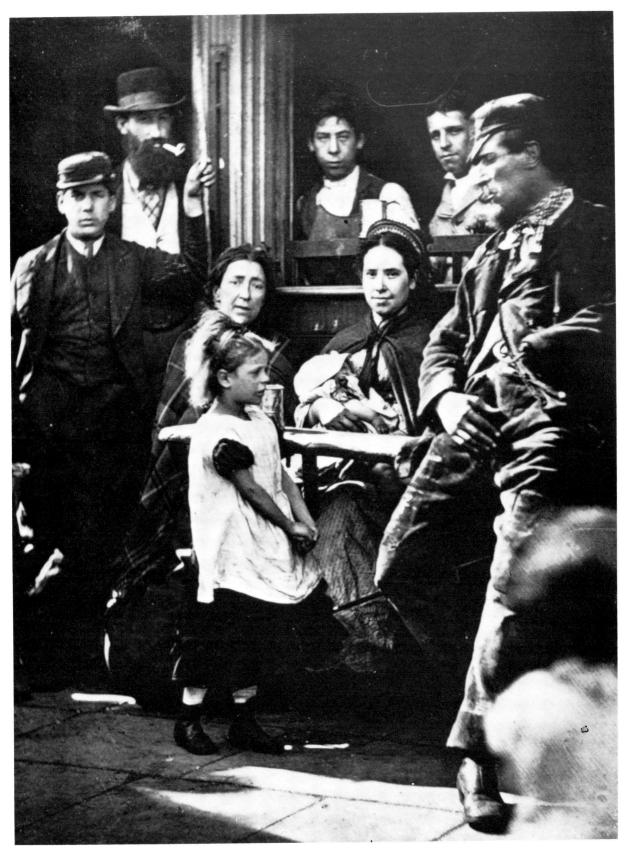

children as they are supposed to enter the Home, and then after they have been in the Home for some time. He is not satisfied with taking them as they really are, but he tears their clothes so as to make them appear worse than they really are. They are also taken in purely fictional positions.'

In a preview of a debate still alive today, Barnardo went to court and defended his methods as an honest representation of the past plight of children so dirty and verminous when taken off the street that they had to be cleaned up immediately. But the court judged him guilty of 'artistic fiction', public faith in his probity was shaken, and from then on Barnardo's studio stuck to stark mug shots for the records. More than 50,000 were taken,

14 LEFT Barnardo's Archives. *Katie Smith, a favourite model in studio pose as match girl. Critics complained that she had never sold matches and a court condemned these recreations as 'artistic fictions'*

15 and *16* BELOW Barnardo's Archives. *Transformation of a Lambeth street urchin. Before. 'Craving Admission and Employment'. After. 'His Desires Being Fully Gratified'*

and today this desolating catalogue of staring children has a power to move which the 'artistic fictions' cannot match.

Understandably, the Victorians buttressed the family to shelter its more vulnerable members from the turbulence outside. But while middle class children were cossetted by piety and familial sentiment, the children of the poor could be exploited both economically and sexually. The double standard of the age kept the pornographers busy. A correspondent in *Photographic News*, in 1863, complained, 'A man who takes a walk with his wife and daughters dare not venture to look at the windows of our photographic publishers.' A decade later when police raided Henry Hayler's establishment in Pimlico they seized, according to *The Times*, 'No less than 130,240 obscene photographs and 5000 stereoscopic slides'. Respected photographers like O. G. Rejlander and Lewis Carroll took implicitly erotic studies. Others were more explicit. The age of consent was then only 13 years but many children younger than that were prostitutes.

The trade in children was revealed by the journalist, W.T. Stead, who dramatized his exposé, 'The Maiden Tribute of Modern Babylon', by purchasing a child outright for £5. This outraged the legal establishment. Stead was charged on a technicality and given three months jail for his pains. Stead lashed back at the prevailing hypocrisy. 'Those who live in a fool's paradise of imaginary innocence and purity, selfishly oblivious to those horrible realities which torment those whose lives are passed in the London inferno.'

Tens of thousands of prostitutes paraded in the centre of the capital. A London barrister, Arthur Munby, walking through the Royal Park of St. James, noted in his diary for 22 July 1864 that there were 105 derelicts by one path on the short stretch between the lake and the Mall. A park keeper told him, 'They are men out of work and unfortunate girls, servant girls many of them, that's been out of place and took to the streets till they've sunk so low that they can't get a living even by prostitution.'

Arthur Munby was obsessed by lower class women. He travelled the country enquiring about their lives and working conditions. The women coalminers of Wigan held a particular attraction and Munby was dismayed when reformers stopped them working underground – an act he saw as blatant discrimination.

17 Barnardo's Archives. *Record portrait*

Munby also paid photographers to take pictures of the women in their work clothes, but this could cause misunderstandings. Crossing Westminster Bridge one afternoon he saw a group of 'dust wenches' and persuaded one into a studio nearby. 'She put on her jacket at my desire, and sat down, holding her dinner can in one hand, and thrusting her strong feet before her: and when I had posed her thus – which I did with my gloves on, seeing how dirty she was – the lens was uncovered.... " Now I think we may dismiss her," I said. She understood me and quickly exclaimed, "Ain't you going to give me nothing Sir?" and then having received a shilling she tramped downstairs in her rude manlike way.' The doorman immediately produced another woman, a female envelope maker who, he promised, would pose for Munby 'with her clothes up'. Then a young man approached saying 'Beg pardon Sir, but was you in want of any ballet girls or poses plastique'. A deeply affronted Munby made his excuses and left for a social evening with the painters Millais and Holman Hunt wondering innocently 'why on earth a dust-

HUNTINGDON COUNTY GAOL,

5th January 1872

PARTICULARS of Persons convicted of an offence specified in the First Schedule of Habitual Criminals' Act, 1869, and who will be liberated from this Gaol within seven days from date hereof, either on expiration of sentence, or on Licence from Secretary of State.

Name and Aliases *Julia Asgothorpe*

Photograph of Prisoner.

Description when liberated.

Age (on discharge) *11*

Height.......................... *4 ft 1*

Hair............................ *D. Brown*

Eyes............................ *Grey*

Complexion *Fresh*

Where born *Nottingham*

Married or single —

Trade or occupation —

Any other distinguishing mark......

Address at time of apprehension......... *Grantham*

Whether summarily disposed of or tried by a Jury. *Summarily*

Place and date of conviction *Huntingdon 27 Jany 1872*

Offence for which convicted *Stealing Bread*

114

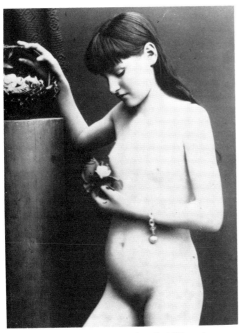

18 ABOVE *Commercial study of child nude, c.1870*

19 LEFT. *For stealing a loaf in Grantham in 1872, Julia, aged 11, was sentenced to 14 days in prison followed by five years in a reformatory*

20 *Arthur Munby with coalminer Ellen Grounds in Wigan, 1873*

21 *Hannah Culwick, Munby's wife, posed as his housekeeper.*

115

woman's portrait should have produced these offensive results'.

When Munby's private papers were finally unlocked in 1950 he was revealed as a man tortured by the eroticism of class, and forced by its taboos into a strange double life. He had, it emerged, married a servant girl, Hannah Culwick, in secret, then represented her to the world for the rest of his long life as his housekeeper. Also discovered with Munby's papers was his rare collection of portraits of nineteenth century women in their working clothes.

Although Britain was by the 1870s the most powerful nation on earth, the world's workshop producing twice as much steel as France, Germany and the United States combined, there are surprisingly few sustained attempts to show conditions in the mills, factories, and mines which powered the industrial revolution. One obvious technical explanation for this neglect is simply lack of light. Outdoor photographs do show men at work on roads, bridges, beaches and viaducts. But trade unionists never found a way to recruit the camera to their cause. Its potential was no doubt limited by the lack of cheap reproduction techniques and if the public

exhibition of prints remained a possibility it does not seem to have been explored. For Marx this was the age when 'man is at last compelled to look with open eyes upon his condition of life and true social relationships.' If so, it was an enlightenment which the camera, with its lazy eye, did little to hasten.

In the last years of the century, however, the construction of the last major railway in Britain was thoroughly documented. A young professional, Sidney Newton, was engaged to follow the tracks from Leicester to London. Travelling bands of navvies still lived rough and their reputation for wild living attracted the evangelists. But Christian socialism was always more appealing to the 'respectable' working men, a social layer quite distinct from the unskilled poor. Newton's photographs also show these men

22 BELOW Sidney Newton. *Blacksmiths at Mowmacre Hill, Leicester, c.1898*

23 RIGHT Sidney Newton. *Trimming the cutting sides on the Great Central Railway, c.1898*

24 RIGHT Sidney Newton. *Ticket examiner at Leicester Central Station, c.1898*

who, by their bearing, now shared with their social betters the ethos of diligence, thrift and self-improvement. Others have the aspect of those working class conservatives perceived as 'angels locked in marble' by the acute Disraeli. Newton's collection of a thousand glass negatives, while not taken for that purpose, can be used to evoke the subtleties of the complex but stable and durable class system which had evolved in Britain by the end of the nineteenth century.

While the camera continued its romance with nature, an agricultural slump in the 1870s forced 100,000 farm workers off the land. Hippolyte Taine from peasant France, observed that the British farm labourers were 'drawn, strained, sad and humble'. The farm women displayed 'haggard faces, blotchily red and a wasted, exhausted look'.

Picture views were big business and George Washington Wilson's business in Aberdeen was among the most successful. It may be that the volume of work left less time for technique to intrude, but some of Wilson's photographs have a matter-of-fact

approach which conveys a sense of the bleakness of life on the land, particularly in the raw north of Scotland. Earlier in the century tens of thousands of Highland crofters, like millions of starving Irish, had been forced off their lands. Many emigrated to North America, others crowded into the foetid slums of Victorian cities like Glasgow.

In 1839, the year the birth of photography was announced, an investigator reported back to Parliament, 'I did not believe until I had visited the wynds of Glasgow that so large an amount of filth, crime, misery and disease existed in one spot in any civilised country.' In the 1850s cholera killed 100 out of every 1,000 Glaswegians. Something had to be done and a plan was made to clear the worst of the cold, overcrowded tenements. But before demolition began the City Improvement Trust commissioned a photographer, Thomas Annan, to make a record of the old town. Annan was neither a campaigner nor an austere documentarian. A superb technician who specialized in architecture and fine art, he approached the job of photographing the squalor with an aesthete's eye. The dark vertical buildings command his pictures; people are tolerated in frame but rendered incidental.

When the campaigning camera did finally come of age it was in a country with more robust and democratic traditions than those prevailing in Europe – the United States. The waves of Irish, German and Scandinavian immigration in the middle of the century had been followed by an influx of east Europeans, Jews and Italians. By the 1880s, downtown New York was the most overcrowded slum in the world. In these slums the camera was not in the hands of a gentleman with a taste for the picturesque; the campaigner here had himself been a down-and-out immigrant. Jacob Riis arrived from Denmark in 1870 and tried to survive as a carpenter, labourer, lumberjack and railway hand. After three years he was destitute. Back in New York he made a meagre living peddling copies of Dickens' novels door to door. Finally Riis talked himself into a job as a newspaper reporter at 10 dollars a week. He completed his first assignment, and fainted from hunger.

By 1889, technical advances allowed photographs to be taken on dry plates with a 4 by 5 inch wooden box camera. The complete kit cost only 25 dollars. More important, a new flash powder had just come on the market. Riis saw the investigative potential of

25 BELOW George Washington Wilson. *Grinding corn in Skye*

26 RIGHT Thomas Annan. *Close at 118 High Street, Glasgow, 1868*

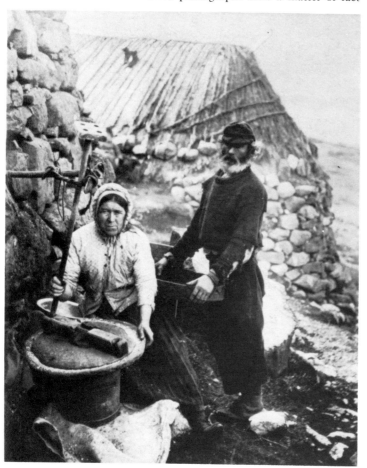

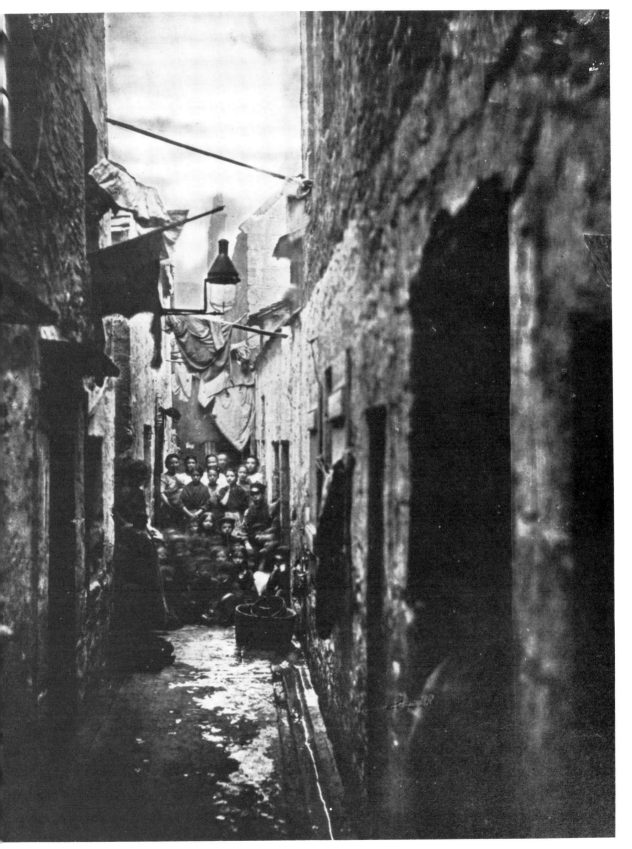

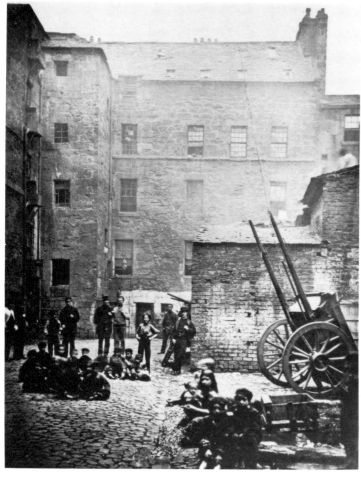

this combination. Having failed to find a cameraman audacious enough for the job, Riis taught himself how to take photographs and thus armed set off on his crusade, determined to expose the dark side of slum life. The flash afforded him visual proof of his allegations. Raw, artless photographs, as direct as his own passion, showed people sleeping fifteen to a room and whole families crowded into tenement sweatshops. Against

27 Thomas Annan. *Close at 46 Saltmarket, Glasgow, 1868*

28 Jacob Riis *Tenement baby, New York, c.1898*

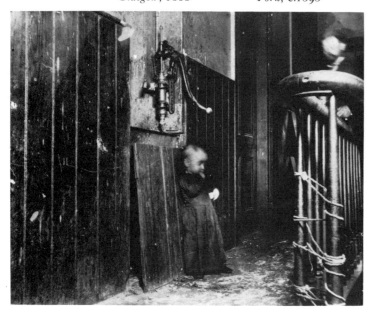

such evidence, Riis claimed, 'there was no appeal'.

His newspaper articles were illustrated with line drawings of his photographs but he also showed lantern slides to large audiences. Then, in 1890, Riis produced his first book, *How the Other Half Lives*, illustrated with seventeen of his pictures. It ran to several editions and won him a powerful ally, Theodore Roosevelt, the President of the New York police board who was to become President of thc United States. Together Roosevelt and Riis closed the notorious lodging rooms in 1896, then Riis won his fourteen year old campaign to clear the slums of Mulberry Bend.

In 1897 the Bend was replaced by a park but Riis' muckraking was resented. Although not formally invited to the opening ceremony, he went along just the same. The local

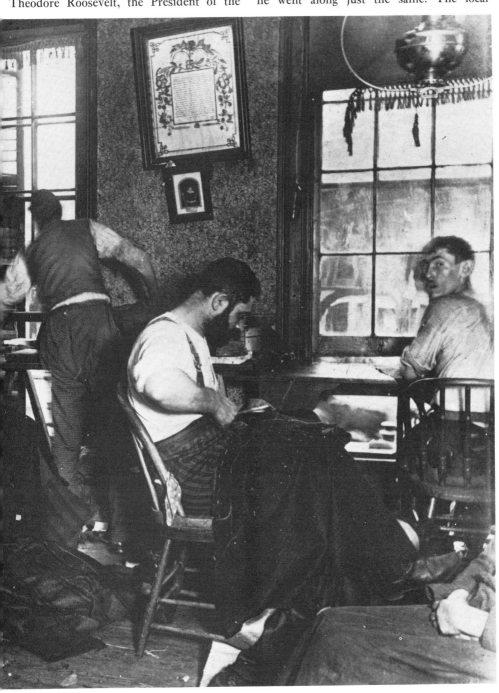

29 Jacob Riis.
*Sweatshop in Ludlow
St. New York*, c.1889

121

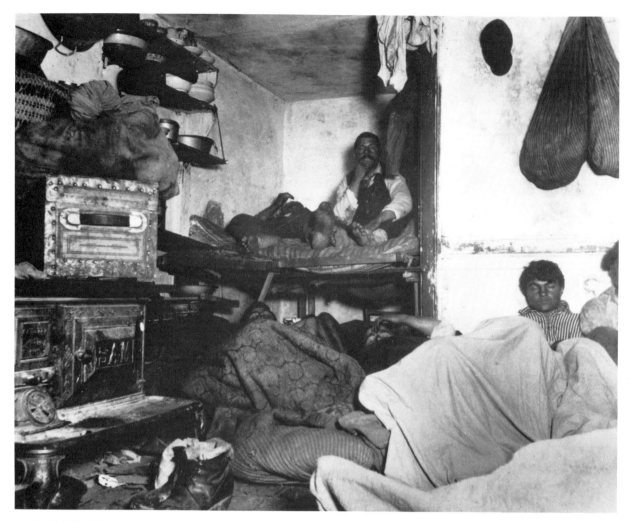

30 Jacob Riis. '*Five Cents a Spot*'; *lodgers in a New York tenement*, c.*1899*

crowd knew, however, where the credit lay and the occasion ended with three cheers for Jacob Riis.

The park at Mulberry Bend is still there today, now in the heart of New York's Chinatown: it remains one of the very few tangible achievements of the camera as an instrument of investigation, exposure, or social reform in the first sixty years of photography.

9 Outback and Beyond

'This Yellowstone – Big Horn country was then unpenned of wire, and unspoiled of railway, dam or ditch. Eastman had not yet made the Kodak, but thanks be, there was the old wet plate, the collodion bottle and bath. I made photographs. With crude home-made cameras from saddle and in log shack. I saved something.'

L.A. HUFFMAN

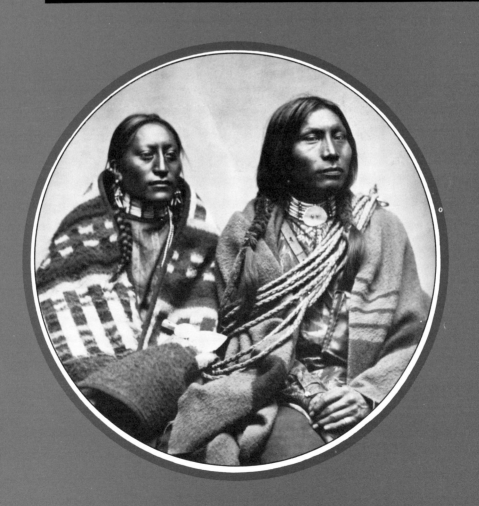

Outback and Beyond

When concern is expressed at the feckless manner in which the poor of the under-developed world persist in multiplying, it should be borne in mind that the poor of Europe had their population explosion the century before. These Europeans emigrated from the hardship of life on the land and the squalor of slum life in the industrial towns. English Chartists left to escape the ruling oligarchy and radicals from the continent crossed the Atlantic in force after the failure of their revolutions in 1848. Scottish Highlanders were cleared from the traditional clan lands to make way for sheep, and in Ireland potato blight finally broke the Celtic spirit and accomplished in two years what England had failed to do in centuries.

But brutal times bred ruthless people, as those who stood in the path of emigrant-invaders were to discover. In the nineteenth century thirty-five million Europeans crossed to America and millions more, overwhelmingly British and Irish, followed the imperial flag to the southern colonies of Africa, Australia, and New Zealand. The cry of the Europeans who fell upon the aboriginal peoples of a still sparsely populated planet was 'survival of the fittest'.

Only photographs now remain of the natives of Tasmania, the island between Australia and New Zealand. When the British first founded a penal colony on the island in 1803, there were four thousand aboriginal Tasmanians. But as settlers began to arrive after the Napoleonic Wars the aboriginies were subjected to systematic murder, rape, and enslavement. Eventually the survivors were confined for their own safety to an offshore island but when the Bishop of Tasmania, Francis Nixon, visited their settlement at Oyster Cove to photograph them on 24 March 1858 only fifteen aborigines were still alive. When the last surviving male died in 1869 the surgeon skinned him and stole the skull; that night intruders came and chopped the hands and feet off the body. Scientists were at that time very excited by arguments about the origin of the human species and what was left of the corpse was soon stolen from the grave. The last female Tasmanian died on 8 May 1876 and two years later her skull and skeleton went on display at Hobart Museum.

New Zealand was settled after 1840. The stubborn Maoris fought three guerrilla wars against the invaders from 1844 to 1872, but their numbers dwindled from quarter of a million to fifty thousand. Meanwhile the thousand white settlers of 1840 had multiplied to half a million within a generation. In the colonies, as the settlers followed the flag, the photographers followed the settlers. Curiosity about this remote country with its bold and dignified natives created a worldwide interest in pictures of tattooed Maoris, but New Zealand professionals like D.L. Munday and the Burton Brothers also produced valuable documentary photographs of frontier life as early as the 1860s.

One of the first, and certainly the most thorough, photographic attempts to show life in the settlements of the southern colonies was undertaken in Australia. The discovery of great veins of gold at the Star of Hope mine in New South Wales attracted prospectors who quickly staked out 1500 claims around the townships of Hill End and Gulgong. In 1872, a horse-drawn photographic wagon arrived carrying Henry Beaufoy Merlin and his assistant Charles Bayliss, who rejoiced in the title of the 'American and Australian Photographic Company'. The partners built a studio in Tambaroora Street at Hill End and for three months minutely documented the shops, houses, and local people, who were then persuaded to buy prints in the carte-de-visite size of $2\frac{1}{4}$ by $3\frac{1}{2}$ inches for about a shilling. Having covered the whole of Hill End, the photographers then moved to nearby Gulgong and repeated the exercise.

1 Francis Russell Nixon. *The Last Tasmanians, 1858*

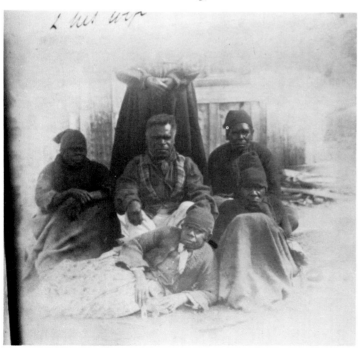

2 Burton Brothers.
*The Maoris Aporo
and Ngareta at
Wairoa*

3 Mohi – a Maori
*chief from Auckland,
New Zealand*

One attraction of such small prints was that immigrants could post them off to show the folks back home in Britain how they had prospered. Indeed the photographers were next hired by a German gold-miner who had dug up the largest chunk of gold ever found and therefore wished to tell the whole world about the glories of Australia. As he was drawn in his American buggy through the dusty streets of Gulgong by a pair of dapple greys driven by his oriental groom, Bernard Holtermann determined to mount a photographic exhibition which would project the image of New South Wales around the world. Merlin and Bayliss travelled the country making 10 by 12 inch plates which were put on display at the Philadelphia Centennial Exhibition 1876 and the Paris Expo of 1878. As a senator Holtermann later urged the Government to spend on photographs advertising Australia around the world to encourage immigration. They refused but today, ironically, the photographs taken by Merlin and Bayliss decorate the country's dollar currency.

Again, there was a darker side to the settlement of this vast continent. Fearing competition from 'the pig-tailed peril', the European settlers discriminated against the Chinese who, it was predicted, if allowed admittance in any numbers, would attack 'like a Mongol horde hurling itself on the rich gold-bearing districts . . . thence to spread like a dangerous yellow plague over the whole

surface of Australia'. First prohibited from gold-mining, the Chinese were eventually excluded by a 'White Australia' policy which ensured a European dominion. Once more, however, it was the aboriginal people who suffered worst. For millenia Australia had sustained a stable population of a quarter of a million hunters living in complete isolation from history. On this precariously balanced culture, the impact of the whites who came in 1788 was shattering. A century later a Frenchman, Edmond La Meslee, wrote of the aborigines, 'Men and women, barely covered in veritable rags and tatters of decomposing woollen blankets, wandered about the camp . . . never have I seen such a degrading spectacle, and I would never have believed that there were human beings capable of living in such a state of nastiness and misery.'

The Gold Rush of the 1850s doubled the white population in a single decade to one million. The overwhelming majority were of British stock and many were descendants of the 150,000 convicts transported across the world by the harsh laws of England. The aborigines, by contrast, were in steep decline and an English observer writing in a handbook for emigrants published in 1872, saw in this the relentless logic of social Darwinism. 'After one or two palpable evidences of the superior power of the white man, they are forced to recognise his supremacy . . . if once the black commences loafing about the more

125

4 Henry Beaufoy
Merlin. *Studio of
the 'American and
Australian
Photographic
Company' in Hill
End with his partner
Charles Bayliss in
the doorway, 1872*

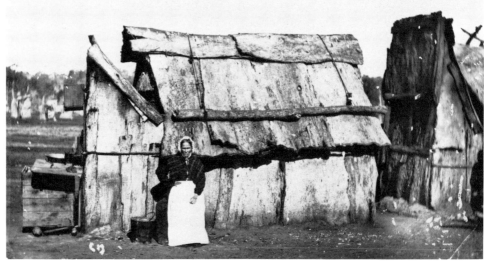

5 Merlin and
Bayliss. *Woman
outside her bark hut,
1872*

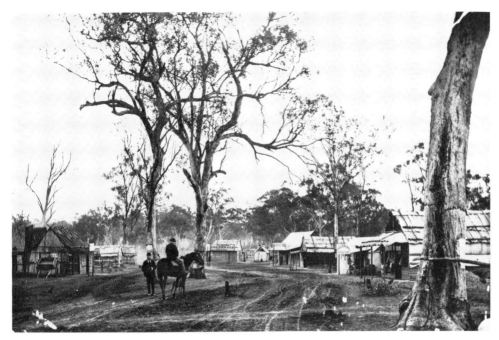

6 Charles Bayliss.
*Merlin on horse with
assistant holding
spare plate on way
to photograph claims,
1872*

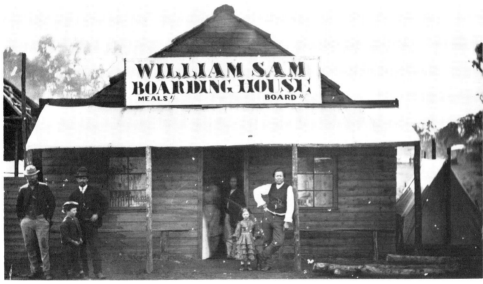

7 Merlin and
Bayliss. *Barred
from gold mining,
this Chinese kept a
boarding house, 1872*

civilized parts, he is sure to die off rapidly.' After decades of regeneration there are now 80,000 aborigines, still only a third of their original strength, in a population of fourteen million white Australians.

When the British began colonizing Southern Africa they clashed not just with the native peoples but also with the Boers, the descendants of Dutch settlers who had come in the seventeenth century. They were tough Calvinist farmers who felt uncomfortably cramped if, from the roof of their homestead, they could see smoke from a neighbour's chimney. To escape British control, 12,000

Boers and their slaves had pushed north from the Cape to establish what eventually became the Boer republics of Transvaal and Orange Free State. By the middle of the nineteenth century there were almost two million blacks in South Africa outnumbering both British and Boers by thirteen to one.

The Zulus were the most aggressive of the Bantu tribes and they clashed first with the Boers who trekked north, then with the British army (page 102). Photographs of Zulu life in many Victorian keepsake books attest to the widespread demand among the picture buying public for commercial photographs of

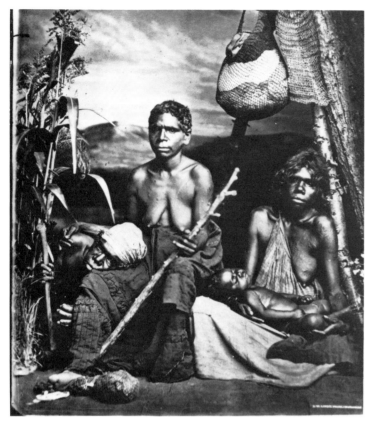

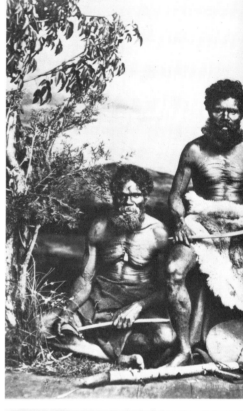

8 ABOVE J.W. Lindt. *Australian Aborigines posed in studio, 1888*

9 ABOVE RIGHT J.W. Lindt. *Aborigines in studio with boomerangs, 1888*

10 ABOVE Charles Wilson. *Zulu children – 'Curiosity', 1897*

11 RIGHT. Charles Wilson. *Zulu girl, 1897*

such 'lesser breeds outside the law'. And later, Britain's imperial wars against the Boers in 1880 and 1899 were also well documented (page 103). Cecil Rhodes made his fortune in the diamond mines of Kimberley and the archives of his De Beers company contain revealing sequences which show the blacks being sucked into the booming mining industry as a philosophy of white supremacy began to harden into a system of apartheid. The merchant-adventurer Rhodes used his vast fortune to annex and give his name to the next British conquest in Central Africa. The imperial fantasies of Rhodes remain unmatched: a will made out in 1877 asked that his fortune be used to establish 'a Secret Society, the true aim and object whereof shall be the extension of British rule throughout the world . . . and especially the occupation by British settlers of the entire Continent of Africa, the Holy Land, the Valley of the Euphrates . . . the seaboard of China and Japan, and the ultimate recovery of the United States of America as an integral part of the British Empire'.

The United States was at this time engaged in its own internal campaigns of conquest. During the Indian wars twenty-five thousand soldiers fought some two hundred battles against the native tribes west of the Mississippi. The Indians had been promised 'perpetual title' on these lands but the treaties were inevitably broken. In 1862, after a winter of near-starvation, the Sioux went on the war-path in Minnesota and massacred 450 settlers, sparing only those they judged to be friends. One white who escaped, Adrian J. Ebell, took a dramatic photograph of the huddled survivors. Another powerful atmospheric photograph taken the same year by B.J. Upton, a professional, shows the enclosure in which 2,000 Sioux were confined after the suppression of the rising. Sentence of death was passed on 307 warriors, but President Lincoln, preoccupied with the Civil War, commuted most sentences. Nevertheless, on 26 December 1862, 38 braves were hanged. A defender of the Indians, Bishop Whipple, argued in mitigation, 'I ask that the people shall lay the blame of this great crime where it belongs, and rise up with one voice to demand the reform of an atrocious Indian system, which has always generated for us the same fruit of anguish and blood.'

While the settlers and soldiers were destroying a way of life, it was simultaneously being preserved on glass plates by the pro-

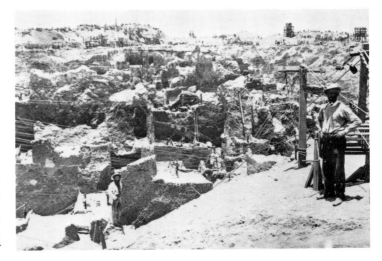

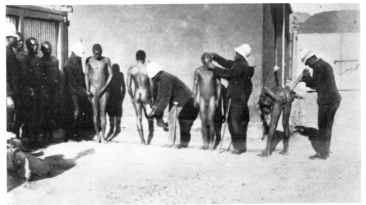

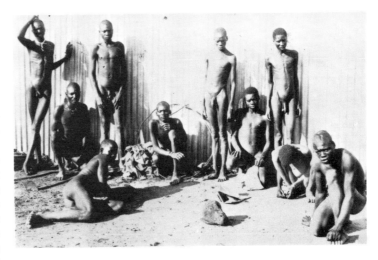

12 TOP De Beers Archives. *Open cast diamond mine with ropeways for hauling up the clay*
13 CENTRE *Searching black miners for hidden diamonds*
14 ABOVE *job applicants awaiting medical inspection*

129

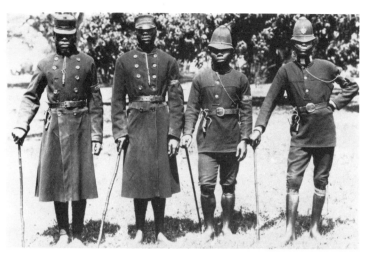

tains and deserts of the West travelled with companies of soldiers to protect them from the more dangerous nomadic tribes; but they brought with them photographers of the calibre of Timothy O'Sullivan, John K. Hiller and William Henry Jackson who, in the troubled decade of the 1870s, made a visual record of the vanishing Americans and their complex and elusive culture. The official report of the Geographical Survey of the Territories for 1875 says of Jackson's work, 'From the two thousand or more negatives made during these six preceding years, we must ascertain what return they have made for the time and money expended on their production. . . . They have done very much, in the first place, to secure truthfulness in the representation of mountain and other scenery . . . in ethnography, it gives us portraits of the varied families of our great Indian population, representing with unquestioned accuracy the peculiar types of each; their manners of living, dressing,

15 Charles Wilson.
Zulu policeman, 1897
16 Adrian J. Ebell.
Survivors of the
Sioux uprising in
Minnesota, 1862

fessional photographers. In the South-West the pueblo Indians, settled in their villages with an ancient and deeply religious culture, were comparatively passive and in consequence much photographed. Government survey expeditions which mapped the moun-

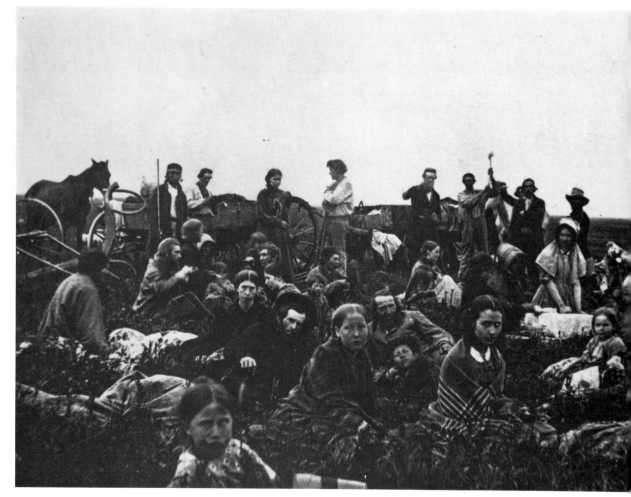

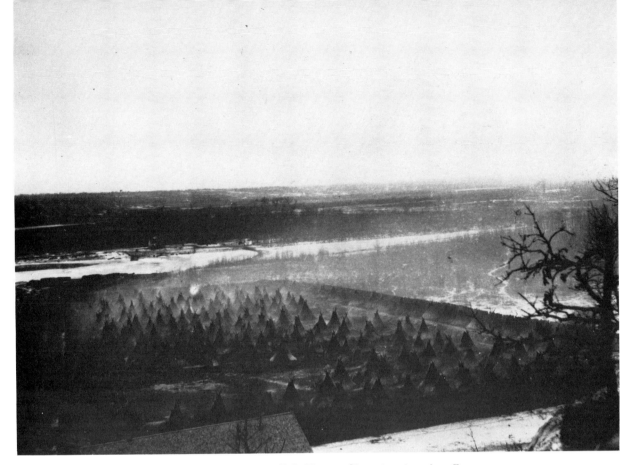

occupations and mythical inscriptions.' W.H. Jackson died in 1942 at the age of 99 and tens of thousands of negatives survive from his long and industrious career, a now priceless record of direct, objective images of the old West.

This kind of frontier photography could be dangerous. A young photographer from Philadelphia, Ridgeway Glover, set out for Montana 'to illustrate the life and character of the wild men of the prairies' but on 14 September 1866 a war party of Arapaho caught him and cut off his head: no trace of his negatives can be found. Will Soule operating near Fort Dodge in Kansas in 1868 photographed a dead hunter, Ralph Morrison, who had been scalped by Cheyenne only an hour before. Soule had himself been badly wounded at Antietam and came west to improve his health. He brought with him a graphic kit and, working mainly from Fort Sill in Texas between 1870 and 1874, managed to photograph the fierce tribes of the Southern Plains among them Comanche, Kiowa, Arapaho, and Apache without mishap. His cache of negatives was rediscovered only recently after being lost for almost a century.

While the army fought to subdue the

17 B.J. Upton. *Sioux imprisoned at Fort Snelling, 1862*
18 W.H. Jackson. *Apache Chief James Garfield*

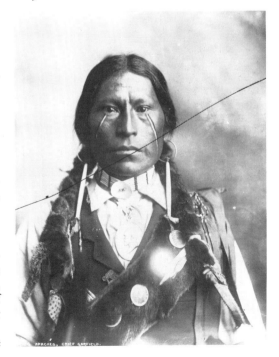

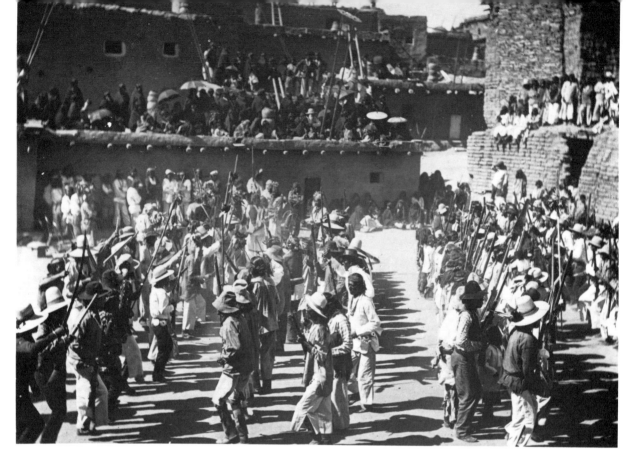

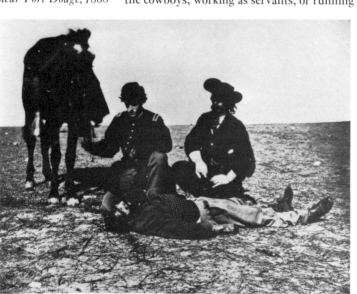

19 W.H. Jackson.
*Ritual dance of the
Zuni Indians at their
pueblo in New
Mexico*
20 Will Soule.
*Scalping of a hunter
near Fort Dodge, 1868*

Indians, the West was being firmly secured for the settlers by the railroads. However, these tracks across prairies, deserts, and mountains were bought with the lives of another race, the Chinese. The first emigrants to escape the turmoil of China made a meagre living on the West Coast cooking for the cowboys, working as servants, or running laundries in the frontier towns. But as the railways drove across the continent in the 1860s, tens of thousands of Chinese were imported as cheap coolie labour. The railhead advanced at such a killing pace, sometimes ten miles a day on open prairie, that many of the coolies just died by the track. Railway building reached a frenzy in the years after the Civil War and the Central Pacific Railroad crossed two summits of the Sierra Nevada, dug fifteen tunnels, and laid 121 miles of track across the high mountains of California, using 12,000 Chinese in what was surely one of the major engineering feats of the nineteenth century.

Many outstanding photographers worked for the railway companies: Alexander Gardner, W.H. Jackson, A.A. Hart, and A.J. Russell who photographed the historic meeting of the tracks at Promontory Point, Utah, on 10 May 1869. His picture shows the jubilation as the golden spike was driven in to commemorate the linking of East and West, but there are no Chinese in attendance. Indeed, as in Australia, European fear of competition from these hard-working Orientals led to outrages, racist attacks by the labour movement, and the eventual curbing

of Chinese immigration into California.

If the Chinese worked too hard for comfort, the Indians were in turn despised for their indolence and failure to comprehend the work ethic and other Protestant virtues. General George Armstrong Custer was openly fatalistic about the future of the red man. 'When the soil which he has claimed and hunted over for so long a time is demanded . . . there is no appeal; he must yield or it [civilization] will roll mercilessly over him, destroying as it advances. Destiny seems to have so willed it, and the world nods its approval.' Civilization chose to deal mercilessly with the Plains Indians by destroying the buffalo on which their nomadic way of life was based. Once, the Great Herd moved north across a front a hundred miles wide but white hunters slaughtered three million buffalo in two years. One reason lies in the words of General Sheridan, spoken in 1875. 'They are destroying the Indians' Commissary . . . for the sake of a lasting peace, let them kill, skin, and sell until they have exterminated the buffalo. Then your prairies will be covered with speckled cattle and the festive cowboy, who follows the hunter as a second forerunner of civilization.'

But it was the prospector who brought the next bitter taste of civilization to the Sioux. Gold was discovered in the Black Hills of Dakota – on sacred tribal land – and the army

under General Sheridan failed to prevent the subsequent invasion of gold miners. The Sioux, betrayed and outraged, confronted and destroyed nearly 300 soldiers of the 7th Cavalry under the command of Custer at the Battle of Little Big Horn in 1876. Crazy Horse, the brilliant strategist who led the attack was subsequently captured and murdered in captivity, and the Sioux under Sitting Bull fled north to Canada. During these troubles a young photographer, Laton A. Huffman, quit the last outpost of civilization in Dakota and made for Fort Keogh where he set up studio in a log cabin with a

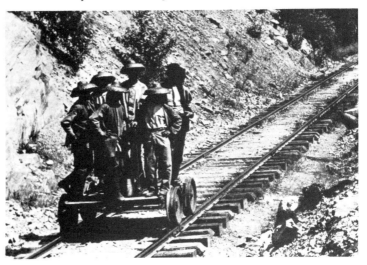

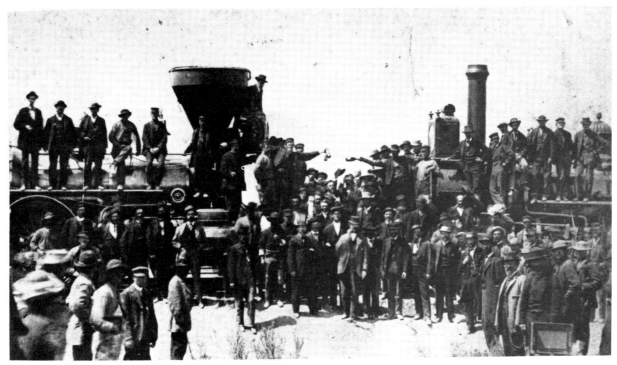

dirt covered roof.

For Huffman, as for so many other professionals who laid down a rich store of memorable and marketable images in the time of the Indians' tragedy, the 1870s became the 'golden decade'. 'Kind fate had it I should be Post Photographer with the Army during the Indian campaigns close following the annihilation of Custer's command.' Huffman had hoped to compile a guide to the sign language of the Plains Indians in his studio but had to abandon the idea. 'The Indians don't take kindly to it and we couldn't make it go.' He survived by selling portraits and supplemented this by guiding parties to hunt and kill buffalo, which he also photographed. After two years Huffman returned from the wilderness to the comparative comforts of Miles City, which was linked to the railway in 1881, and set up a portrait studio.

In 1881 Sitting Bull and his Sioux finally surrendered but the squalid postscript to the Indian Wars came in 1890. A belief took hold that an Indian Messiah would appear and deliver them from the white man and a frenzy of ghost dancing seized the dislocated tribes, greatly alarming the settlers. Sitting Bull was killed in a scuffle with soldiers and as the Sioux tried to flee they were caught and herded to a place called Wounded Knee where, with little pretext, the army opened fire and massacred 300 men, women and children. The Indian Wars were over. Even Geronimo of the Apches had surrendered to

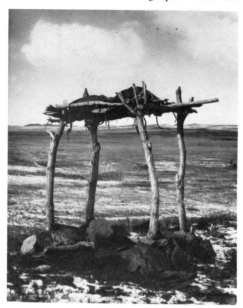

23 L.A. Huffman. *Prairie grave of a Sioux warrior, 1879*

24 L.A. Huffman. *'Five Minutes Work': Slaughter of the buffalo in Montana*

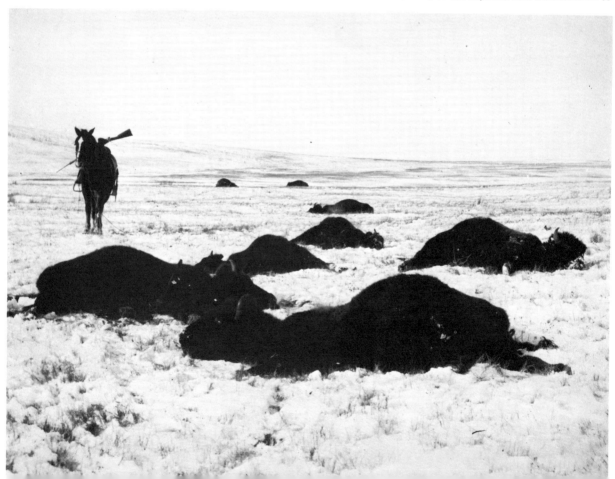

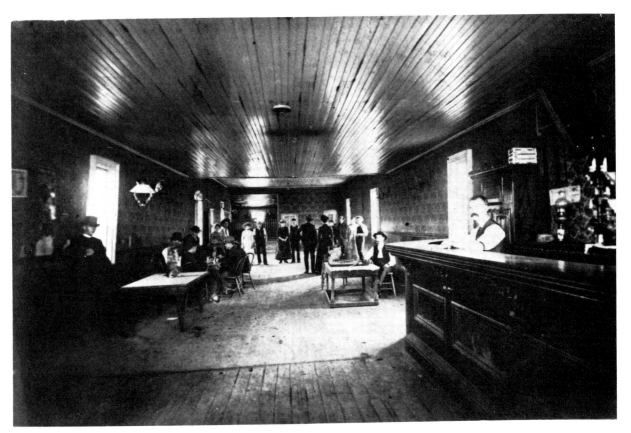

the inevitable, lingering on to die at Fort Sill in Texas, still a prisoner of war, in 1909.

The West had been tamed by the railways, the settlers, and the ranchers. The free-ranging cowboy had lasted barely a generation and by the end of the century the hell-raisers of legend were becoming hired hands of a competitive cattle industry. Meanwhile the population of the United States had risen from seven million at the beginning of the century to seventy million at its close. And the settlers who pushed West in search of free land got what came to be called 'The Last Chance' in Oklahoma. The territory known as the Cherokee Outlet, taken as ever from the Indians, was to be laid open to those prepared to race across it and stake a claim. Special trains and thousands of covered wagons brought the land-hungry in from all over America. Aware that the occasion was not just historic but also highly visual, a photographer called William S. Prettyman with five assistants built a special camera platform overlooking the starting line. Then, at noon on 16 September 1893, a single rifle shot rang out and the last great scramble of the white settlers for someone else's land was underway.

25 Bat Masterton's brother behind the bar at 'The Varieties' dance hall in Dodge City, 1878

26 The lynching of J.H. Burton, John Gay, and William Gay in Russel County, 1894

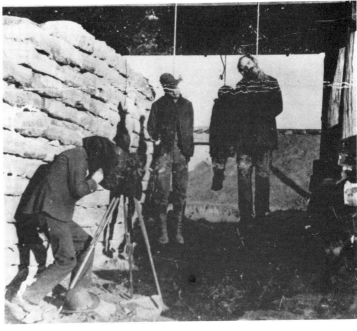

To the white mind, the act of conquering the American West proved such a potent experience that it was soon to take on the configurations of myth, even for those who had lived through it. The photographer, L.A. Huffman, who took portraits of many of the cowboys (a third of whom, incidentally, were Mexican or black) in his studio at Miles City, went on to become a Montana politician and looked back nostalgically to the days when life still had an unexplored frontier. 'Then came the cattle men, the trail boss with his army of cowboys, and the great cattle round ups. Then the army of railroad builders. That – the railway – was the fatal coming. One looked about and said, "This is the last West." It was not so. There was no more West after that. It was a dream and a forgetting, a chapter forever closed.'

The global ascendancy of the Europeans may now be in slow decline but there will remain in their archives the photographic record of cultures ruined and people made extinct, a visual detritus collected with an amoral objectivity by the camera which followed, usually at a safe distance, the conquests of soldiers and settlers. This record will serve to show that it was not a dream, although there is indeed much that deserves to be forgotten.

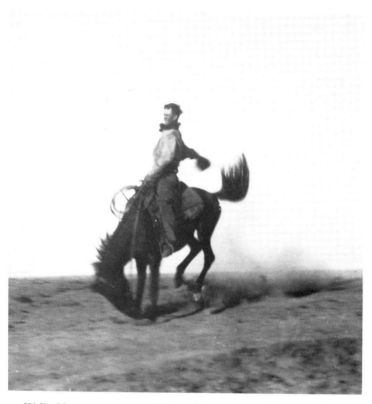

27 W.D. Harper.
Bronco Busting, 1904

28 William S. Prettyman. *Opening of the Cherokee Outlet, Oklahoma, 1893*

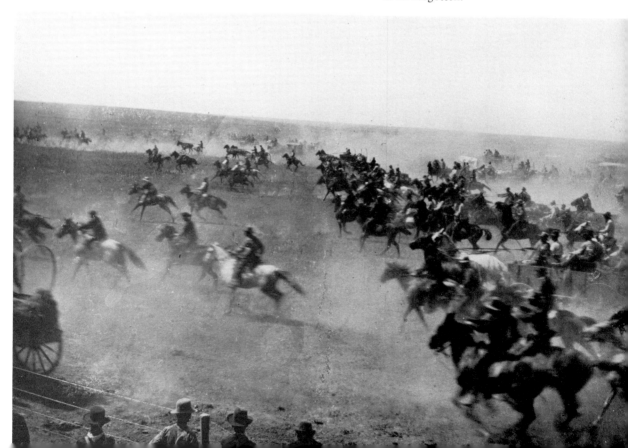

10 News Flashes

'A steam boiler cannot explode, or an ambitious river overflow its banks – a gardener cannot elope with an heiress, or a reverend bishop commit an indiscretion, but straight way, an officious daguerreotype will proclaim the whole affair to the world.'

National Gazette of Philadelphia

News Flashes

Marc Antoine Gaudin, a French daguerreotypist, devised a strategy in 1843 which helped slow cameras cope with subjects prone to unpredictable movement: 'Look in the box,' he ordered the first of many baffled children, 'and watch the dicky bird.' Gaudin, as it happens, was also one of the first photographers to try for still pictures of subjects in motion. He showed in 1841 that a whiff of bromine vapour made his small daguerreotype plates sensitive enough to register distant scenes of moving traffic. During those first few years of photography there was certainly an impressive acceleration as improved lenses and faster chemicals brought exposure times down from many minutes to a matter of seconds under ideal conditions. In the autumn of 1840 Fox Talbot himself reduced some exposure times through the new calotype process to about a minute or less. Nonetheless, in normal conditions it still took a few minutes to soak up the light required for a standard-sized picture by either of the original processes.

The eclipse of both daguerreotype and calotype came in the 1850s with the introduction of a process in which a solution of collodion was spread over a glass plate, sensitized in a bath of silver nitrate, placed in a camera and exposed, developed in a darkroom on the spot, and subsequently fixed with yet another chemical. But dauntingly cumbersome though it was, this wet collodion technique also gave much faster pictures and a small positive portrait, for instance, could now be made in two seconds. More importantly for the ultimate conquest of action, collodion made possible the perfection of the stereoscopic picture.

The stereoscopic principle (page 50) had been known before photography but it was then impossible to produce the two finely differentiated images required to recreate a scene in depth. That problem was overcome however by photography and in particular by the introduction of the collodion glass plate. The stereoscopic camera also had its own particular qualities which helped reduce exposure times. The camera's twin lenses had a short focal length, the effect of which was to minimize the movement of distant objects. And by focusing light intensively, small negatives could be made, in bright conditions, in a very short time. The stereoscope, in which the twin-image was viewed, then magnified the picture and brought out the detail. Through these advantages the stereo-camera in the 1850s managed to achieve a limited mastery of movement.

More traditional photographers had meanwhile evolved a variety of innocent ploys which gave the illusion of things caught in the act. John Dillwyn Llewelyn, for instance, enhanced his landscape studies with a variety of birds and beasts – all stuffed. Posing humans was of course easier, and it remained a recourse of the more creative, or less scrupulous, for the rest of the century and beyond.

1 BELOW The formidable array of kit required to prepare, expose, and develop a collodion wet plate glass negative

2 RIGHT John Dillwyn Llewelyn with his collodion equipment in the field, 1853

3 John Dillwyn Llewelyn. *One of his 'motion' pictures showing the smoke from the funnel of the steamer* Juno *docked at Tenby, 1854*

4 Gustave Le Gray. *French warships in Toulon harbour seen firing a salute for their admiral Bruat who had died of cholera en route from the Crimea in his flagship* Montebello, *the three-decker in the middle distance, 2 December 1855*

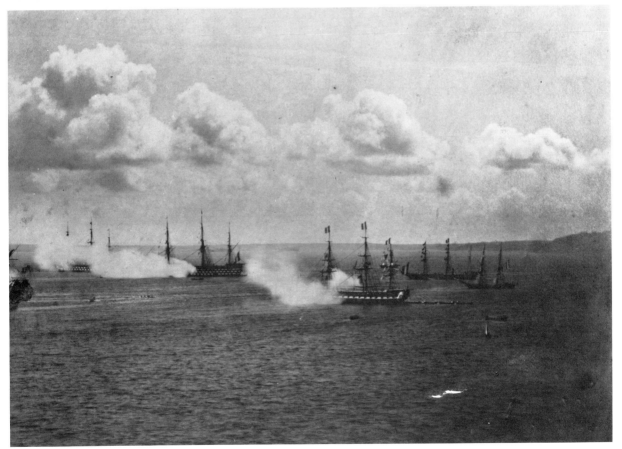

5 Gustave le Gray. *'Brig upon the Water'*, *one of the first photographs to combine clouds and sea in the same scene, 1856*

6 George Washington Wilson. *HMS* Cambridge *firing a broadside specially commissioned for the stereo-camera, 1857*

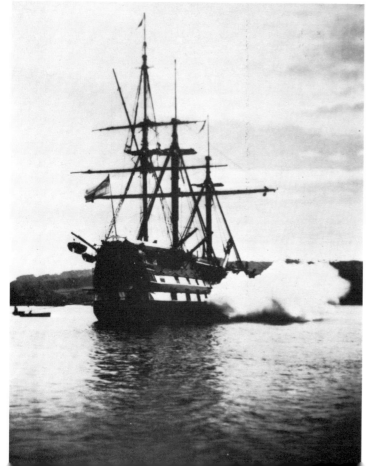

John Dillwyn Llewelyn was married to a cousin of Fox Talbot which helps explain an interest in photography dating back to 1839. Under the title 'Motion' he exhibited four photographs in London's Bond Street in 1854 and won a silver medal the following year at the Exposition Universelle in Paris. A press photographer noted that his photograph of the steamboat *Juno* at Tenby 'has fixed instantaneously the floating smoke and steam'. His daughter later recalled the excitement that prevailed when a 'post-haste' message reached their Welsh home 'asking for fresh copies of the two of his four instantaneous pictures to replace those which Queen Victoria had admired so much she insisted on carrying them off!' The Queen's interest is explained by the fact that these are the first photographs which actually showed waves breaking.

One effect for which professionals strove, the motion of waves and the presence of clouds, was first achieved by a French painter-turned-photographer, Gustave Le Gray. Normally, the contrast with a darker landscape caused the sky to burn out and left the print 'bald-headed'. Using the bright reflection from the water, Le Gray succeeded

in balancing sea and sky and his 'Brig upon the Water' when exhibited in London was acclaimed 'the grandest effort ever seen in photography'. The previous year when the body of a French admiral was borne into Toulon harbour, Le Gray had photographed the ship's guns firing a salute.

In 1857 a Scots photographer, George Washington Wilson, set up a very similar picture which was to dramatize and publicize the stereo-camera's potential for instantaniety. Wilson, photographer to the Queen in Scotland, persuaded the Admiralty to fire broadsides for his benefit and the stereocard which so excited the public showed smoke billowing from a battleship's guns. In 1859, Wilson photographed the traffic in Edinburgh and the same year Edward Anthony in New York captured the bustle of Broadway in the rain. The technique behind these street

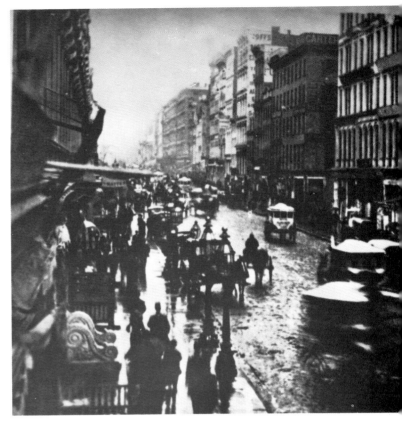

7 Edward Anthony. *Stereo camera stops the traffic on a rainy day on Broadway, New York, 1859*

8 Paul Martin. *On the spot with his hand-held camera for this amateur's 'news' picture of an overturned carriage in High Holborn, London, 1894*

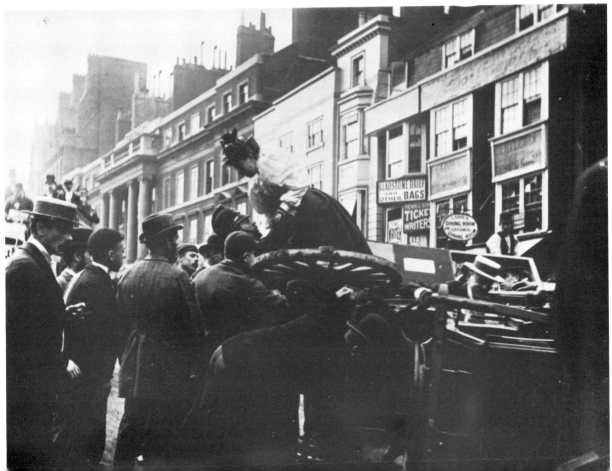

scenes involved shooting along the lines of traffic with a stereo-camera set above street level to minimize the effect of movement. By 1862, Valentine Blanchard almost brought the camera down to street level when he rode through London's traffic in his cab-cum-darkroom taking pictures from the roof.

The next general advance in photography

9 Paul Martin. *Candid camerawork on the beach at Yarmouth, 1892*

10 *Advertisement for the camera favoured by Paul Martin, 1891*

came when the thirty-year dominance of collodion was ended by the introduction of dry plates which were in mass production by the end of the 1870s. Cameras now became much smaller and were also fitted with fast mechanical shutters. The 'candid' camera was at last to hand. In the 1880s there was an inconsequential fashion for 'detective' cameras, devices which generally combined poor performances with improbable disguise. Nevertheless the idea of snapping people unawares had an enduring appeal.

The finest early exponent of candid camera work was a young London artisan, Paul Martin. His best work in the 1890s shows ordinary Londoners, directly and intimately, at work and at play. With the reduction in complexity and cost, working class enthusiasts like Martin had at last been able to take up photography. He moved easily and unobtrusively among his own class with his Fallow-field 'Facile' Hand Camera (which looked like a parcel) carried under his arm and primed for action. Despite the vivid documentary quality of Martin's work, he was not motivated by sociological concern but simply by a need for originality which he hoped might bring him – as it did – acceptance in the photographic salons.

While very much the product of the technical revolution he so shrewdly exploited, Paul Martin was also in his working life a victim of these same advances. He had been apprenticed as a wood engraver just at the time when the first publication of a half-tone photographic block in a newspaper in 1880 signalled the decline of that craft. Martin later recalled, 'Few wood-engravers realized what photography was going to bring in its train. I knew that monster when he was only a sprat, for I took up photography as an amateur in 1884. . . . When the monster made a lunge at me I dodged him and clung to his tail and am still hanging on.'

Martin's technical virtuosity also allowed him to make some of the earliest pictures taken at night. These scenes of London's West End in 1895 won him the medals he coveted and had such an influence on fellow amateurs that a Society of Night Photographers was founded; photography was at last overcoming its traditional fear of the dark.

Electricity had been an ally of photography's earlier attempts to escape the tyranny of available light. In 1851, Fox Talbot strapped a copy of *The Times* to a rapidly spinning wheel, dimmed the lights at Lon-

don's Royal Institution, and seared a readable image on to an albumen plate with a brilliant spark from an electrical battery. By the end of the 1850s, Nadar in Paris was making harshly lit portraits with electric arc light. Then in 1861, Nadar, with his customary flair, chose a bizarre venue to dramatize the power of electric light – the catacombs under Paris. Here, surrounded by skulls and bones by the million, Nadar made exposures which took 18 minutes and were enlivened by clothed dummies. He next moved his experiments to the sewers where he encountered an unexpected problem. 'At the moment when all precautions had been taken, all impediments removed or dealt with, the decisive moves being about to take place – all of a sudden, in the last seconds of the exposure, a mist arising from the waters would fog the plate – and what oaths were issued against the *belle dame* or *bon monsieur* above us, who without suspecting our presence, picked just that moment to renew their bath water.'

It took three months to make a set of one hundred underground photographs but Nadar's scenes caused a sensation when they were exhibited in London in 1862. In London's fashionable Regent Street, where the roofs were already dotted with photographer's glasshouses, Henry van der Weyde set up the first electrically lit studio in 1872 – in a basement. Using a gas-driven dynamo and a four-foot reflector which brought exposures down to a few seconds, van der Weyde advertised an all-hours service which was popularized by the Prince of Wales who dropped in one night for a portrait on his way home from the opera.

But electricity was of course cable-bound so the camera's future freedom to penetrate dark places lay with the flashlight. Pyrotechnic compounds were in use by the 1850s and flashlit portraits were made in studios using a 'photogen' mixture which burned in a glass lantern for some fifteen seconds.

A firm in Lancashire also began manufacturing magnesium ribbon and in 1864 a Manchester photographer, Alfred Brothers,

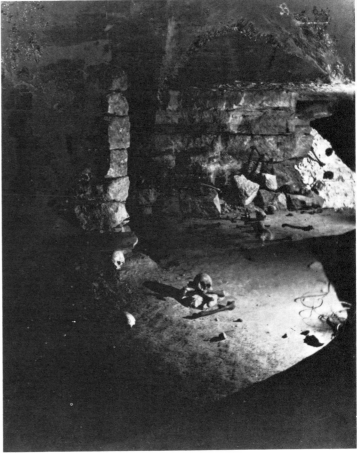

11 TOP Paul Martin. *Eros at Piccadilly Circus. One of the earliest night photographs, taken on an exposure of 15 minutes, 1896*

12 RIGHT Nadar. *Skulls and bones in the catacombs of Paris, illuminated by electric arclight, 1861*

143

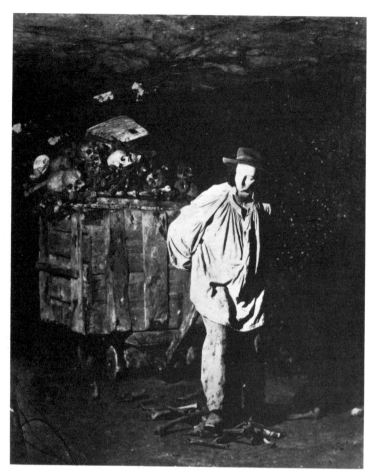

took the first magnesium-lit portrait. He then went on to demonstrate this new light source underground at the Blue John fluospar mine in Derbyshire. The following year the Astronomer Royal of Scotland, Professor Piazzi Smith, used burning magnesium wire to photograph the inner chamber of the Great Pyramid which he hoped might yield the secret of the universe. Unfortunately the magnesium generated so much smoke in the unventilated chamber that only one exposure a day was possible.

The term 'flashlight' came into common use along with magnesium powder in the mid-eighties. When combined with the fast dry plates and mechanical shutters, all the elements necessary for the practise of photo-journalism were to hand and in 1888 the newspaper reporter, Jacob Riis, brought them together in action. On 12 February 1888, the New York *Sun* headlined his first exercise in photo-journalism:

> 'Flashes from the Slums
> Pictures taken in dark places by the Lighting Process
> Some of the Results of a Journey Through the City
> with an Instantaneous Camera –
> The Poor, the Idle, and the Vicious'

And, the sub-editor might have added, the Greatly Alarmed. As the zealous Riis blazed

13 Nadar. *With exposures underground taking 18 minutes, scenes were enlivened by dummies, 1861*

14 C. Piazzi Smyth. *Inside the Great Pyramid. Taken with successive magnesium flares which produced ghost images of Arab helpers, 1865*

his trail through the startled underworld, 'Our party carried terror wherever it went. The spectacle of strange men invading a house in the midnight hours armed with (magnesium) pistols which they shot off recklessly was hardly reassuring . . . and it was not to be wondered at if the tenants bolted through the windows and down the fire-escapes.' The fire hazard inherent in the magnesium flash was increased when Riis took to firing a heap of powder in a frying pan. On one occasion his spectacles saved him from being blinded; another time, while photographing a huddle of blind beggars, his flash set fire to the room. Fortunately, as a policeman assured him when the flames were smothered, the hovel had been just too dirty to burn.

The Riis articles made a great impact but his powerful photographs could only be reproduced as line drawings. For, despite the proven demand, the publishing industry was remarkably slow to devise ways of reproducing photographs in newspapers. Back in the 1840s magazines like the *Illustrated London News* had been launched to exploit the public enthusiasm for realistic illustrations prompted by photography. It sold 26,000 copies of the first issue in 1842, and by 1863 its circulation stood at over 300,000. Illustrated magazines, particularly those in America during the Civil War, sometimes used photographers whose pictures (which usually had to be drawn) would be passed on to the wood engravers. While processes did exist for the more measured business of making photographs for books, it was not until 1880 that the development of the half-tone block (a plate broken into a screen of minute dots of varying size) allowed *The Daily Graphic* in New York to publish its first photograph, a gritty view of a shanty town transposed by Stephen Horgan onto a screen of seventy lines per inch, side by side for the first time with type.

Another novel journalistic use of photographs came from the ever-inventive Nadar

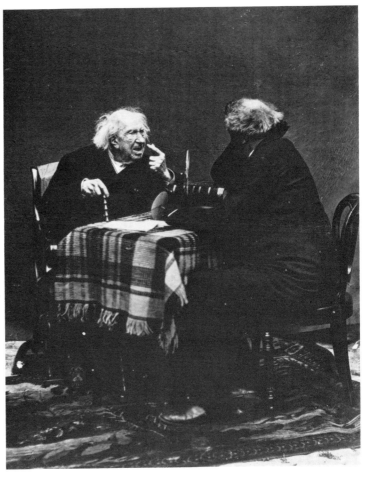

15 Jacob Riis. *Magnesium flash allowed the journalist to expose life in the underworld of New York. These derelicts are queuing for plank-beds in a police lodging house, 1888*

16 Paul Nadar. *The first photo-interview for a newspaper. Subject was the 100-year-old scientist, Michel-Eugene Chevreul, who had been present in 1839 when the secret of the daguerreotype was made public in Paris, 1886*

in 1886. In *Le Journal Illustré*, he conducted a photo-interview with a hundred-year-old chemist, Michel-Eugene Chevreul, and printed the text below each picture: the issue sold out immediately. The appeal of the printed picture was undeniable but the conservatism of newspaper publishers was also deeply rooted. When Stephen Horgan proposed that the New York *Herald* should print photographs he was fired, but he pursued this initiative at the *Tribune* and in 1897 it became the first newspaper to experiment successfully with half-tone printing on high-speed presses. By this time many illustrated magazines were dropping engravings in favour of half-tone, and thirteen photo journals were being published in London by 1899. An analysis made the same year also showed that 213 of 328 illustrations in nine leading international magazines were now half-tone reproductions

17 C.F. Stelzner. *Daguerreotype of ruins of Hamburg, 1842*

18 Illustrated London News *engraving of the Hamburg fire based on artist's imaginings*

146

19 ABOVE Franklin Bacon and John Taylor.
Flood in Rochester, New York, 1865

20 BELOW *Engraving of the same scene
published in* Harper's Weekly, *1865*

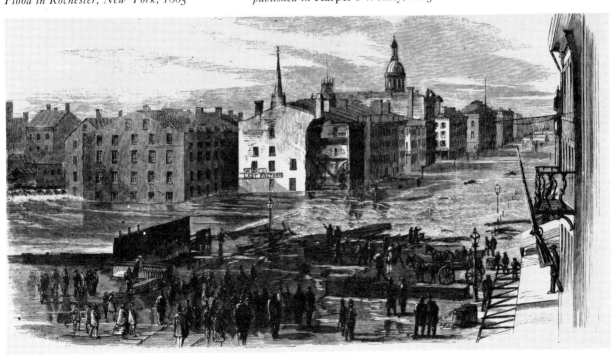

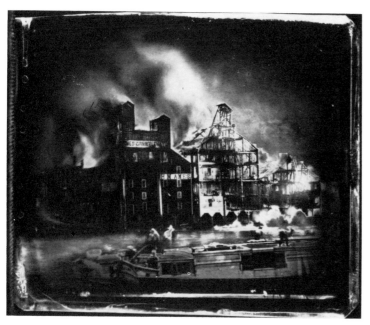

Great Fire of 1842 and, interestingly enough, the *Illustrated London News* had quite independently published an engraving of the conflagration based solely on its artist's imaginings. In the last century the agenda of public interest was little different from that followed by popular journalism today: fires, accidents, executions, wars, state occasions, glimpses of the famous or notorious, and any stunt or oddity calculated to make the customer stop and stare. Before the development of picture magazines and newspapers, images like these were simply sold as prints, singly or in sets, often as stereocards.

One of the first photographs showing an event of the kind most likely to excite a picture editor today was taken by Platt D. Babbitt in 1853 at Niagara Falls. Babbitt held the lucrative franchise for the American side of the Falls, and had put it to original use. With his camera set up under a canopy he shot tourists unawares, then sold them his 'candid' photographs – a technique made possible by the light reflected from the Falls. One day while Babbitt was working his pitch, a canoe with two men in it overturned upstream; one canoeist was carried over the falls but the other grabbed a log sticking between two rocks in mid-stream and clung on while unsuccessful attempts were made to rescue him. Meanwhile Babbitt set up his tripod on the river bank and took a photo-

21 George Barnard. *Daguerreotype of burning mills at Oswego, New York, 1853*

of photographs. In 1904 the *Daily Mirror* in London became the first daily newspaper to carry photographs regularly, a decision which was to help turn an ailing paper for gentlewomen into the bestselling tabloid in Britain. Photo agencies had also begun to meet the burgeoning demand for newsworthy pictures, and companies like Underwood and Underwood in America built up world-wide networks of freelances. Very soon a new breed of professional was flourishing, the news photographer.

Events which made 'news' had attracted the camera from the earliest days. A daguerreotype exists of the ruins of Hamburg after the

22 Platt D. Babbitt. *Tourists snapped at Prospect Point, Niagara, 1853*

23 William England. *Henri Blondin, crossing the Niagara on a tightrope, pauses considerably for the benefit of the slow cameras covering the stunt, 1859*

graph of the doomed man who was swept to his death when his strength eventually gave out after eighteen hours.

Niagara in those days must have been the most visited and photographed sight of the embryonic tourist trade; a natural setting therefore for early demonstrations of that pseudo-event, the stunt. Henri Blondin crossed the Falls on a tightrope in 1859, pausing considerably en route for the slow cameras, only to be upstaged by an Italian signorina who plodded across the high wire with her feet in buckets. Later Captain Webb, the first man to swim the English Channel, tried to swim the river above the Falls but was washed away and drowned. Mrs. Webb ended up at Niagara selling souvenir photos of her dead husband.

Some of the best news photographs, then as now, were neither set up, commissioned, nor predictable, but simply the result of someone with a camera being in the right spot, at the right time, with the right news instinct. The spread of the cheap hand camera obviously multiplied by millions the likelihood of someone capturing the unexpected, so when earthquake and fire devastated San Francisco in 1906 it quickly became the world's best documented natural disaster. Some of the most dramatic news pictures of the catastrophe were taken by Arnold Genthe who, while specializing in portrait photography, knew a good story when it hit him. In fact Genthe was hit so hard that his cameras were destroyed in the first 'quake. Undeterred, he scrambled down to his local photographic dealer who, predicting correctly that the

24 Platt D. Babbitt. *John Avery stranded in the rapids above Niagara Falls. He clung on for 18 hours before being swept away, 1854*

25 BELOW *Maria Spelterini upstaged Blondin by crossing the falls with her feet in buckets for the stereo-camera*

26 LEFT *Amateur news picture of a train crash on the distinctive circular print of an early Kodak camera*

149

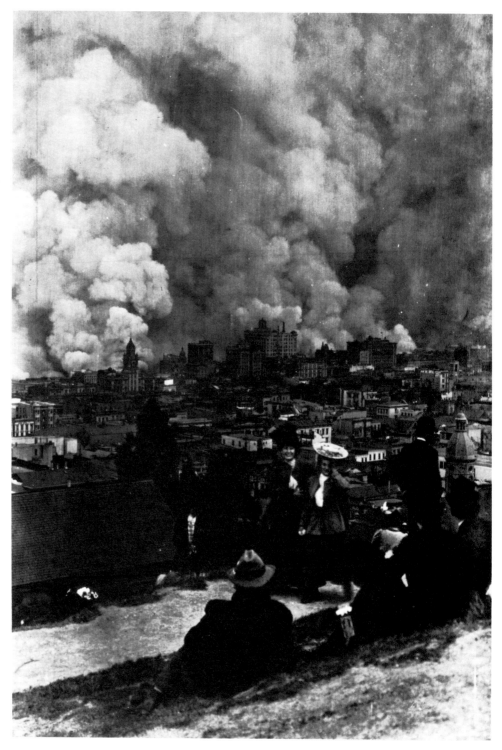

27 Arnold Genthe.
*View of San Francisco
earthquake and fire
from a lookout on
Russian Hill, 1906*

whole district would soon burn down, allowed him the pick of his stock. Genthe chose a Kodak 3A Special and stayed that night in Golden Gate Park while the town burned, and with it his own priceless collection of books and pictures. Genthe, however, just kept on shooting, a not altogether unusual reaction: when threatened by act of God or man, distance it by observing it through a lens. In that way somebody's real life tragedy can often become someone else's scoop.

150

11 Wheel of Life

Here we have the naked, absolute fact: here, for the first time, human eyes may see just how the human body moves in the performance of its function, how backs bend and hips dance and muscles strain and swell. This is not an art, but it is a mine of facts of nature that no artist can afford to neglect.

The Nation

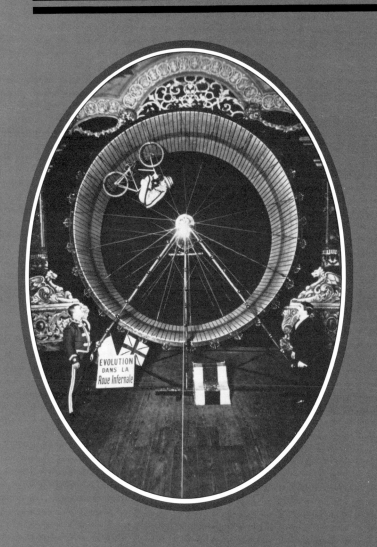

Wheel of Life

Ever since the first brand was whirled in the dark beside some primeval campfire, mankind has been able to observe the phenomenon of image retention – that fractional inefficiency of the eye which allows the image to linger when the object itself was moved on. In the decade before photography the effect of persistence of vision was being dramatized by simple toys with complicated Greek names like thaumatrope, stroboscope, phenakistiscope, and a 'Wheel of Life' which came to be called the zoëtrope. The simplest, the thaumatrope, was a disc with a drawing on each side; when the disc was twirled the images

merged to put, for instance, a bird inside a cage. The zoëtrope was an open drum inside which a strip of drawings was placed; when the drum was spun, the characters on the strip, viewed through slits in the drum, appeared to move. As the century progressed, these toys were manufactured in considerable quantity for home entertainment.

The use of photographs to create an illusion of motion was delayed by a technical paradox: before images could be made to move, still photographs had first to be taken of things in motion. However, photography did eventually catch up with the action through improved lenses, more sensitive emulsions, and faster shutters. By the 1870s enough progress had been made to encourage the use of a camera in an attempt to solve one of the oldest visual puzzles – how does a galloping horse move its legs?

Artists down the ages and across all cultures had made their various guesses. Many favoured the flying gallop position with legs outstretched front and back which, if speculative, did at least convey an impression of speed. But if that were the case, why then did the beat of galloping hooves drum in threes? The lack of certainty nagged at those artists of the realist school who made a fetish of detail. The French painter Meissonier built a length of railway track along which he could travel in a darkened carriage to keep pace with a running horse. But even this close observation proved inconclusive.

Meanwhile, the scientific inquiry into animal motion was being pursued by another Frenchman, Professor Etienne-Jules Marey. He put rubber balls inside the shoes of a horse and ran rubber tubes up to a pneumatic recorder held by the rider. In this way he proved that four hooves gave three beats because two always hit the ground together. But the movements of the galloping legs still defied depiction and Marey noted: 'Science has two obstacles to its progress: firstly, the ineffectiveness of our senses to discover the truths, and secondly, the inadequacy of language to communicate those truths we *have* discovered.' His observations were published in 1868 in a book entitled *Du Mouvement dans les Fonctions de la Vie*. When it reached America, Marey's book was to add

1 and 2 Two of the pictures used by Muybridge in his lectures to demonstrate the failure of artists down the ages to understand how a horse moved its legs

momentum to a train of events which led directly to the camera evolving a technique which could at last produce pictures of objects in motion.

A former governor of California, Leland Stanford, had got into a debate with some sporting cronies about whether his champion horse was ever in 'unsupported transit' – in other words, did a running horse ever have all four feet off the ground at any one time? For proof they shrewdly turned to photography and their commission went to Eadweard Muybridge, an Englishman working in San Francisco. Born plain Edward Muggeridge, the photographer had changed his name in 1850 in homage to the Anglo-Saxon kings once crowned in his home town of Kingston-upon-Thames. Young Eadweard went west in 1852 where his eccentricity may have been intensified: in Texas he was thrown from a stage coach and landed on his head. Muybridge took up photography in the 1860s and his views of the Yosemite Valley (page 44),

sold internationally under the romantic lens-name of 'Helios', soon won him an international reputation.

Leland Stanford also had a colourful past as gold miner and railway boss, and it was he who drove in the historic spike at Promontory Point in Utah, (page 133), which finally linked east to west. Stanford's prize trotter, Occident, was a reclaimed cart horse with an extra-long stride. Although no photographs survive of Muybridge's attempt with a single camera to show Occident with all four hooves off the ground in 'unassisted transit', Stanford's argument was apparently proved, for this report appeared in the *San Francisco Alto* in April 1873. 'The first experiment of opening and closing the camera on the first day left no result; the second day, with increased velocity in opening and closing, a shadow was caught.

3 Eadweard Muybridge. *His photographs of horses in motion at last showed the true positions of the legs of a galloping horse*

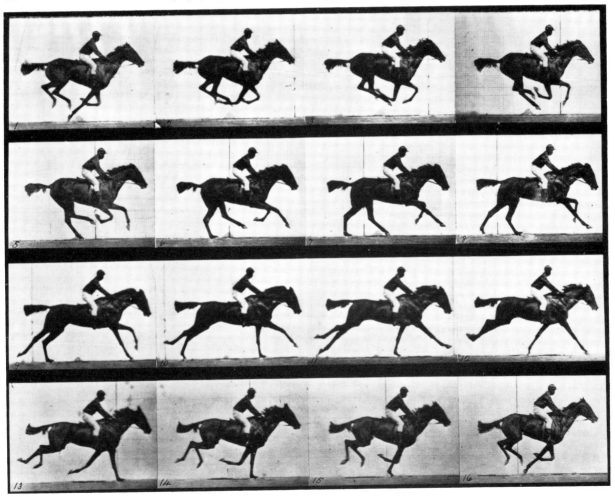

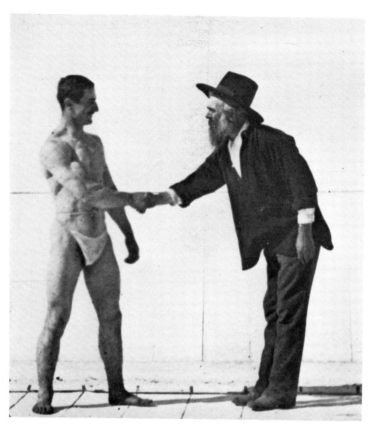

4 Muybridge shaking hands with one of his models, 1879

pictures that offended his artistic taste, no matter how much money he was offered to do it.' Muybridge was acquitted, but not however on grounds of insanity; the jury simply reckoned that the rascally Larkyns had got what he deserved.

Muybridge and Stanford next resumed their experiments in 1877 at Palo Alto racetrack on a scale that soon answered all remaining questions about the legs of running horses. A forty-foot long camera house with a dark room attached was built opposite a marked-off screen; a limestone coating was laid to reflect light; rubber ground sheets kept down the dust; and twelve cameras were set up with specially imported lenses and electrically operated shutters. These fast cameras were triggered when the metal-rimmed wheels of a horse-drawn sulky made contact with wires stretched across the track. In other experiments the running animals broke threads and so released the shutters. By June 1878 Muybridge was confident enough to summon the press who reported, 'It was a brilliant success . . . Even the thread-like tip of Mr Marvin's whip was plainly seen in each negative, and the horse was exactly pictured . . . Mr Muybridge, a photographer of genius and an artist of rare skill, was the operator. He is, practically, the inventor of the process, although the design or idea was suggested by Governor Stanford, who has unstintedly supplied the means to perfect the apparatus.' The total cost to Stanford had been $42,000. The results amazed the public who found the true position of the horse's legs both ungainly and unlikely. But the matter was now beyond doubt: generations of equestrian painters had, after all, got it wrong.

Muybridge went on to enthral audiences throughout Europe with a device he called a zoopraxiscope. This not only showed his Californian photographs in rapid sequence, thus making them appear to move, but also acted as a primitive projector. A press report of his London lecture with the Prince of Wales in the chair and Tennyson in the audience, stated: 'Mr Muybridge first threw on the screen a series of artists' sketches of the horse in motion. In no single instance had he been able to discover a correct drawing and to prove his statement, he then threw on the screen several series of pictures representing the different positions taken up by the horse as he walks, trots, ambles, canters or gallops. One thing is very clear from his pictures, namely – that when a horse has two of his feet

On the third day, Mr Muybridge, having studied the matter thoroughly, contrived to have two boards slip past each other by touching a spring, and in so doing to leave an eighth of an inch opening for the five-hundredth part of a second, as the horse passed, and by an arrangement of double lenses, crossed, secured a negative that show "Occident" in full motion – a perfect likeness of the celebrated horse.' Any plans for more ambitious experiments came to a sudden halt in 1874 when Muybridge murdered his wife's lover.

Flora Stone, a young divorcee, was ill-matched with Muybridge and their son, Florado Helios, was, it appears fathered by another British emigrant, a drama critic and con-man called Harry Larkyns. When Muybridge found proof of this cuckolding he rushed to the house where Larkyns was and shot him through the heart. 'I am sorry this little trouble occurred on your premises', he said to the ladies present, then gave himself up. The defence pleaded insanity. 'What sane man,' they asked, 'would pose on a rock 3,400 feet up just to make a picture more interesting?' They went on to argue that 'He was obviously insane because he refused to do

suspended between supporting feet, they are invariably lateral (i.e. on the same side). This no painter – ancient or modern – had ever discovered.'

Muybridge's ambition was now to compile a great visual dictionary of humans and animals in action. Work began in Philadelphia in 1884 sponsored by the University of Pennsylvania which supplied money, facilities, and students of both sexes prepared to take off their clothes in the cause of science or the pursuit of art. Sportsmen exercised their various skills; women spanked children, emptied pails of water, and climbed into bed; a range of unfortunates also hobbled across camera to demonstrate their deformities; and Muybridge himself appeared naked swinging a pick and a shovel. Monitoring the project to ensure that it served only the interest of art and science was a university committee of doctors, artists, and vets. By 1887 Muybridge had 20,000 photographs which were subsequantly published on 781 plates in eleven large volumes entitled *Animal Locomotion*.

The Muybridge photographs were first published in France in the journal *La Nature*. They were seen by Professor Marey, the man who, unwittingly, had helped start it all off. He wrote enthusiastically to the editor, 'I am lost in admiration over the instantaneous photographs of Mr Muybridge. Can you put me in touch with the author? I want to beg his aid and support to solve certain physiological problems so difficult to solve by other methods, for instance, the questions connected with the flight of birds. I was dreaming of a kind of photographic gun, seizing and portraying the bird in a series of attitudes, displaying the successive different movements of the wing.' Dr Marey went on, 'We could perfectly see the movement of all imaginable animals. So far as artists are concerned, it would create a revolution since we could

5, 6 and 7 Three of the hundreds of studies in movement made by Eadweard Muybridge at the University of Pennsylvania in 1884–85 and later published in Animal Locomotion

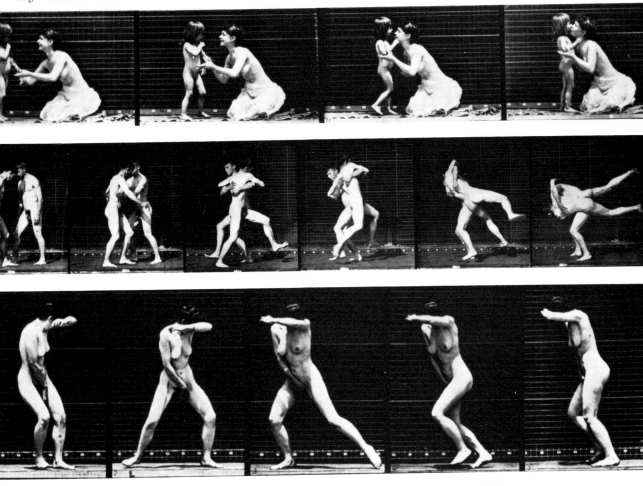

155

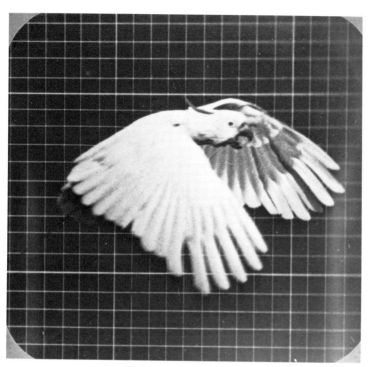

furnish them the true attributes of motion, which no model could pose for them . . . my enthusiasm is overflowing.' In fact, the 'gun' Marey mentions was not his own inspiration; an astronomer, Pierre Janssen, had first used a photo-gun in 1873 to record on a circular glass plate the passage of Venus across the sun.

Muybridge was flattered by the professor's enthusiasm. He sent him a picture of pigeons in flight and during his lecture tour of Europe he spent six months with Marey in France in 1881. But Marey now went on to devise his own techniques for photographing movement which were significantly different from the multi-camera approach of Muybridge. His photo-gun was loaded with a circular glass plate which rotated to register twelve separate exposures in half a second. However, some of Marey's most striking images were subsequently recorded on a stationary plate. Since repeated exposures on the same plate with a bright background would inevitably cause it to burn out, Marey designed a 'black hole' in a small park outside Paris. This was a stage lined with black velvet across which passed a bizarre range of subjects from pole-vaulters to pelicans. In these

8 Another plate from Animal Locomotion *showing a parrot in flight*
9 Eadweard Muybridge. *Boxers, 1884–85*

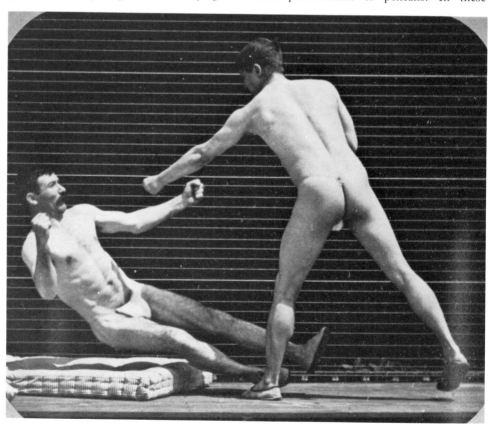

experiments, Professor Marey pulled photo-sensitive material past a rapidly firing shutter and, in so doing, pioneered the principle of the modern movie camera.

One less academic application conferred more immediate benefits on the public and was suggested by Muybridge himself: in 1888 a fast camera recorded the first race-track photo finish. But the real revolution in popular entertainment was to be the moving picture – as Muybridge had anticipated. That same year, 1888, he had met the American Thomas Edison, electrical wizard and inventor of the phonograph, and talked of combining photographs with sound. This was also the year in which the Kodak camera first appeared, loaded with a paper roll which could take one hundred exposures. Soon this roll of paper negative was replaced by a roll of film. All the elements required to make moving pictures were to hand and the problems which remained were simply tech-

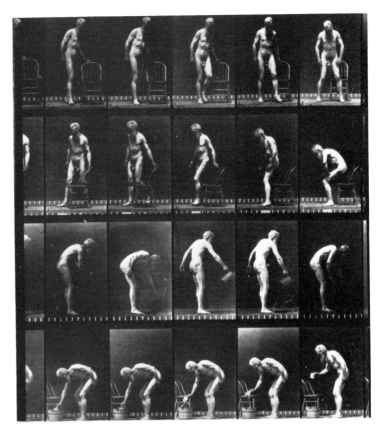

10 Eadweard Muybridge. *Self-portrait of the photographer as his own nude model*
11 E.J. Marey. *The Professor, on the left, at his experimental station in a park just outside Paris*

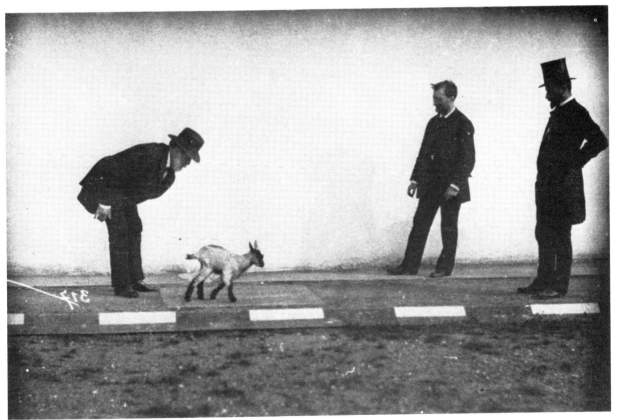

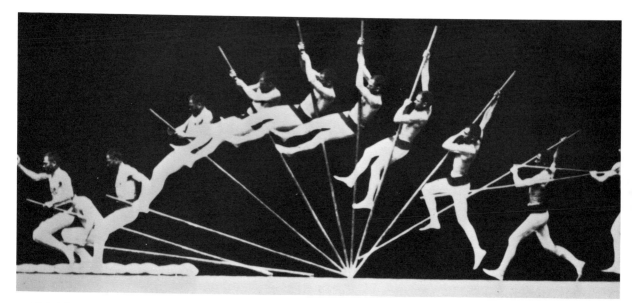

12 E.J. Marey.
Chronophotograph of
a pole-vaulter,
c.*1890*

13 E.J. Marey.
Chronophotograph
of boxers, c.*1890*

nical. The first moving picture show was now only a matter of time.

Much of the basic work on projection was carried out for purely scientific purposes by Professor Marey. Unfortunately, in one of those familiar deceits encouraged by the brutally competitive times, his assistant Georges Demeny surreptitiously patented the basic design of Marey's projector. Edison put a machine on the market in 1894 called the Kinetoscope which ran photographs fast enough to create the sensation of movement but (oddly for the inventor of the light bulb) did not project and could therefore be viewed by only one person at a time. The real breakthrough into cinema as we know it today dates

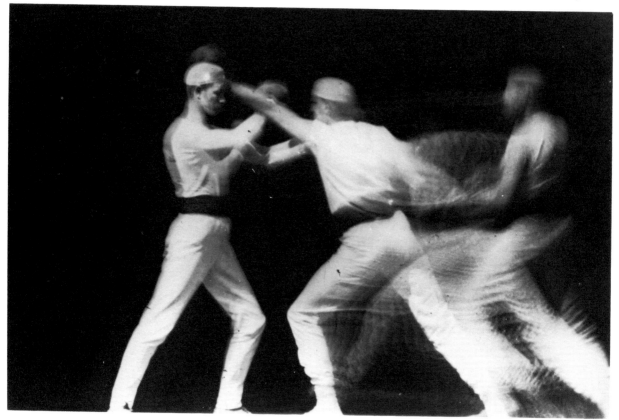

14 E.J. Marey.
*Smoke flows around
various obstacles in
an early experiment
in aerodynamics,
c.1900*

159

from 28 December 1895. At the Grand Café in Paris, in the same Boulevard des Capucines where Nadar had worked and the Impressionists had held their first exhibition, a paying audience was panicked by the sight of a train coming straight at them out of a screen. They also watched – with fascination – more commonplace scenes like workers leaving a factory. The factory, in Lyons, belonged to the Lumière brothers, Louis and Auguste, who had solved the principal engineering problems of projection by clawing a strip of film with sprocket holes through the light beam of their cinematograph projector and stopping it dead in the gate sixteen times a second. The Lumières then went on to produce films which demonstrated a power no photograph, however anecdotal, could ever match. In *L'Arroseur Arrosé* they used pictures alone to tell the story of a child with a hose playing a prank on a gardener – the two dimensions of photography had gained a third dimension of narrative time.

Eadweard Muybridge had meanwhile retired to his birth place of Kingston-upon-Thames and in his last years showed little interest in the film industry he had helped bring into being. He died in 1904 while digging a scale model of the Great Lakes in his back garden. This diffidence about the cinema was shared by Professor Marey who continued with his scientific inquiries until he also died in 1904, just a few weeks after his old friend and collaborator. Strangely enough the Lumière brothers, creators of the first commercial films, themselves turned back to photography and worked towards perfecting a colour process. 'The cinema', they had concluded, 'is an invention without any future.'

12 Truth and Beauty

I am not a painter, nor an artist. Therefore I can
see straight. And that may be my undoing.

ALFRED STIEGLITZ

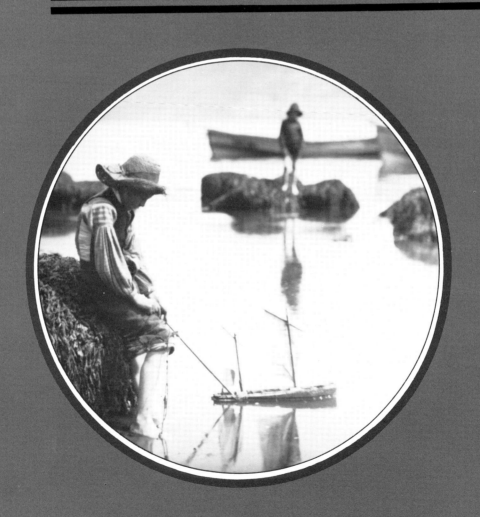

Truth and Beauty

The Victorian passion for art bordered on lust and was inflamed by the insecurity of a nascent middle class. In a century marked by a heightened awareness of history, this new class stood in acute need of a past and it soon fell to the more imaginative among its artists to invent one. Where other hard-eyed observers saw only rural idiocy, the romantic artists began to glimpse a lost rustic idyll. From the threads of a more distant past they spun a cocoon of classical myth, biblical parable, and tribal legend. Here persons of refinded sensibility could find shelter from a world still restless, hungry, and generally uncouth, while awaiting the certain arrival of a more civilized future. And what better ally of Progress than Art, whose purpose must therefore be, as one mid-Victorian critic pronounced, 'not merely to amuse, but to instruct, purify, and ennoble'.

Photography, accessible and still immature, was an easy conquest for those who came preaching or exploiting. After watching the first two decades of its development, Charles Baudelaire concluded that photography 'was the refuge of every would-be-painter, every painter too ill-endowed or too lazy to complete his studies'. There is certainly no disputing that 'sun pictures' or 'painting with light' did attract many failed artists whom Baudelaire despised: 'a revengeful God has given ear to the prayers of this multitude. Daguerre was his Messiah.' Of course Daguerre himself had painted, Fox Talbot dabbled, and today we remember as photographers many others whose paintings are all but forgotten. Fox Talbot spoke of photography as 'the royal road to drawing' and, describing his own study 'The Open Door' (page 14), offered a rationale for his artistic impulse. 'We have sufficient authority in the Dutch School of painting for taking as subjects of representation scenes of daily and familiar occurence. A painter's eye will often be arrested where ordinary people see nothing remarkable. A casual gleam of sunshine, or a shadow thrown across this path, a time-withered oak, or a moss-covered stone may awaken a train of thoughts and feelings and picturesque imaginings.' Talbot was, in fact, by the standards of the time, remarkably restrained.

Roger Fenton is now best remembered for his photographs of the British Royal Family and the Crimean War (page 81), but he had studied previously at the *atelier* of the French historical painter, Paul Delaroche. While Fenton took many conventional still lifes and landscapes, even he occasionally succumbed to fancy-dress photography. Despite these lapses it seems possible that Fenton's sudden decision to abandon photography in 1862 may have been brought on by his disgust at the excesses of the 'art' photographers.

In 1855, a German photographer, Franz Hanfstaengl, was still able to surprise the public with the confession that he had retouched a negative. However, it was not long before this minor violation gave way to massive reconstructions. An English painter in water colours, William Lake Price, took

1 Roger Fenton.
Still Life, c.1858
2 William Lake
Price. *A 'historical'*
study showing Don
Quixote in his study,
1855

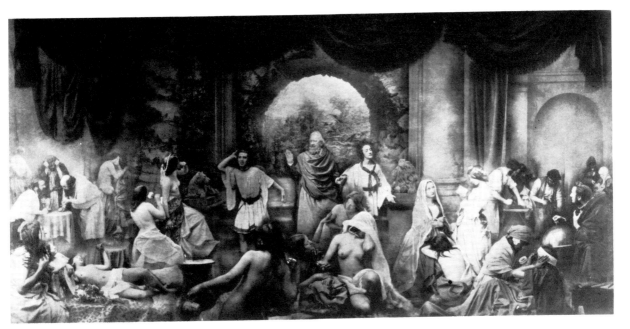

up the camera and began producing 'historical' studies. Oscar Gustave Rejlander, a Swede working in Britain who had painted Old Masters in Rome, and picked up the basic principles of photography in just an afternoon, made the most ambitious art photograph ever – an allegorical study measuring 31 by 16 inches, painstakingly created through combining 30 separate negatives. This panorama, 'Two Ways of Life', contrasted Industry with Dissipation and achieved its bare-breasted wantonness with the help of 25 models from Madame Wharton's 'Pose Plastique Troupe'. Attempts to display this 'moral' tale in Scotland in 1857 almost disrupted the national photographic society; honour was finally satisfied when it was hung with a drape on that half of the image given over to Dissipation which had, admittedly, been made to look rather inviting by Madame Wharton's models. Queen Victoria proved more broadminded than her Calvinist subjects and bought 'Two ways of Life' for Albert to hang in his study.

Not all Rejlander's composites were so elaborate (it took only two negatives to deliver John the Baptist's head on a plate) but accusations of bad taste almost broke his confidence. In 1859, he wrote plaintively to another practitioner of 'art' photography, Henry Peach Robinson: 'I am tired of photography for the public . . . particularly composite photos, for there can be no gain and no honour, only cavil and misrepresentation!' However, Rejlander went on manu-

4 O.G. Rejlander. 'The Head of John The Baptist', delivered on a plate with the help of two negatives c.1857–58

5 O.G. Rejlander. A 'problem' picture of an unemployed worker entitled 'Hard Times' c.1860

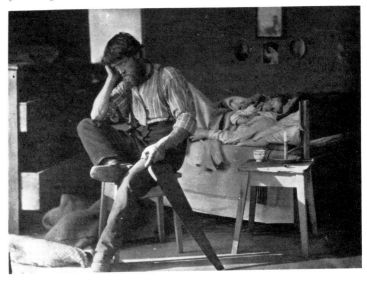

facturing anecdotal photos although he did also put his camera at the service of science, and Charles Darwin, by illustrating *The Expressions of the Emotions in Man and Animals*.

Henry Peach Robinson was yet another painter turned photographer. And again, his declared intentions were suitably elevating: 'We want to apply these discoveries to higher purposes than we have hitherto done.' One high-minded composition was received with critical hoots and snorts in equal measure: 'Fading Away', featured a consumptive girl, surrounded by her family on five negatives, repining to the accompaniment of Shelley:

Must, then, that peerless form
Which love and admiration cannot view
Without a beating heart; those azure veins
Which steal like streams along a field of snow,
That lovely outline, which is fair,
As breathing marble, perish.

Charges of tasteless exploitation and 'morbid sentiment' were again ignored by the robustly literal Prince Albert who placed a standing order for prints of all Robinson's future photo-effusions. Robinson naturally kept both nerve and custom and continued turning out a number of composites each year. Although some scenes have, over the century, acquired a patina of camp charm, even Robinson was moved to condemn his own 'Lady of Shallot', fashioned in 1861. 'It was a ghastly mistake to attempt such a subject in our realistic art.' How photographic realism co-existed with his many other allegorical, anecdotal, and genre creations was not convincingly explained, but Robinson did go straight in later years.

Thankfully, some of the 'art' photography of the early period retained a vestigial realism. Many of William Grundy's views of the English countryside, for instance, are direct and dignified. The gentleman amateurs who founded the Calotype Club in the 1850s included Dr. Hugh Diamond (page 107) and Frederick Scott Archer, the artist who invented the collodion process. In attempting to raise the status of photography they, like Roger Fenton, P. H. Delamotte, and others in England, and Charles Nègre, Gustave Le

6 Henry Peach Robinson. *This composite photograph of a dying girl 'Fading Away' was attacked as tasteless, 1858*

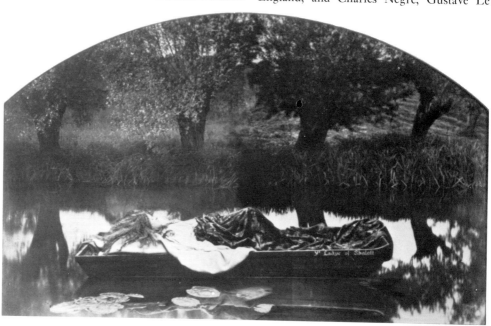

7 Henry Peach Robinson. *The Lady of Shallot, 1861*

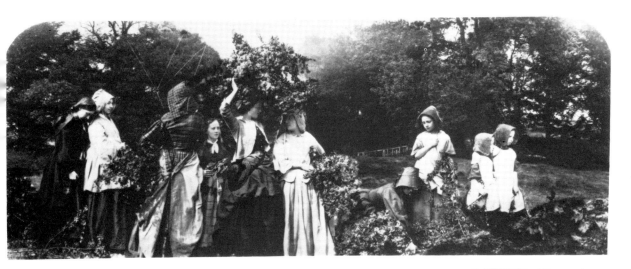

8 H.P. Robinson *was the most long-lived of the fancy dress photographers. This scene 'Bringing Home the May' was composited from nine separate negatives, of which two are shown, in 1892*

Gray and Adolphe Braun in France, concentrated largely on landscapes, architectural views, and still lifes.

The high moral tone of Victorian art in Britain and its concern for sharp detail stem partly from the influence of the critic John Ruskin. In his annual review of exhibitions at the Royal Academy, Ruskin lent his considerable support to the painters of the Pre-Raphaelite Brotherhood. While some 'art' photographers slavishly followed painterly fashions, the Pre-Raphaelites adopted a way of seeing which was markedly 'photographic' in its sharpness, depth of focus, and perspective. Yet the greatest portraitist of Victorian England was the unfocussed Julia Margaret Cameron.

Although now best remembered for her expressive Rembrandt-lit close-ups, these represent only part of her output; many of her other photographs show the influence of her cultural milieu, inhabited as it was by Pre-Raphaelites like Holman Hunt and Burne Jones, and the dominating Alfred, Lord Tennyson. Cameron also projected her sentimentality onto the poor in anecdotal studies with titles like '70 Years My Darling 70 Years' and 'Pray God Bring Father Safely Home'. The lower orders seen through the distorting lens of art photography became comforting metaphors for piety, sentiment, hard work, or gormless fun; they even showed their teeth and smiled a lot (unlike the grimly burdened bourgeoisie) – an

idealized and thoroughly deserving poor.

This misbegotten application of photography's unique ability to give a true record of outward appearance came from the desire of photographers to be dignified by the title 'artist'. Deep offence was therefore given to the gentlemen, and the few lady practitioners of the 'black art' when the organisers of the Universal Exhibition in London 1862 relegated photography to that part of the event set aside for machinery. In France, Nadar, the bohemian friend of the greatest artists in an age dominated by French painting, and his distinguished colleagues demanded that photography be allowed access to the official exhibitions of art. A commission solemnly pondered this question for six years before the Attorney General of France, M. Rousselle, pronounced formally in 1862 that photography was indeed a fine art.

As the tremors warning of upheavals to come ran through the art world, photography was undistrubed. After the excitement of the

9 LEFT ABOVE William Grundy, *A scene from his series*, English Views, *published in 1857*
10 LEFT Julia Margaret Cameron. *A genre scene of fisherfolk entitled* 'Pray God Bring Father Safely Home', *1874*

11 Julia Margaret Cameron. *'The Passing of Arthur' : a photograph created to illustrate Tennyson's 'Idylls of the King', 1874*

early collodion era with its stereocard and carte-de-visite crazes, its travel photography and booming portrait studies, photography languished in the decade preceding the technical breakthroughs of the 1880s which culminated with Eastman's Kodak in 1888. But the following year, 'art' photography was hit by the rhetorical blast of the future in a book by Peter Henry Emerson, *Naturalistic Photography*. Emerson was another of those Victorian polymaths who enliven the history of photography: born in Cuba of an American father and English mother, with the advantage of a Cambridge education and a considerable private income, Emerson became a doctor of medicine, naturalist, writer of detective stories, billiards ace, keen photographer, and reckless polemicist. He made himself the most ferocious critic of the fancy-dress photographers with their sentimental scenes and artistic pretensions. His demand was for a more honest pursuit of the camera's capacity for visual truth and an end to manipulation. *Naturalistic Photography* was said to have burst 'like a bombshell dropped at a tea party'. He exhorted his followers: 'Do not call yourself an "artist photographer" and make "artist painters" and "artist sculptors" laugh: call yourself a photographer and wait for artists to call you brother.' His attack on 'bagmen' who work 'to please the public as for filthy lucre or for metal medals' was directed at the veteran faker H.P. Robinson, bedecked as he was with no fewer than 73 medals of merit.

As well as offering brilliant insights into the nature of photography, Emerson also talked a good deal of nonsense about the focussing of eyes and art history, and his demand for 'naturalistic' photography carried echoes of Frances Bates and his New English Art Club who had advocated a 'naturalistic' school of painting a few years before. Undoubtedly, the most persuasive ally Emerson had in the debate he provoked was his own photography. His first book *Life and Landscape on The Norfolk Broads* was illustrated with platino-type prints whose grey

12 Peter Henry Emerson. '*Coming Home from the Marshes*', *a platinum print from his book* '*Life and Landscape on the Norfolk Broads*', *1886*
13 Peter Henry Emerson. '*Gathering Water-Lilies*', *1886*
14 Peter Henry Emerson. '*Gunner Working up to a Fowl*', *1886*

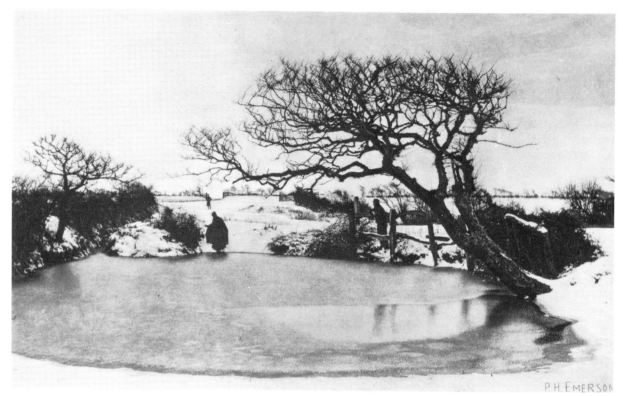

P.H. EMERSON

15 Peter Henry Emerson. '*A Winter's Morning*', *a photogravure from 'Pictures from Life in Field and Fen', 1887*

tones were ideally suited to the flat misty landscape of the Broads. The approach to the fenmen and women in his photographs is direct, and the occasionally stilted quality is off-set by the documentary content which, though unremarked in the squabbles of the

time, adds durability to his work.

While the bolder spirits rallied to the 'naturalist' cause, a counter attack was mounted to discredit Emerson's misconceived theory that the eye sees in planes of differing focus. Traditionalists took to mocking his followers as 'fuzzies'. Even by the standards of art controversies, this spat was delightfully confused. Tormented by ego and petty jealousies, Emerson suddenly denounced the presumption of his followers and condemned his own cause in a black-bordered epitaph published in 1891 'in memory of Naturalistic photography', which, he declared wickedly, had in its short but eventful life:

Upset many conventions
Helped to further monochrome photography to the utmost of its limited art boundaries . . .
Produced many prigs and bubble reputations,
Exposed the ignorance of the multitude,
Brought out the low morality of certain persons in the photographic world . . .
Encouraged many amateurs to babble and make the words 'art', 'truth' and 'nature' stink in the nostrils of serious artists . . .

And so on. 'The limitations of photography

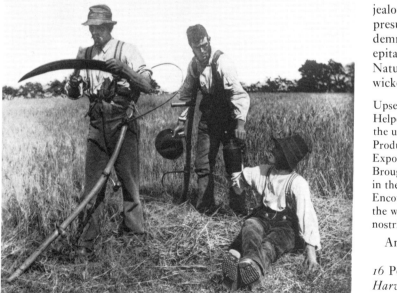

16 Peter Henry Emerson. '*In the Barley Harvest*', *a photogravure from 'Pictures of East Anglian Life', 1888*

168

are so great,' he wrote, 'that though the results may and sometimes do give a certain aesthetic pleasure the medium must always rank the lowest of the arts.'

But this apostasy did not deter the most committed experimentalists. Emerson's tender ego must have been further bruised when H.P. Robinson, after 30 years of arty-faking, deftly placed himself in the van of an anti-Establishment faction which called itself the Linked Ring Brotherhood and set up an annual 'salon' in 1893 in competition with that of the London Photographic Society. Other activists included George Davison, H.H.H. Cameron (son of Julia Margaret), and J. Craig Annan (son of Thomas), but just as their predecessors were influenced by the prevailing fashion in painting, so some of the 'pictorialists' now sought to emulate the Impressionists, using soft focus lenses, coarse grained paper, and manipulations of print and pigment for what Emerson denounced as 'meretricious effects' and 'precious daubs'.

The aping of the avant garde by some of the pictorialists was more than just a recurrence of the craving for artistic status. It was also an attempt to create a distance between themselves as artists and the hoi polloi who were now at last able to challenge the near-monopoly of photography which the leisured classes had held for half a century. Emerson was an unabashed elitist who argued that if the early standards of the gentlemen amateurs had been maintained, 'photography today would have probably been practised by artists and scientists alone, a noble and learned profession, instead of being practised, as is now only too often the case, by illiterate and ignorant tradesmen.'

Whatever the confusion of his ideas, Emerson had a discriminating eye. He admired the work of one of the founders of the Linked Ring, Frank Sutcliffe, who lived in Whitby, a small fishing port in Yorkshire. Sutcliffe is an interesting case study of the ambitious professional, a photographer with

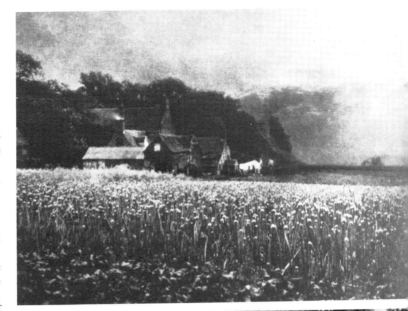

17 George Davison. *'The Onion Field'*, *a study by one of the leaders of the Linked Ring Brotherhood whose 'meretricious effects' were condemned by Emerson, 1890*
18 Frederick H. Evans. *A founder of the Linked Ring Brotherhood who is best remembered for his 'pure' architectural studies. This picture 'Sea of Steps' was taken at Wells Cathedral, 1903*

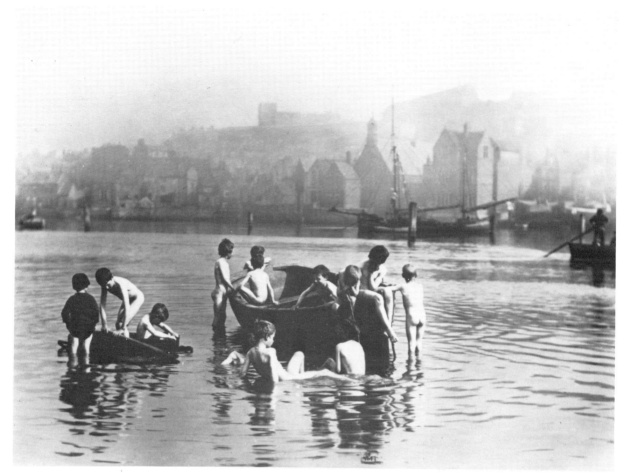

19 Frank Meadow
Sutcliffe. '*The Water
Rats*' *is the most
famous picture taken
of life in the
Yorkshire fishing
town of Whitby
where Sutcliffe
worked as a
professional
photographer, 1886*

20 Frank Meadow
Sutcliffe. *View
across Whitby
Harbour towards the
Marine Hotel, 1882*

170

a 'naturalistic' eye, who nevertheless suffered more than most from a sense of photography's innate inferiority. As the son of a painter he had inherited a low opinion of his trade: 'were not all photographers looked on as men who thought they could do much when they could do nothing at all? Yes it is a terrible thing to have been brought up with a feeling of contempt for one's handicraft.' Although Sutcliffe was an admired member of the Linked Ring, as town photographer in Whitby he lived the life of a tradesman and worked long hours in his studio during the tourist season. Professional photography was a tough business in the last quarter of the century.

At the beginning of his career Sutcliffe was commissioned to do views for Francis Frith of Reigate who advised him never to include figures in landscape studies since customers did not like other people in their pictures. A London dealer also told him to make his photographs bigger since most people bought only by size. And there was little aesthetic satisfaction to be got from his portrait factory with its painted backdrops and artificial rocks: to persuade sitters that plain backgrounds were more tasteful he hung a couple of Rembrandt prints in the studio – but customers didn't think much of them either. Sutcliffe's reverence for high art had been encouraged by a brief visit as a

21 Frank Meadow Sutcliffe. *Dorothy Taylor baiting lines,* c.*1880*

22 Frank Meadow Sutcliffe. *Many of the Whitby studies are of the fisherfolk and their now vanished way of life,* 1889

23 FACING PAGE
Frank Meadow Sutcliffe *This trick of photographing directly into the sun behind the topsail achieves a 'contre-jour' effect that few of his contemporaries would have attempted.*

24 Frank Eugene: *This group portrait shows some of the outstanding turn-of-the-century photographers: from left to right – Eugene, Alfred Steiglitz, Heinrich Kuhn, and Eduard Steichen, 1902*
25 Alfred Stieglitz. *'The Steerage', 1907*

young man to the home of the awesome Ruskin in the Lake District. On setting up shop in Whitby he proclaimed himself 'photographer to John Ruskin' – only to find that local folk had never heard of him. This need to make a living during the day helps explain why many of Sutcliffe's outdoor photographs were taken at dawn or dusk. Winter also allowed him to escape from the studio, but on one of his negatives he wrote, 'Don't do any more snow scenes: nobody buys them.'

Sutcliffe did not scruple to pose his subjects. To set up one of his most famous photographs, 'The Water Rats', he brought one of the boats from across the bay and gave boys pennies to pose as directed. But behind the beauty of Sutcliffe's compositions the reality of life in Whitby can be clearly seen. By documenting the fisherfolk, and a way of life which has vanished, Sutcliffe's pictures now exert a strong nostalgic appeal. And whatever the artifice of 'The Water Rats', its power also derives from its inherent reality: the boy on the left of the boat looking away across the harbour is 11-year-old James Edward Locker – he died in Whitby in 1968, aged 93. Despite Sutcliffe's neurosis about art and photography, his record of Whitby continues to gain in power while the creations of others in the Linked Ring survive only as pictorial curiosities or auction room commodities.

Sutcliffe's work has the same appeal as Hill and Adamson brought to their studies of fisherfolk in the 1840s. The calotypes of the Edinburgh partnership were brought from obscurity by J. Craig Annan, one of the 'purist' members of the Linked Ring, and exhibited in 1899 in Hamburg (although it remains one of the mysteries of nineteenth century photography that Germany quite failed to match the achievements of Britain, the United States and France). The Photo–Club in Paris was the French equivalent of the Linked Ring and Robert Demachy experimented skilfully with gum prints which allowed him to pigment and work the coatings until the images looked more like drawings than photographs. This then was one of the many ironical results of the revolution to which Emerson first gave voice in the name of naturalism, an art-photography derived yet again from painting and, just as shamingly, still displaying marked cultural lag.

Back in 1888 Emerson's eye had picked out

26 LEFT Alfred Stieglitz. '*A Winter's Day in New York*', *1893*
27 ABOVE Eduard Steichen. *Isadora Duncan at the Parthenon*, c.*1913*
28 Eduard Steichen. '*Self Portrait*'. *1903*

29 Clarence H.
White. *'Raindrops'*,
1908

31 Robert Demachy. *This French
photographer used coloured pigments to
achieve a 'painterly' effect,* c.*1903*

30 Frederick
Holland Day.
'Negro Head', *1908*

for special attention a photograph made by a young American studying in Europe, Alfred Stieglitz. When he returned to New York, Stieglitz soon began to influence the direction of American photography. The individual styles of the Americans proved almost as contradictory as those of their European counterparts, but Stieglitz himself declared for 'straight' photography and set off on a single-minded pursuit of an uniquely photographic way of seeing which was less beholden to older forms. In 1902, he made his most radical break with tradition and founded the American Photo-Secession, a movement which was later centred on his gallery at 291 Fifth Avenue. His magazine *Camera Work* actively promoted outstanding photographers like Alvin Coburn, Frank Eugene, Clarence H. White, and Edward Steichen. While in England the salons of the Linked Ring whimpered to their inevitable end in 1908, the Americans, with that peculiar instinct for photography they had already demonstrated in war, in the conquest of the West, and in photo-journalism, cut a path through the tangle of cultural influences which had so hampered the Europeans. The combination of purism and fanaticism which allowed Stieglitz to declare, 'photography is my passion, the search for truth my obsession,' also inspired him to create an ambience which encouraged the Americans to set about evolving the forms of photography which in the end proved best suited to survive the rigours of the twentieth century.

13 The Ends of Art

'Why should the artist persist in treating subjects
that can be established so clearly with the lens of
a camera? It would be absurd, wouldn't it?
Photography has arrived at a point where it is
capable of liberating painting from all literature,
from the anecdote, and even from the subject.'

PABLO PICASSO

The Ends of Art

Tradition has it that the first sight of a photograph in 1839 caused Paul Delaroche to exclaim 'From today painting is dead.' In fact the French painter said that Daguerre's process 'completely satisfies all the demands of art, carrying certain essential principles of art to such perfection that it must become a subject of observation and study even to the most accomplished painters'. Nor is there much likelihood that the aged Turner, of all people, looked at a pin-sharp daguerreotype and murmured, 'This is the end of Art, I am glad I have had my day.' Nevertheless the apocrypha does give a clue to the fear and confusion of a privileged craft suddenly confronted with a machine for manufacturing images. The first to be displaced by the new technology were the makers of miniature portraits, many of whom, to avoid destitution, had to retrain as image-machine operators. An early survey of professional photographers at work in Hamburg and Berlin showed that a third of them had previously been painters.

With so many failed painters and street hustlers practising photography for money, a stigma soon attached to any over-close liaison between the distinguished practitioners of painting and 'the black art'. While traffic between easel and darkroom was brisk, most couplings were kept discreet and clues to the humble origin of a painted image were frequently destroyed. However, enough evidence has now been amassed by investigators like Aaron Scharf and Van Deren Coke to demonstrate beyond doubt the influence of the camera's new way of seeing on the development of Victorian painting – including the work of many artists presumed previously to have been touched only by genius.

But from the first there were also notables who openly acknowledged the service of photography in reducing the drudgery of art. In France, the grand Romantic painter Eugène Delacroix conducted many sessions in which he carefully posed models before the camera, amongst them the bold-looking girl whom he subsequently transformed in paint into his 'Odalisque'. Another obvious use for the photograph was as an aide-memoire for the painters of portraits in oils. For D.O. Hill in Edinburgh in 1843, the

1 Eugène Delacroix. 'Odalisque' oil, 1857.
And a photograph of a nude from an album compiled by Delacroix

ambition of his painting 'Deed of Demission' made the camera indispensable – the faces of 470 Calvinist divines were pressed onto a canvas 5 feet by 11½ feet which took twenty-three years to complete. The painting itself is now an unvalued piece of work; the photographs on which it was based are famous.

The camera's mechanical mastery of detail strongly recommended it to an age which eagerly conflated observed facts into revealed truths. The advent of photography undoubtedly gave momentum to the Realist Movement which, with Gustave Courbet as its battering ram, burst into the Paris salons of the 1850s. Courbet's paintings were, indeed, abused as 'banal scenes worthy only of the daguerreotype'. Although Courbet did make occasional use of photographs, his real offence was to assault the dominant Romantic style. When 'Les Baigneuses' was exhibited in 1853, Napoleon III is said to have thumped the great rump of the woman bather in outrage: Courbet had shamelessly conferred the monumental scale of the Romantic style, previously reserved for saints and heroes, on the most common people. Worse, Courbet effectively sent up the prevailing convention by giving his low life subjects the affectations of the illustrious. Thus the Ideal with its sacrosanct concept of Beauty was subverted, so it was argued, by a Realist 'cult of ugliness'.

Courbet openly declared the union between the 'ugliness' of his realism and his radical politics: 'Romantic art, like classical, meant art for art's sake . . . In all things men must be ruled by reason . . . Deducing from this the negation of the Ideal with all its consequences, I arrive at the emancipation of the individual and, finally democracy. Realistic art is essentially democratic.' In representational art the camera was of course the great leveller, yet even in photography there were pressures to repel the commonplace. When the Langenheim brothers in Philadelphia in the 1840s showed a daguerreotype of people eating at a table, it was withdrawn as too vulgar for public display. Even in 1855 the leading French photographers refused to let their first public salon be demeaned by a picture of a man cutting his corns. But beneath the scandals about Realism and the 'ugliness' of Courbet's peasants and workers which disturbed the aesthetic of the salon, the critic Castagnary heard the deeper political rumble which so unsettled the bourgeoisie. 'They had defeated the prole-

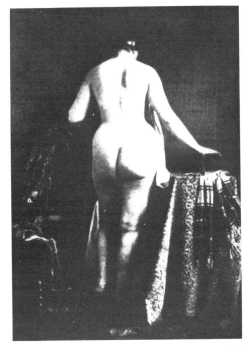

2 Gustave Courbet. '*Les Baigneuses*' *(detail) oil, 1853. And* Julien de Villeneuve, *nude study acquired by Courbet in 1853*

tariat in the streets of Paris (in 1848) . . . and here was that vile multitude, chased out of politics, reappearing in painting.' The fissures which had divided France since the Revolution widened further after 1848, alienating both workers and intellectuals from tradition and authority in a way which presaged future revolutions in both politics and art.

In Britain, by contrast, industrial growth and the imperial adventure were helping to promote a self-confident culture which had an appeal across the classes. The annual summer exhibition at the Royal Academy was a major event attracting a quarter of a million visitors, including the Royal Family. The most popular paintings glowed with patriotism, piety, moral virtue, and shared sentiment. And adding to the broad appeal was an increasingly photographic way of seeing. By 1852 *The Art Journal* could detect 'pictures, and bits of pictures in which the aid of the camera was apparent'. Such pictures included the hugely popular paintings of W.P. Frith like 'The Railway Station' and 'Derby Day' for which the photographers Samuel Fry and Robert Howlett were commissioned to make location studies of

characters and scenes. And while the 'art' photographers with their composites were taking themes from painting, simultaneously paintings like Millais' 'Apple Blossom', and other uncannily lit and detailed work of the Pre-Raphaelites, appeared to borrow back many of the characteristics of the photo-composites.

Britain also had its 'realists'. Richard Redgrave, for instance, painted 'The Sempstress' to complement a bitter poem about the exploitation of sewing women:

> Stitch – stitch – stitch
> In poverty, hunger and dirt,
> Sewing at once, with a double thread,
> A shroud as well as a Shirt.

Yet as the century advanced social realism in Britain did not mature. The hostility to it was perhaps most brutally expressed by the critic Walter Bagehot when he declared that 'the character of the poor is an unfit topic for continuous art'. Instead middle-class dilemmas were explored in 'problem pictures' with titles like 'The Confession', 'Mariage de Convenance – After', 'The Prodigal Daughter', etc. These attempted in near-photographic detail to tell a story. The most relentless of the genre is a tryptych by Augustus Egg called 'Past and Present', bursting with symbols which attempt mutely to explain the fall of the lady of the house seen in the first picture prostrated on the

3 William Powell Frith. *'The Railway Station'. Painted with the aid of photographs commissioned from Samuel Fry who made studies of passengers and stock at London's Paddington Station, 1860–62*

4 John Everett Millais. '*Apple Blossom*', oil, 1856–59. *A Pre-Raphaelite study with many of the characteristics of the photo-composites then popular*

drawing room carpet before her stricken husband and uncomprehending babes. While a long caption hints at the subsequent death of the betrayed husband, the outcast wife finishes up in the third frame under an arch on the river – 'last refuge of homeless sin, vice and beggary of London: the thin starved legs of · bastard child – perhaps dead at her breast – protrude from her rags'.

The copyright on the most instructive and uplifting paintings was sold for large sums to engravers whose print runs suggest that this art found a place on the wall of the lowliest cottage. These Victorian pictures with their 'natural' composition, detail, and perspective, lacked the radical content and style of the French. But while the Realists across the Channel were soon overrun, the British Academicians, buttressed as they were by mass support, successfully resisted the pro-

5 John Everett Millais. '*Princess Marie*', oil, 1882. *And* Armand Richard, *Princess Marie*, c.1880

6 Augustus Leopold Egg. 'Past and Present', three oils, 1858.

This cautionary tale was captioned: 'August the 4th. Have just heard that B. has been dead more than a fortnight, so his poor children have now lost both parents. I hear she was seen on Friday last near the Strand, evidently without a place to lay her head. What a fall hers has been.' THE TIMES

spelled out the packed symbolism: '(The wife) lies prostrate before her heart-stricken partner, who holds the letter, the evidence of treachery in his hand. Their two children look up from their amusement of card-building at the sound of her fall. Their card castle has a French novel (by Balzac) for its foundation – a Hogarthian indication of the source of their mother's perversion.'

found shifts which were starting to move painting away altogether from its role of depicting as naturally as possible the external appearance of things.

So while photography acted as a template for the less imaginative, it also forced artists to reconsider the traditional ways of seeing. In addition, some subtle aspects of camera vision also indicated new areas of visual perception which the more adventurous began to explore. The distinctive blurring of trees caused by the movement of branches during the long exposures of early landscape photographs appears in the landscapes painted by Jean Baptiste Corot, an associate of several distinguished photographers. Corot also adopted the photographic effect of 'halation', the spread of light around outlines, caused by the refraction of light in the coated glass plates first commonly used in cameras around 1850. When Corot died hundreds of photographic studies were found among his effects. The dramatic cropping of scenes was certainly a novel feature of the Japanese art which caused a sensation in Europe in the 1860s. However, this effect, at its most random, was already familiar from the increasingly informal photographs of the time, as was the exaggerated foreground of wide-angle perspective. The angle of vision of Impressionists like Claude Monet, looking down on the crowded boulevards of Paris, parallels exactly that of the stereo-cameras which in the late 1850s began to populate the streets previously left empty by the slow daguerreotype.

Nor was the evidential value of photography ignored. In 1867, Maximilian, a puppet Emperor installed by the French in Mexico, was captured and shot by republican insurgents. While the execution of the Emperor Maximilian as painted by Edouard Manet does not tally in several important respects with eyewitness accounts, the faces of the principals are based on available cartes-de-visite. The tonal contrasts in this painting are also markedly harsh and 'photographic'. The Impressionists held their first exhibition in 1874 in the old photographic studio of Nadar, and Renoir confirmed the importance that the Impressionists attached to developments in photography. The poet Paul Valéry states that the work of Edgar Degas achieved a remarkable new synthesis by combining 'the snapshot with the endless labour of the studio'. Degas was a keen photographer who based his rare landscapes on his own camera studies. The camera's unique quality can be detected most strikingly in the arrested motion of Degas' ballerinas, no longer straining for narrative effect but offering, like photographs, a fragment of experience snatched out of the flow of time.

Degas also drew horses straight from the photographs of animals in motion taken by Eadweard Muybridge (p. 153). Muybridge's

7 Edouard Manet. 'The Execution of the Emperor Maximilian', oil, 1867. The faces of the principals in the painting were based on cartes-de-visite then in circulation. The photograph is of Miramon, the condemned general on Maximilian's left, 1867

8 Edgar Degas. *Princess Metternich, oils,* c. *1875. And* Adolphe Eugene Disdéri. *Prince and Princess Metternich, cartes-de-visite,* c.*1860*

9 Franz von Lenbach. *'Self-portrait in oils with wife and daughters', 1903. And Lenbach's photographic study for his family painting, 1903*

Animal Locomotion sold in eleven volumes at $600 in 1887, and among the many artist subscribers were Holman Hunt and Millais in England, Rodin in France, and Franz von Lenbach in Germany. Initially, these stop-action photographs were of most obvious interest to painters like Jean Meissonier whose obsession with realistic detail led him to repaint the legs of warhorses in his historical studies when the true positions were finally revealed. But slavish reproduction could cause problems: the accurately painted horses of the American Thomas Eakins, bereft of any notation of motion, were dismissed as 'petrified'. Artists had been warned a century before by Canaletto against slavishly

following the view of the *camera obscura* 'where scientific accuracy offends against commonsense'. Now it was Auguste Rodin who cut through arguments about whether artists should be guided by the imperfect eye or the infallible machine. He pointed out that the pursuit of 'true reality' through still photographs was a chimera since time itself never stops.

Images which did at least convey an impression of objects in motion through time and space were produced as a by-product of scientific inquiries into movement by Professor Marey (page 157) in Paris. Among the artists subsequently inspired by Marey's overlapping images were Marcel Duchamp

in his painting of 'Nude Descending a Stair-case' and the Italian Futurists who in 1909 declared in the by then obligatory Manifesto, 'we affirm that the world's magnificence has been enriched by a new beauty: the beauty of speed', before rocketing off into fascism. In more recent times British painters like Francis Bacon and David Hockney have also based paintings on the classic work of Muybridge in *Animal Locomotion*.

The last great advance into the traditional preserve of painting came at the end of the century. It was a development long imminent and welcomed in 1895 by Paul Gauguin. 'Shall I tell you what will soon be the most faithful work of art? A photograph, when it can render colours, as it will soon be able to. And would you have an intelligent being sweat away for

months to achieve this same illusion of reality as an ingenious little machine?' Colour had been applied to photographs from the beginning by hand-tinting, although the mirrored surface of the cold daguerreotype was in practice so delicate that colours had literally to be breathed onto it. Much of the colouring of photographs on metal, paper, and glass was done by painters of miniatures who had been displaced by the collapse of their trade. For more entertaining effect, stereo-cards were made with coloured tissue which was then pricked full of holes and luridly backlit. But the attempts to produce real colour images by photo-chemistry date back to 1840. The first successful demonstration was made in 1861 by the Scots physicist James Clerk Maxwell who projected three transparent slides in red, green, and blue to create a tartan ribbon in colour. The race to be first with a practical colour process led to frantic competition and not a few hoaxes. By the 1870s Ducos du Hauron in France could make crude colour

10 BELOW Marcel Duchamp. 'Nude descending the Staircase', No. 2, oils, 1916. Inspired by the chronophotographs (page 158) of Professor Marey

11 RIGHT James Tissot. 'Waiting for the Ferry', oils. Tissot based his painting on this photograph of his mistress, Kathleen Newton, and her children. Tissot in bowler hat makes himself less visible in the painting, c.1875

photographs, but the real breakthrough came with the 1890s when Frederick Ives in Philadelphia invented the *Kromscop* for viewing colour pictures in 3-D by combining stereoscopic transparencies. In Dublin in 1894 John Joly patented a screen process and at last produced good quality photographs which could be viewed unaided. However, the most popular process, developed by the Lumière brothers in 1903, was called *auto-chrome*. These photographic plates, made up of tiny grains of dyed potato starch, remained on the market for thirty years.

By the end of the century most painters had overcome the old aversion to photography: some, though they remained discreet, painted scenes straight off photographs, others even painted over them. The critic most contemptuous of those locked into camera-vision was the French critic and poet Charles Baudelaire who had declared as far back as 1859, 'Each day art further diminishes its self-respect by bowing down before external reality; each day the painter becomes more and more given to painting not what he dreams but what he sees. Could you find an honest observer to declare that the mission of photography has no part at all in this deplorable result?' As photography's 'natural' view of the world became more dominant those painters content to imitate it were mocked for their 'petty little pursuits of realism'. Symbolists declared for the Imagination and the Norwegian painter Edvard Munch, with his tortured vision, said that

12 Paul Gauguin 'Mother and Daughter', *1890. And* Henry Lamasson. *Detail from a photograph taken around 1887*

186

he had no need to fear photography since it could not be used in Heaven or Hell. Painting was now in flight from the material world, hurtling inwards towards subjectivity and abstraction. The avant garde fled from the culture-hungry bourgeoisie and the first philistine stirrings of the twentieth century's mass societies. They worked hard to foster the myth of artist as heaven-touched genius, apocalyptic outsider destined to shock and thrill the bourgeoisie. This cultism, supported by the fantastic money rituals of the art market, served to obscure for a time the increasingly marginal role of painting. By the turn of the century, painting had been dethroned, and with the coming of moving pictures the camera gained indisputable control over the expanding empire of images. As an influence today painting is all but invisible. Even photography, though presently indispensable to newspapers, magazines, and posters, is now in trouble. The still camera has become the image-machine of industries of exploitation and control like pornography, advertising, and surveillance. In the information industry photographs are used more to attract than inform; pictures as evidence or news are now more vivid and

convincing as electronic images. Indeed, the technical revolution taking place in video bids to displace the photograph even from its most popular and familiar role as family memory bank. After being linked umbilically to the visual arts for half of the last century, the cultural influence of the contemporary photograph is now slight.

The art world once shared by gentlemen photographers and Royal Academicians seems changed beyond recognition. But Victorian art was an industry in which the image-manufacturers made fortunes. These Academicians were held in great respect and decorated with knighthoods and peerages. It was, after all, an industry which contributed to the nation's well-being; it manufactured a web of illusion and ideology which helped hold together the seemingly irreconcilable for an impressively long time. The function did not, however, die with Queen Victoria. Today the styles and purposes of Victorian art are pursued

13 Sir Lawrence Alma-Tadema. 'The Roses of Heliogabalus', oils, 1896. Fresh roses were brought weekly from the South of France to the painter's grand London home to lend precision to petals in this neo-classical fantasy

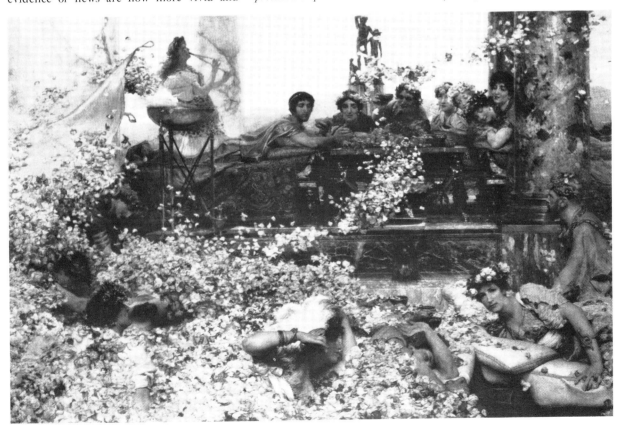

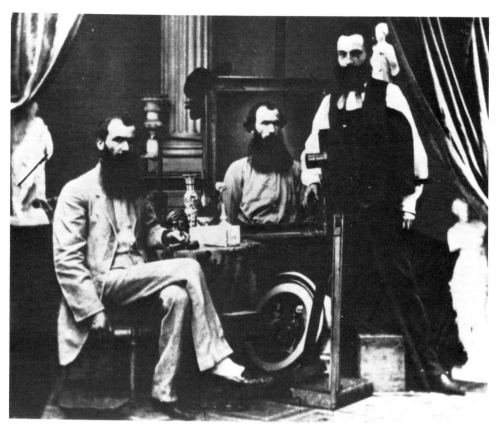

14 Janicat.
'*Photographer and Painter*', c.*1880*

quite unselfconsciously by industries which prefer to believe they have no past – film and television. An obsession with detailed naturalism as the best underpinning for fantasy led Sir Lawrence Alma-Tadema to import fresh roses weekly from the French Riviera to the lavish temple he had built in north London, thus ensuring the perfection of each petal in his 'Roses of Heliogabalus'. These paintings in turn came to influence a young film producer called Cecil B. de Mille. Sir John Millais boasted that he could make £30,000 a year and still have four months' annual holiday. It was the owner of Pear's Soap Company who instituted the link between the authority of art culture and other kinds of consumption: in 1886 he bought Millais' 'Bubbles' for £2,200 and used it to sell soap. Lustrous and enviable images remain essential elements in the modern cult of consumption which now celebrates the advertiser's Ideal. The spirit of Alma-Tadema survives in the glowing vision of the olden days still favoured by producers of television drama. To the location cameraman the appeal of Nature is undiminished, and

worshipped with every sun that sets on screen. The anecdote of the 'problem' picture is now the soap opera story line. The documentary directors manipulating symbols and sentiment are the electronic Landseers, dedicated like their Victorian predecessors 'to move the hearts of millions'. Those in control of the image industries even organize themselves into Academies and are well rewarded and decorated for their services to popular culture. But what Royal Academicians could once be relied upon to do unbidden is, in these uncertain times, now required by Government decree. The role of the image brokers is to inform, educate, and entertain the masses (now referred to as the Audience) in a fashion compatible with good taste and good order. And the new electronic culture is as widely popular, and much more persuasive, than its Victorian counterpart. Today the electronic camera is in indisputable control of the still expanding empire of the image. Painting is almost dead. And, increasingly, the most important thing about photography is not what it now says, but what it once was.

Photographic Acknowledgements

The acknowledgements for the Vignettes opening each chapter are listed according to their chapter number, those for the chapters according to illustration number.

Vignettes
1 The Fox Talbot Museum
2 The National Portrait Gallery, London
3 Bibliothèque Nationale, Paris.
4 Kodak Museum
5 Public Domain
6 Library of Congress
7 National Army Museum, London
8 The Surrey Constabulary
9 National Portrait Gallery, London
10 Gernsheim Collection, Humanities Research Centre, The University of Texas at Austin
11 Stephen White Vintage Photographs, Los Angeles
12 Sutcliffe Gallery, Whitby
13 Birmingham Art Gallery

Chapter 1: First Impressions
The Science Museum, London 1, 2; Gernsheim Collection, Humanities Research Center, The University of Texas at Austin, 3, 4, 6, 12; Walker Art Gallery, Liverpool 5; The Royal Photographic Society 7; The Fox Talbot Museum 8, 10, 13, 14, 15, 16, 17; Société française de la photographie 9, 18, 19; Bayerisches Nationalmuseum 11; Scottish National Portrait Gallery 20, 21, 22, 23, 24, 25; International Museum of Photography at George Eastman House 26, 27

Chapter 2: Mirror Image
Gernsheim Collection, Humanities Research Center, The University of Texas at Austin 1, 11, 14, 16; Massachusetts Historical Society 2; Metropolitan Museum of Art 3, 5, 15; Society for the Preservation of New England Antiquities 4; International Museum of Photography at George Eastman House 6, 7, 8; Crown Copyright, Victoria and Albert Museum 9, 10, 17, 18, 19, 20; Graham Ovenden 12, 13; Monuments Historiques 21, 22, 23, 24, 25, 26, 27

Chapter 3: World on a Plate
Crown Copyright, Victoria and Albert Museum 1, 2, 3, 10, 11, 12, 13, 14, 15; Bibliothèque Nationale 4, 5; Sotheby's Belgravia 6, 7; India Office Library and Records, London 8; Royal Geographical Society 9; Private Collection 16; Courtesy of the Boston Public Library, Print Department 17; International Museum of Photography at George Eastman House 18; Special Collections, Research Library, University of California at Los Angeles 19; Library of Congress 20; The Scott Polar Research Institute 21, 22, 23, 24; Popperfoto 25, 26, 27

Chapter 4: Photographic Pleasures
Bernard Howarth-Loomes 1, 2, 3, 4; National Portrait Gallery, London 5, 6, 7, 8, 9, 10; The Kodak Museum 11, 12, 19, 20, 21, 22, 23, 24, 26; Hastings Museum 13, 14, 15, 16; Graham Ovenden 17, 18; Courtesy of Exeter University Library and the National Library of Australia 25

Chapter 5: Caught in Time
Royal Photographic Society of Great Britain 1; Société française de la photographie 2; Bibliothèque Nationale 3, 4, 19, 20, 22; Royal Archives Windsor, reproduced by gracious permission of Her Majesty The Queen 5, 14, 15, 16, 17; Greater London History Library 6, 7, 8; Radio Times Hulton Picture Library 9; London Transport Executive 10; National Maritime Museum, London 11; National Portrait Gallery, London 12; Bibliothèque Historique de la ville de Paris 18; Musée Carnavalet 23; U.S. Dept. of Interior 24; Lewis W. Hine Collection, Local History and Genealogy Division, The New York Public Library, Astor, Lenos and Tilden Foundations 26, 27; Collection Texbraun

Chapter 6: Eyewitness of War
The Scottish National Portrait Gallery 1, 2; The Imperial War Museum 3, 4, 6, 7; The National Army Museum, London 5; The Library of Congress 8, 9, 10, 11, 12, 13, 14, 15, 16, 17, 18, 19; The Radio Times Hulton Picture Library 20; Crown Copyright, Victoria and Albert Museum 21; Underwood and Underwood (Bettmann Archives) 22; The Stockmarket, Los Angeles 23, 24

Chapter 7: Soldiers of the Queen
National Army Museum, London 1, 2, 5, 6, 7,

Index of Photographers and Artists